SHIMMERING IN A
TRANSFORMED LIGHT

SHIMMERING IN A TRANSFORMED LIGHT

WRITING THE STILL LIFE

ROSEMARY LLOYD

CORNELL UNIVERSITY PRESS
ITHACA AND LONDON

First published 2005 by Cornell University Press

Printed in the United States of America

Design by Scott Levine

Library of Congress Cataloging-in-Publication Data

Lloyd, Rosemary.
 Shimmering in a transformed light : writing the still life /
Rosemary Lloyd.
 p. cm.
 Includes bibliographical references and index.
 ISBN 0-8014-4296-6 (cloth : alk. paper)
 1. Literature, Modern—20th century—History and criticism.
2. Literature, Modern—19th century—History and criticism.
3. Still-life in art. 4. Still-life in literature. I. Title.
 PN771.L59 2005
 809'.93357—dc22

 2004017455

Cornell University Press strives to use environmentally responsible suppliers
and materials to the fullest extent possible in the publishing of its books.
Such materials include vegetable-based, low-VOC inks and acid-free papers
that are recycled, totally chlorine-free, or partly composed of nonwood
fibers. For further information, visit our website at www.cornellpress.
cornell.edu.

Cloth printing 10 9 8 7 6 5 4 3 2 1

FOR MARY ANN

CONTENTS

ILLUSTRATIONS

PREFACE

I want to begin with a confession. Although I have long enjoyed looking at paintings, I was for many years the sort of gallery-viewer who focused above all on landscapes and portraits, dashing down the corridors devoted to flowers, dead animals, and related topics while carefully averting my gaze, keeping still life in the background of my thinking about the arts. I understood only too well Sir Joshua Reynolds's dry comment in his *Journey to Flanders and Holland:* "Dead swans by Weenix, as fine as possible. I suppose we did not see less than twenty pictures of dead swans by this painter."[1]

Then, when I was a young lecturer, a colleague sent me a postcard depicting Manet's *Fish (Still Life)* (1864; fig. 1). I was profoundly shocked. Why would anyone send someone a picture of dead fish? But this wasn't just any colleague. This was Alison Fairlie, the Baudelaire specialist who had been my doctoral thesis supervisor, a scholar I deeply respected and greatly admired. I couldn't just attribute this choice to poor taste or to the desire to pass off an unwanted postcard on a junior colleague. However dimly, I perceived this as a message, and I kept the postcard for years until at last I learned to read it not as dead fish but as the play of light on surfaces, the exploration of shape and shade, a meditation on being and becoming, a work of art as demanding and as satisfying as any portrait or landscape.

[1] Joshua Reynolds, *A Journey to Flanders and Holland,* ed. Harry Mount (Cambridge: Cambridge University Press, 1996), 102.

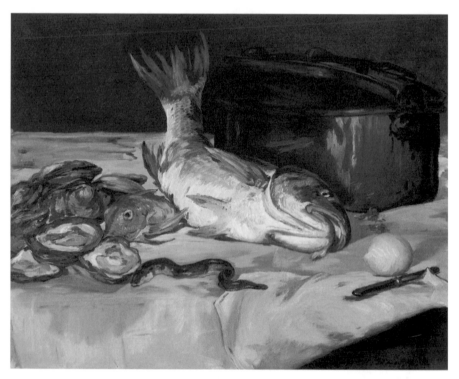

FIGURE 1. Edouard Manet, *Fish (Still Life),* 1864. Oil on canvas, 73.4 × 92.1 cm. Mr. and Mrs. Lewis Larned Coburn Memorial Collection, 1942.311. Reproduction © The Art Institute of Chicago.

After all, as Virginia Woolf argues: "Looked at again and again half consciously by a mind thinking of something else, any object mixes itself so profoundly with the stuff of thought that it loses its actual form and recomposes itself a little differently in an ideal shape which haunts the brain when we least expect it."[2] Still life draws on that haunting of the mind by objects. Based on the Dutch term *stilleven,* "still life" refers to inanimate objects—fruit, flowers, vessels, dead fish, and so on—captured in painting, either as the central subject of the work or embedded in a canvas devoted to a subject from history, a landscape, or a portrait. Charles Sterling, regarded as the founding father of still life studies in the visual arts, asserts that any work that depicts inanimate objects gathered together into a coherent whole can be regarded as a still life, that genre that appears to derive, however indirectly, from the classical *xenia,* the display of succulent items guests might be offered in their host's home.[3] It should perhaps be emphasized that a "coherent whole" does not necessarily imply a sense of order. Often, and increasingly so in modernist works, the still life objects convey a sense of messiness, of disorder, of chaos impinging on a world from which theological certainties were being eroded.

Objects, even the most trivial, even the most messily arranged, have indeed for millennia been attracting the attention not just of artists but also of writers. Philostratus, for instance, in a sensuous passage that also belongs to the subgenre known as the *xenia,* responds to that early challenge that artists had recognized and that writers also saw the world as issuing to them. "It is a good thing," he maintains, "to gather figs and also not to pass over in silence the figs in this picture." In other words, what is at issue is not just the object itself but also the representation of it, both in painting and in prose. Philostratus goes on, with seductive and succulent enjoyment:

> Purple figs dripping with juice are heaped on vine-leaves; and they are depicted
> with breaks in the skin, some just cracking open to disgorge their honey, some split

[2] Virginia Woolf, "Solid Objects," in *The Complete Shorter Fiction,* ed. Susan Dick (San Diego: Harcourt Brace, 1989), 104.

[3] See Charles Sterling, *Still Life Painting: From Antiquity to the Twentieth Century* (New York: Harper & Row, 1981). On the question of whether still life should be seen as genre or as a series, see Norman Bryson, *Looking at the Overlooked* (Cambridge: Harvard University Press, 1990), 7–11.

apart, they are so ripe. Near them lies a branch, not bare, by Zeus, or empty of fruit, but under the shade of its leaves are figs, some still green and "untimely," some with wrinkled skin and over-ripe, and some about to turn, disclosing the shining juice, while on the tip of the branch a sparrow buries its bill in what seems the very sweetest of the figs. All the ground is strewn with chestnuts, some of which are rubbed free of the burr, others lie quite shut up, and others show the burr breaking at the lines of division. See, too, the pears on pears, apples on apples, both heaps of them and piles of them, all fragrant and golden. You will say their redness has not been put on from outside, but has bloomed from within. Here are gifts of the cherry tree, here is fruit in clusters heaped in a basket, and the basket is woven, not from alien twigs, but from branches of the plant itself. And if you look at the vine sprays woven together and at the clusters hanging from them and how the grapes stand out one by one, you will certainly hymn Dionysius and speak of the vine as "Queenly giver of grapes." You would say that even the grapes in the painting are good to eat and full of winey juice. And the most charming point of all this is: on a leafy branch is yellow honey already within the comb and ripe to stream forth if the comb is pressed; and on another leaf is cheese new churned and quivering; and there are bowls of milk not merely white but gleaming, for the cream floating upon it makes it seem to gleam.[4]

From antiquity, still life has inspired not only painters but also, as the quotation from Philostratus shows, writers, who clearly revel in the chance to set themselves up as rivals not just of artists but also of the external world itself, finding words that convey the shapes and textures, the promises and the suggestions, the hidden implications and overt messages embedded in even the most trivial and familiar objects we gather around us in making the domestic space we call home.

Humanity's fascination with the objects offered to us apparently at random by the world underlies and gives muscle to this rhetorical impulse. As Virginia Woolf puts it in her short story "Solid Objects" (1910), a child is drawn to "pick up one pebble on a path strewn with them, promising it a life of warmth and security upon the nursery mantelpiece, delighting in the sense of power and benignity which such

[4] Philostratus, *Imagines,* trans. A. Fairbanks (Cambridge: Harvard University Press, 1931), 123–25.

an action confers, and believing that the heart of the stone leaps with joy when it sees itself chosen from a million like it."[5] Writing about such solid objects, like painting them, is also a source of delight, both for the writer or artist and for the reader or viewer, but the use to which novelists have put evocations of the objects that make up the staple fare of the painted still life—pebbles and shells, cut flowers, pipes, musical instruments, fruit and vegetables—is often neglected by readers preoccupied with reading for the plot or seeking out the psychological aspects of characters.

In this book I focus on those evocations, in a deliberately eclectic group of works primarily but not exclusively written in prose during the last century and a half. I make no claim to being exhaustive, seeking only to suggest various possibilities for responding to these still lifes. My hope is that this sample of written still lifes will encourage others to explore further possibilities in this fruitful but overlooked area.

I am particularly grateful to the Guggenheim Foundation for the fellowship that enabled me to complete this project. Their generosity is deeply appreciated. It is also a great pleasure to express my gratitude to the College of Arts and Sciences at Indiana University and to Dean Kumble Subbaswamy, who made it possible for me to take up the fellowship. My thanks are also due to many audiences whose responses and tips have proved invaluable to me: audiences at the Universities of Liverpool, England; Edinburgh, Scotland; Melbourne, Australia; the Chinese University and the Chinese International School, Hong Kong; and at conferences held in Madison, Wisconsin; Bloomington, Indiana; and Lexington, Kentucky. Roger Hillman and Peter Hambly kindly sent me catalogues of still life exhibitions, for which I am pleased to be able to thank them. I also owe a special debt to the following people who have been generous with their advice: Mary Ann Caws, John Hollander, Elizabeth Honig, Barbara Wright, and above all Paul Lloyd. I am profoundly grateful to Bernhard Kendler: his encouragement and enthusiasm have been uniquely

[5] Woolf, *Complete Shorter Fiction,* 103–4. Iris Murdoch takes up this theme in her novel *The Green Knight,* in which her character Moy becomes increasingly guilt-ridden at the thought that she has taken a stone from its rightful place in nature.

important to me for many years, and it is a great pleasure to be able to thank him for them.

Earlier versions of parts of chapters 2, 4, and 5 appeared as "Children and Objects" in *The Child in French and Francophone Literature,* ed. Norman Buford, French Literature Series 31 (Amsterdam: Rodopi, 2004), 171–81; "Powerless in Paradise: Zola's *Au Bonheur des dames* and the Fashioning of a City," in *Peripheries of Nineteenth-Century French Studies,* ed. Timothy Raser (Newark: University of Delaware Press, 2002), 156–64; "Portrait of the Poet as Still Life," *Romance Studies* 21 (2003): 25–38; and "Objects in the Mirror: Gendering the Still Life," *Yearbook of Comparative and General Literature* 49 (2001): 39–56. All have been substantially revised. I am grateful to the editors and publishers of these works for allowing republication.

Note: Except where otherwise indicated, all translations are my own.

SHIMMERING IN A
TRANSFORMED LIGHT

INTRODUCTION

Current existence, the ultimate astonisher

DOROTHY RICHARDSON, *Pilgrimage*

"A lemon can be an inspiration as well as a fruit,"[1] the Australian modernist painter Margaret Preston insisted, while Virginia Woolf mused, when she heard her sister Vanessa Bell and their friend the art critic Roger Fry discourse on the Paul Cézanne still life that Maynard Keynes had just acquired: "What can 6 apples *not* be."[2] In her contemplation of the Cézanne still life, Woolf continues:

> There's their relationship to each other, their colour, their solidity. To Roger &
> Nessa, moreover, it was a far more intricate question than this. It was a question of

[1] Margaret Preston, Aphorism 53. Quoted in Elizabeth Butel, *Margaret Preston: The Art of Constant Rearrangement* (Ringwood, Victoria: Penguin Books Australia, 1985), 5.

[2] Virginia Woolf, *The Diary of Virginia Woolf,* ed. Anne Olivier Bell and Andrew McNeillie (London: Hogarth Press, 1977–84), April 18, 1918, 1:140–41. The Cézanne painting *Pommes* is in the Fitzwilliam Museum, Cambridge. Vanessa Bell's account of her first sighting of this still life is just as excited but refers to seven apples (see her *Selected Letters,* ed. Regina Marler [London: Bloomsbury, 1993], 213).

pure paint or mixed; if pure which colour: emerald or viridian; then the laying on of the paint; & the time he'd spent, & how he'd altered it, why, & when he'd painted it—. We carried it into the next room, & lord! how it showed up the pictures there, as if you put a real stone among sham ones; the canvas of the others seemed scraped with a thin layer of rather cheap paint. The apples positively got redder & rounder & greener.

Appreciating Cézanne's still life calls for a response to shape and perspective, an awareness of technique and chronology, a sensitivity to the work of the artist, and a sense of comparison with other works, but for Woolf as a writer it also demands something else, a sense of listening to what the work says to her as an individual and above all, perhaps, a determination to seize something of its essence in her own medium and in her own terms. John Hollander, in his survey of poets' responses to painting, convincingly argues:

All ecphrastic writing, whether in verse or prose, must exploit deeper rhetorical design as well as respond to a number of more obvious considerations. These would include, for example, the matter of scale: the scale of writing and of parts of the written text as well as of reading the image. Then, too, there is the identification—and thereby, often, the construction—of parts or elements of the image being addressed; selection among these, and ascriptions of relative primacy or ancillary quality, of relative prominence and importance. There is the emergence of some explanatory or interpretative agenda [. . .] in every case there may be—at some level—possible mimesis of elements in the image, be they purely narrative, iconographic, formal, or, in pictorial and poetic modernity, formally and structurally semiotic.[3]

[3] John Hollander, *The Gazer's Spirit* (Chicago: University of Chicago Press, 1995), 90. The word is more frequently spelled "ekphrasis"; I follow Hollander's "domesticated" spelling here. The French term *transposition d'art* is more immediately comprehensible, suggesting the transformation of a subject or theme from one artistic medium into another. One might think of Delacroix's depiction of Shakespeare's Hamlet gazing at the skull, for instance, or of Baudelaire's poem "Les Phares" (The Lighthouses) evoking the paintings of Leonardo da Vinci or the statues of Michelangelo, or W. H. Auden on Jan Brueghel's painting of the Fall of Icarus, for example ("About suffering they were never wrong").

While Hollander's focus here is on ecphrasis—that is, the written response to a real or imagined work of visual art—similar rhetorical challenges face writers seeking to capture in their texts the verbal equivalents of still lifes, passages that have at their core the appreciation of the objects that lie at the heart of domestic, everyday life.

We see the same kind of challenge, for instance, when the French novelist Alain Robbe-Grillet turns his attention to a tomato:

> A quarter tomato, truly without blemish, machine-cut into a fruit of perfect symmetry. The surrounding flesh, compact and homogeneous, of a lovely chemical red, reveals a regular thickness between the band of gleaming skin and the housing in which the seeds are arranged, yellow and well calibrated, held in place by a thin layer of greenish jelly along the swelling of the heart. The heart itself, soft pink and slightly grainy, begins, near the lower hollow, with a network of white veins, one of which continues nearly up to the seeds, but in what might be an uncertain way. At the very top, a barely visible accident has occurred: a piece of peel, which has come loose from the flesh for about a millimeter or two, rises up, imperceptibly.[4]

Robbe-Grillet creates here a small still life, one that not only stands by itself as independent of the plot, but that also reflects back on the novel itself by focusing on the power of observation and on how complex, indeed sometimes impossible, it is to note perfectly everything that surrounds us—how to account for the contradiction between the initial sense of perfection and the awareness on closer inspection of a flaw, even if it is—especially if it is—"imperceptible." It is an exercise for both writer and reader in how to read the world and the text posing as a banal slice of tomato, an exercise that parallels Robbe-Grillet's choice of the apparently banal form of the detective story to revitalize the novel as genre.[5]

But this passage also acts as a commentary on still life paintings, in which our attention is often seized by an initial appearance of perfection, isolated from the rest of existence: a bowl of perfect peaches, a bunch of exquisite flowers, for instance,

[4] Alain Robbe-Grillet, *Les Gommes,* ed. J. S. Wood (Englewood Cliffs, N.J.: Prentice-Hall, 1964), 130. The novel was first published in 1953.

[5] On this, see above all Robbe-Grillet's own theoretical arguments in *Pour un nouveau roman* (Paris: Editions de Minuit, 1963).

caught in that particularly intense light that often seems to surround and isolate the still life object. But look closer, as Robbe-Grillet's narrator does with the tomato, and you become aware of the flaws, the caterpillar devouring a leaf, the worm in the fruit, the bruising, the decay, the signs of decomposition that are an essential part of still life, which, even when it does not have as its central focus items from the *vanitas* motif,[6] is always both a *memento mori* and a *carpe diem*.[7] It is a response to the world and our mortal condition that both urges us to think of our end and encourages us to seize our pleasures while we can.[8]

The response to the external world, either in reality or in painting, poses a question that Woolf expresses in broader terms when she takes up the challenge thrown down by Goethe in *Faust* to ask: "If one does not lie back and sum up and say to the moment, this very moment, stay you are so fair, what will be one's gain, dying?"[9] Like Stéphane Mallarmé's depiction of the poet faced with the universe's demand that he respond to the interrogation "Qu'est-ce, ô toi, que la Terre?" (What, O Mortal, is the Earth?),[10] this is a vital question, even for those moments that are not fair. Moreover, such questions lie at the very heart of the artistic genre or series known as still life. And however much secularization has marked Western society over the last two centuries, that question has lost none of its potency for having changed its nature from primarily religious to largely existential.

Capturing the moment is in part the purpose of still life, that art form that seizes the fleeting if banal joys associated with such basic acts as eating and drinking, or

[6] That is, those still lifes devoted to reminding the viewer of the brevity and futility of human existence, usually by accumulating objects associated with time-wasting pastimes (cards, soap bubbles, even musical instruments, for instance) together with those that symbolize the brevity of human life (for example, skulls, clocks, or guttering candles).

[7] Ernst Gombrich, indeed, argues that "any painted still life is *ipso facto* also a vanitas" because if you try to touch, say, painted fruit you hit cold canvas (*Meditations on a Hobby Horse, and Other Essays on the Theory of Art* [London: Phaidon, 1963], 104).

[8] On this, see, for example, Sybille Ebert-Schifferer, *Still Life: A History* (New York: Abrams, 1999), 22, and Christopher Braider, *Refiguring the Real: Picture and Modernity in Word and Image, 1400–1700* (Princeton: Princeton University Press, 1993), 115–16.

[9] *Diary of Virginia Woolf,* 4:135.

[10] This quotation is taken from Mallarmé's 1873 poem in memory of Théophile Gautier. Mallarmé, *OEuvres complètes,* ed. Bertrand Marchal (Paris: Gallimard, 1998), 1:27.

with the artifacts that we gather around us in creating a domestic space we call home, or with objects that suggest luxury or status or that act as repositories of memory. It is a genre that conveys, to quote the Australian art critic Robert Hughes in his collection of essays characteristically titled *Nothing If Not Critical,* "apprehensible truth, visible, familiar, open to touch and repetition"[11] but that can at the same time invite symbolic readings that confer on it a timeless quality extending far beyond that initial purpose of giving lasting form to a fleeting moment. Moreover, that initial purpose is far from being the only function of still life, which, as Norman Bryson argues in *Looking at the Overlooked,* situates itself at the interface of three cultural zones, each of which broadens and extends that purpose.[12]

First, there is that familiar zone depicting the life of the table and the household interior, a zone to which modernism applied its own particular stamp in such paintings as Paula Modersohn-Becker's *Still Life with Blue and White Porcelain* (1900: Niedersächsisches Landesmuseum, Hanover) or Margaret Preston's *Implement Blue* (1927). Then there is the domain of sign systems that encode that subject matter through suggestions, hints, or images relating it to other cultural concerns in other domains, concerns such as class, race, gender, or ideology. Take, for instance, the contrast between Anne Vallayer-Coster's *Still Life with Ham, Bottles, and Radishes* (1767: Staatliche Museen zu Berlin, Gemäldegalerie), which speaks of simple, lower-class pleasures, and François Desportes's *Silver Tureen with Peaches* (c. 1740: Nationalmuseum, Stockholm), which suggests a different, more opulent and more ostentatious, social class. Or the differences between Méret Oppenheim's *Breakfast in Fur* of 1936 (Museum of Modern Art, New York), which wittily promotes an ideology that separates art from utility, and Natalya Goncharova's *Linen* (1913: Tate Gallery, London), which moves women's work into the domain of heavy labor, bringing to mind parallels between ironing clothes and the steel mills. Indeed, *Linen* also plays with notions of gender identity, since, as the notes to the Tate Gallery's website affirm: "The two sides of the work are divided between male (shirts, collars and cuffs) and female (lace, blouses, aprons) items of laundry."[13] Still life's third domain, finally,

[11] Robert Hughes, *Nothing If Not Critical* (New York: Penguin, 1990), 76.

[12] Bryson, *Looking at the Overlooked,* 14.

[13] See http://www.tate.org.uk/. This site also draws attention to the artist's initials on the iron.

concerns the technology of painting, so that the painting focuses on the sign as sign, drawing attention to the kinds of technical details that Vanessa Bell and Roger Fry addressed in response to Cézanne's apples. As Margaret Preston asserts, the reason there are "so many tables of still life in modern paintings is because they are really laboratory tables on which aesthetic problems can be isolated."[14]

Thus, Vincent Van Gogh, in a characteristically enthusiastic letter to his brother Theo, notes of a still life he has been working on:

> A blue enamel coffeepot, a cup (on the left), royal blue and gold, a milk jug in squares of pale blue and white, a cup—on the right—of white with a blue and orange pattern, on an earthen tray of grayish yellow, a jug in earthenware of majolica, blue with a pattern in reds, greens and browns, and lastly 2 oranges and 3 lemons; the table is covered with a blue cloth, the background is greenish-yellow, so that there are six different blues and four or five yellows and oranges.[15]

Looking back at this painting a few days later he would remark, as if this particular laboratory table had worked out satisfactorily: "The last canvas absolutely kills all the others; it is only a still life, with coffeepots and cups and plates in blue and yellow; yet it is something quite apart."[16]

Just as still life has these broader functions as well as its most obvious purpose, so it is found not only in canvases devoted to capturing the multifarious pleasures objects offer us, but also in portraits and historical paintings: the basket of knitting on the table in David's *Lictors Returning to Brutus the Bodies of His Sons* (1789: Musée du Louvre, Paris), or the partially peeled orange in Vermeer's *Girl with the Wine Glass* (c. 1659: Herzog Anton Ulrich-Museum, Brunswick). Inserted into a portrait—particularly, perhaps, a self-portrait—it can offer its own whispered comment, ironic or admiring, on the sitter's hobbies or nature. Embedded within these wider horizons, still life, long regarded as the lowliest of the pictorial orders, intro-

[14] Aphorism 45, quoted in Sidney Ure Smith, *Margaret Preston: Recent Paintings* (Sydney, Australia: Sidney Ure Smith, 1929).

[15] Vincent Van Gogh, *The Complete Letters,* 3 vols. (Boston: Bulfinch Press, 2001), 2:568. The letter, although not dated, was written in 1889.

[16] Ibid., 2:583.

duces a note of quiet commentary, reinforcing the creative life of women, who knit and produce children in a world where fathers can order the execution of their sons, or sardonically suggesting, in the Vermeer, that the task of seduction is almost complete: the woman is almost ready to follow the orange and unpeel her garments.

While writers have long been seen as vying with the painters of portrait and genre, history and landscape, I want in this book to think about the extent to which the *sotto voce* commentary provided by still life can be detected in written texts and, above all, in novels, at points where the plot stops and the narrative viewpoint focuses on the elements we associate with the painted still life: a pipe, with a thread of tobacco suggesting it has just been set down; a heap of books, their varied titles and haphazard disposition inviting meditation on the implied reader or, more generally, on the act of reading; a mixed bouquet of flowers or a cup and saucer, whose presence suggests something about their owners or about the values of the society that produced them, or about the role of the physical world within the space of the novel.

The ways in which the encoding of still life can take place, and the ways in which still life in painting and in writing draws attention to the technology and practice of painting or writing, may of course be radically different in the two media, even if parallels can be established along the lines I have been suggesting. I am arguing not for the negation of difference in practice but rather for a heightened awareness of what is involved in each medium when a still life is produced. After all, *writing* about objects, and *painting* objects, are two different tasks, as Lessing insisted in his highly influential study of the statue of Laocoön, and as critics and creative artists and writers have argued ever since in different and often revealing ways. Commenting on the records of oral histories he had read in preparation for his series of paintings inspired by the bushranger[17] Ned Kelly, the artist Sidney Nolan contended: "When you take an oral tradition and write it down there is always a degradation. When you take an oral tradition and paint it there is less of a loss. Painting is simply a more immediate language than writing."[18]

[17] The Australian term for an outlaw living in the bush and subsisting by crime.
[18] Quoted in Elwyn Lynn, *Sidney Nolan's Ned Kelly* (Canberra: Australian National Gallery, 1985), 9. Among the histories Nolan had read was the report of the Royal Commission on the Police Force of Victoria, with its frequent recourse to vernacular language, and Kelly's own account of his life, the doc-

Others have more subtly, or perhaps simply more tactfully, stressed difference rather than hierarchy. Thus, in a suggestive passage in her 1985 novel *Still Life,* A. S. Byatt explores a credo briefly expressed in the sentence: "Both metaphor and naming in paint [are] different from these things in language." The passage merits quoting at some length:

> Language might relate the plum to the night sky, or to certain ways of seeing a burning coal, or to a soft case enwrapping a hard nugget of treasure. Or it might introduce an abstraction, a reflection, of mind, not mirror. "Ripeness is all," language might say, after observing, "We must endure our going hence even as our coming hither." Paint too could do these things. Gauguin made a woman from two pears and a bunch of flowers. Magritte made bread from stones and stones of bread, an analogy operating a miracle. Van Gogh's painting of the Reaper in his furnace of white light and billowing corn said also, "Ripeness is all." But the difference, the distance fascinate[s]. Paint declares itself as a force of analogy and connection, a kind of metaphor-making between the flat surface of purple pigment and yellow pigment and the statement "This is a plum." "This is a lemon." [. . .] We know paint is not plum flesh. We do not know with the same certainty that our language does not simply, mimetically, coincide with our world.[19]

Byatt links that discovery to Sartre's realization in his novel *La Nausée* that he could not adequately describe the roots of a chestnut tree, but of course it goes back to Plato and is a central element of modernist and postmodernist texts.

Mallarmé, lamenting that the French word for "day" sounds dark while the word for "night" sounds light, recognizes that were it not so, poetry would not exist, and Australian novelist David Malouf offers his solution through a witty foregrounding of the need for the metaphorical in order to depict apples and pears. In Malouf's 1984 novel *Harland's Half Acre,* there is a zestful passage recalling the artistic gifts of the narrator's father, who sells fruit and vegetables:

ument known as the Jerilderie letter. For a recent novelistic attempt to capture this language, see Peter Carey's *True History of the Kelly Gang* (New York: Knopf, 2000).

[19] A. S. Byatt, *Still Life* (New York: Collier, 1985), 177.

His restriction, so far as everyday employment went, to the mundane world of fruit and vegetables, left his real gifts undeclared, and one caught a glimpse of what they might be only when the fruit-growers and distributors, each year in August, mounted their display-stands at the Brisbane Show. Then at last he could show his hand. Those ordinary objects, Granny Smiths and Jonathans polished to a waxy brightness, William pears, Valencias, pawpaws, mangoes, bananas, were freed into a new dimension. Transcending their edible selves, and leaving behind the world of orchards at Stanthorpe or plantations at Bowen, and the suburban dining tables for which they were intended, they became the merest abstract shapes and colours to be deployed as imagination decreed: in maps of the seven states of the Commonwealth, as the kangaroo, emu and shield in the national emblem, as a star-burst of ten-foot poinsettias, in diamond shapes, lozenges and zigzags like the markings on a serpent, or as letters that spelled out the name of the firm in an elaborate scroll flanked by cornucopias spilling giant apples and pears, that when looked at closer were made up of dozens of real-life apples and pears.[20]

Malouf's still life moves away from the primarily mimetic to highlight the imaginative transformation of the everyday into the remarkable, the artistic potential of even the most humdrum act, and it serves as a metaphor for the ability to perceive the true potential not just of fruit and vegetables but of language: "[My father] had an eye," the narrator concedes, "for how nature might outdo itself."[21]

Similarly, one might argue after reading this still life, Malouf has an eye and an ear for how language might outdo itself, in a description at first precise enough to suggest such still lifes as Juan Sánchez Cotán's *Quince, Cabbage, Melon, and Cucumber* (c. 1602; fig. 2) or his *Still Life with Vegetables* (Museo provincial de Bellas Artes, Granada), or Fede Galizia's *Still Life with Peaches in a Porcelain Bowl* (Silvano Lodi Collection, Campione, Switzerland) but unraveling as each attempt at preciseness uncovers a different metaphor, one that shows that what we see is not what we get, but something both lesser and greater. It is also a passage that transforms the domestic to the majestic and that lifts the still life out of the range of what is termed rhopogra-

[20] David Malouf, *Harland's Half Acre* (London: Chatto & Windus, 1984), 52.
[21] Ibid.

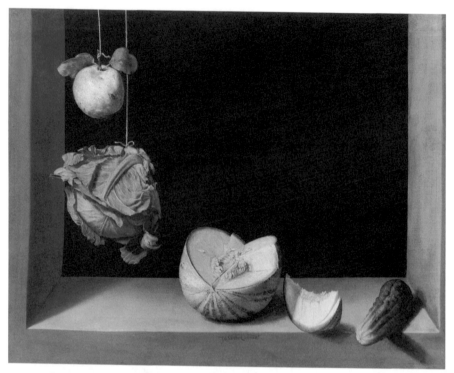

FIGURE 2. Juan Sánchez Cotán, *Quince, Cabbage, Melon, and Cucumber,* c. 1602. San Diego Museum of Art (Gift of Anne R. and Amy Putnam).

phy, the depiction of trivial wares, trifles, or debris,[22] and into something quite different. This indeed is frequently the case with both painted and written still lifes of the last century and a half: the sharp focus on the ordinary, or on what we might superficially take to be ordinary, reveals it in all its strangeness, forcing us to reconsider the nature and the function of objects both within and outside the human context.

If we think about written rather than painted still lifes, it is clear that many poems, whether or not they are ecphrases—that is, evocations of works of art, real or imaginary—are the written equivalent of a still life, capturing an object under the glass of a sonnet, for example. Mallarmé's sonnet "Surgi de la croupe et du bond," for instance, asks to be read as a suave attempt to rival the vases of flowers painted by his friends Odilon Redon, Edouard Manet, and Claude Monet, not in terms of realistic representation but in stimulus to the imagination.[23] It is even more obvious as a technique among the French Parnassian poets. François Coppée's sonnet "Le Lys" (1866) offers a clear example:

> Hors du coffre de laque aux clous d'argent, parmi
> Les fleurs du tapis jaune aux nuances calmées,
> Le riche et lourd collier, qu'agrafent deux camées,
> Ruisselle et se répand sur la table à demi.
>
> Un oblique rayon l'atteint. L'or a frémi.
> L'étincelle s'attache aux perles parsemées,
> Et midi darde moins de flèches enflammées
> Sur le dos somptueux d'un reptile endormi.
>
> Cette splendeur rayonne et fait pâlir des bagues
> Eparses, où l'onyx a mis ses reflets vagues
> Et le froid diamant sa claire goutte d'eau;

[22] On this term, see Norman Bryson, *Looking at the Overlooked* (Cambridge: Harvard University Press, 1990), 182–83.

[23] See my article "The Art of Distilling Life: Mallarmé, Misogyny, and the Seduction of the Feminine," *Australian Journal of French Studies* 31, 1 (1994): 97–112. Hollander would term this a "notional ecphrasis" because its aim is not to evoke a preexisting painting but rather to suggest a potential painting. The poem was first published in 1887.

Et, comme dédaigneux du contraste et du groupe,
Plus loin, et sous la pourpre ombreuse du rideau,
Noble et pur, un grand lys se meurt dans une coupe.[24]

[From the lacquer coffer with its silver nails
Amidst the yellow carpet's flowers with their calm shades,
The rich, heavy necklace with its cameo clasps
Flows half spreading out onto the table.

An oblique ray lights it. The gold trembles.
A spark clings to the scattered pearls,
And noon hurls fewer flaming arrows
On the sumptuous back of a sleeping reptile.

This splendor radiates making the scattered rings
Grow pale, where the onyx has set its vague reflection
And the cold diamond its clear drop of water.

And, as if disdainful of the contrast and the group,
Further off, under the shadowy crimson of the drapes,
Noble and pure, a tall lily is dying in a cup.]

This is still life in the strongest sense of the expression: objects without a human presence, objects whose form and substance suggest a cold, immutable permanence, with only the lily to hint at the possibility of alteration and decay. The poem's form heightens that sense of stasis, bound as it is by the constrictions of a highly traditional sonnet, one that obeys all the rules that Théodore de Banville sets down, however tongue-in-cheek, in his witty and highly influential study *Petit Traité de poésie française* (Short treatise on French poetry).[25]

[24] Luc Decaunes, *La Poésie parnassienne* (Paris: Seghers, 1977), 204–5.
[25] Théodore de Banville, *Petit Traité de poésie française* (1872; reprint, Paris: Les Introuvables, 1978), 173–74.

Still life, however, lends itself not just to static but also to mobile poetic forms, as we can see when Eugenio Montale takes it up in 1939:

> Poi che gli ultimi fili di tabacco
> al tuo gesto si spengono nel piatto
> di cristallo, al soffitto lenta sale
> la spiarle del fumo
> che gli alfieri e i cavalli degli scacchi
> guardano stupefatti[.]

> [Now that with a flourish you've stubbed out
> the last shreds of tobacco
> in the crystal ashtray, a slow spiral
> rises to the ceiling.
> The knights and bishops of the chess set stare
> Amazed.][26]

Or consider Elizabeth Bishop's use of a deliberately trivialized fixed form to underpin the ugliness of modern mass-produced food:

> The bakery lights are dim. Beneath
> our rationed electricity,
>
> the round cakes look about to faint—
> each turns up a glazed white eye.
> The gooey tarts are red and sore.
> Buy, buy, what shall I buy?[27]

[26] Eugenio Montale, *Collected Poems, 1920–1954*, trans. Jonathan Galassi (New York: Farrar, Straus & Giroux, 1998), 253.

[27] Elizabeth Bishop, *The Complete Poems, 1927–1979* (New York: Farrar, Straus & Giroux, 1983), 151. The poem appeared in *Uncollected Works* in 1969. The slant rhymes that precede this sudden outbreak of perfect but trivial rhyming underpin and highlight this technique.

And just as it is part of the tradition of still life painting for the artist deliberately to invite comparison with the other still lifes his or her works recall, so these lines gain more force when set against some of the echoes suggested by that final question, especially perhaps Christina Rossetti's seductive list of dangerous wares in her 1862 poem "Goblin Market":

> Apples and quinces,
> Lemons and oranges,
> Plump unpecked cherries,
> Melons and raspberries,
> Bloom-down-cheeked peaches,
> Swart-headed mulberries,
> Wild free-born cranberries,
> Crab-apples, dewberries,
> Pineapples, blackberries,
> Apricots, strawberries—
> All ripe together
> In summer weather
>
> Rare pears and greengages,
> Damsons? and bilberries,
> Taste them and try:
> Currants and gooseberries,
> Bright-fire-like barberries,
> Figs to fill your mouth,
> Citrons from the South,
> Sweet to tongue and sound to eye,
> Come buy, come buy.[28]

While the ecphrastic nature of such poems has often been explored,[29] the still life inserted into a novel or short story tends to be overlooked, swept aside in modes of

[28] Christina Rossetti, *Goblin Market* (London: Gollancz, 1989), 7–8.
[29] On this, see, above all, Madeleine Cottin's edition of Gautier's *Emaux et Camées* (Paris: Lettres Mo-

reading that differentiate prose from poetry, privileging plot over detail. Yet such still lifes are nonetheless powerful presences. Christopher Braider argues convincingly that "the immediate motive behind poetry's appropriation of painting lay in that feature of painting which most excited poets' envy: its unique enjoyment of a faculty the classical tradition of ecphrastic rhetoric called *enargeia,* the power of filling the beholder with an overwhelming sensation of dramatic physical presence."[30] That *enargeia* is also present in the written depictions of objects associated with still life, perhaps all the more so in that these objects are such familiar elements of daily existence. Braider is illuminating here too: "Drawing directly on everyday life, [still life] demands no special skill or knowledge on the viewer's part; and the symbolic license derived from its humble subjects lends it a richly unexpurgated energy often lacking in higher, more responsible forms of art."[31] Think, for instance, of this brief still life in Virginia Woolf's *Mrs. Dalloway* (1925):

> There were flowers: delphiniums, sweet peas, bunches of lilac; and carnations, masses of carnations. There were roses; there were irises. [. . .] And then, opening her eyes, how fresh, like frilled linen clean from a laundry laid in wicker trays, the roses looked; and dark and prim the red carnations, holding their heads up; and all the sweet peas spreading in their bowls tinged violet, snow white, pale—as if it were the evening and girls in muslin frocks came out to pick sweet peas and roses after the superb summer's day, with its almost blue-black sky, its delphiniums, its carnations, its arum lilies, was over.[32]

dernes, 1968); Jean H. Hagstrum, *The Sister Arts* (Chicago: University of Chicago Press, 1958); James A. W. Heffernan, *The Museum of Words* (Chicago: University of Chicago Press, 1993); and John Hollander's *The Gazer's Spirit* (Chicago: University of Chicago Press, 1995).

[30] Christopher Braider, *Refiguring the Real: Picture and Modernity in Word and Image, 1400–1700* (Princeton: Princeton University Press, 1993), 9.

[31] Ibid., 135. Of course, there is a rich symbolism embedded in many of the still lifes that draw on the *vanitas* or *memento mori* themes, but a viewer with no knowledge of that symbolism can still have an immediate and satisfying response to them. For a debate on the relative value of iconographic readings (those that interpret the objects in a work of art as allegorical or symbolic) compared with those that respond to the narrative or descriptive qualities of art, see Svetlana Alpers, *The Art of Describing: Dutch Art in the Seventeenth Century* (Chicago: University of Chicago Press, 1983).

[32] Virginia Woolf, *Mrs. Dalloway* (Frogmore, St. Albans: Panther, 1976), 13–14.

It is a passage remarkable not just for the intensity of the description but also for the energy behind it, an energy that drives both the abundance of the list and the comparison with the fresh linen and the girls, together with that extraordinarily powerful, melancholy ending when all the accumulated drive and weight of the sentence crashes into the three final bleak syllables.

In his seductive exploration of the objects with which we surround ourselves, Jean Baudrillard offers a useful matrix for thinking about the energy potentially released by the written still life:

> The object: this humble and receptive walk-on character, this kind of psychological port of call, this confidant as it was experienced in traditional daily life and illustrated by all Western art until our own times, this object was the reflection of a total order, linked to a well defined concept of decor and perspective, substance and shape. According to this concept, shape is an absolute demarcation between inside and outside. It is a fixed container, the interior being substance. Objects—and especially furniture—thus possess over and above their practical function, a primordial function as recipient, a container for the imaginary.[33]

Objects as reflectors of the shape we impose on daily life are also, as Baudrillard contends, the forms around which we weave imaginative transformations or philosophical explorations of reality. Exploring the nature of those patterns and transformations enabled by objects as they are described in prose is part of my aim in this book.

But I want also to build on the suggestion Baudrillard puts forward in this passage to consider the ways in which such representations of objects invite us to see the world with different eyes, in ways different from those modes of vision made possible by the more abstract analysis of personality or the descriptions of nature that are often more prominent in prose fiction. After all, still lifes can also reveal themselves

[33] Jean Baudrillard, *Le Système des objets* (Paris: Gallimard, 1968), 38. Naomi Schor's attack on Baudrillard's nostalgia as elitist (*Reading in Detail: Aesthetics and the Feminine* [New York: Methuen, 1987], 56–57) seems unnecessarily reductive, and the term "elitist" too much of a glib shorthand to allow for the complexities of his argument.

to be analyses of character, the character of the person who arranges them as well as that of the person who views them, as happens in A. S. Byatt's 1996 novel *Babel Tower,* when Frederica, trying to see if she can share a house with Agatha Mond, "diagnoses the brown jar of graded wooden spoons, large and small, deep and flat, the clean tea-towels on scarlet hooks; the well-used but scrubbed chopping board; the glass jars full of coffee beans, cereals, tea, brown sugar, white sugar." While this still life reveals something about Agatha, the comment that follows is also a reflection on Frederica: "Here is natural order, in which someone takes pleasure."[34] What Frederica fails to guess is that while it may well give pleasure, there is little natural about it because it came about only as the result of a frantic effort to get the house in order just before her arrival. It is a remark that insists, among other things, on the necessity of reading not just print but also objects, and on reading them by means of more than just a fleeting glance.

One reason why still life enables us to read the world differently is that it frequently chooses subject matter so ordinary that it starts by inviting us to see it as we always do. The eighteenth-century thinker Denis Diderot, responding with delight to the paintings of Jean-Baptiste-Siméon Chardin at a time when they were less highly regarded than they are now, claimed: "To look at paintings by other artists, it seems I need to create eyes for myself; to look at those of Chardin, I need only keep the eyes that nature gave me, and use them well. [. . .] O Chardin, it is not white or red or black that you crush on your palette, but the very substance of the objects, it is air and light that you seize on the tip of your brush and that you attach to the canvas."[35]

But what another great admirer of Chardin, Marcel Proust, discovered, was that in teaching him how to use his own eyes properly, the still life painter also taught him to see the world with fresh eyes, or at least so we might extrapolate from a masterful passage in *In Search of Lost Time:*

[34] A. S. Byatt, *Babel Tower* (New York: Virago, 1996), 296.
[35] Denis Diderot, *Essais sur la peinture: Salons de 1759, 1761, 1763,* ed. Jacques Chouillet and Gita May (Paris: Hermann, 1984), 220.

> Wings and a different respiratory system, one that would allow us to cross immensity, would be of no use to us, for if we were to go to Mars or Venus while retaining our usual senses, they would confer on everything we might see the same aspect as the things of this Earth. The only true voyage, the only fountain of youth, would not be achieved by visiting new lands but by having different eyes, seeing the universe with the eyes of another person, of a hundred other people, in seeing the hundred universes that each of them sees, that each of them is; and we can do this with an Elstir, with a Vinteuil, with their peers, we truly fly from star to star.[36]

What happens with the still lifes created by Proust's character, the artist Elstir, is that the familiar and the everyday suddenly cease to be so, are stripped of that banality and set free of the clichés and accumulated familiarity they have built up. It is as if they had been subjected to the liberating and revitalizing force of Occam's razor: "If God the father created things by naming them, it is by removing their name, or by giving them another name, that Elstir re-created them. The names that designate things always respond to a notion of intelligence that is foreign to our true impressions and forces us to eliminate from them everything that does not correspond to that notion."[37] Painted objects, and by extension objects reforged in imaginative prose, can thus be liberated from the weight of familiarity imposed on them by the noose of habitual language. This is also what Stéphane Mallarmé means when he emphasizes, in his 1873 poem in memory of Théophile Gautier, the importance of creating a name for the lily and the rose, a name that would more closely correspond in sound and shape to the sensory charge of the flowers themselves.[38]

Proust reaches this insight by way of his study of Chardin, unpublished during his lifetime but apparently written in 1895, when he was in his early twenties.[39] In the arresting opening to this article, the writer imagines "a young man of modest means and artistic tastes, sitting in a dining room at the banal and gloomy moment

[36] Marcel Proust, *A la recherche du temps perdu,* ed. Pierre Clarac and André Ferré (Paris: Gallimard, 1954), 3:258 (henceforth *RTP*). The passage is from *La Prisonnière,* first published in 1923, the year after the writer's death. Elstir is Proust's artist figure while Vinteuil is his musician.

[37] Proust, *RTP,* 1:183.

[38] Mallarmé, *OEuvres complètes,* 1:28.

[39] See Marcel Proust, *Contre Sainte-Beuve,* ed. Pierre Clarac (Paris: Gallimard, 1971), 885.

when lunch is over and when the table has not yet been completely cleared."[40] Because his imagination is still caught in the glory of high art preserved in museums and cathedrals, he is unmoved by the sight of silverware and tablecloth, the leftover food and the dirty glasses, the cat prowling through the platter of oysters. It is only when he sees these scenes enshrined in a museum that he is able to detect their inherent beauty: "the interior of a kitchen where a live cat walks on oysters, while a dead ray hangs on the wall, a buffet already half-cleared with knives still lying on the tablecloth."[41] What Proust offers here is a little ecphrasis adapting into his own medium a well-known painting by Chardin, *The Ray.* Transformed by Chardin, these objects become sights of beauty because, Proust argues, Chardin found them beautiful to paint. Beauty here is not some essence intrinsic to an object, or a category immutably imposed by some external source, but a product of the artist's own ability to convey the excitement and joy that the task of painting the object occasioned. Once you have understood the life of Chardin's painting, Proust adds, "you will have conquered the beauty of life."[42]

In *In Search of Lost Time,* this ability to see the beauty of the world because painters have taught us to see its excitement is also underlined by the narrator in his thinking about Elstir:

> Ever since the time I'd seen them in Elstir's water colors, I'd been trying to rediscover in the real world, and loved as something poetic, the interrupted gesture of knives, still lying crooked, the swollen roundness of an unfolded napkin over which the sun had laid a strip of yellow velvet, the half-empty glass that displays all the better for being half empty the noble sweep of its shape, and, deep within its translucent window in which the day lay condensed, a little wine, dark but glittering with light, the displacement of its volume, the transformation of liquids through the effect of lighting, the alteration of plums that move from green to blue to gold in the half plundered fruit bowl, the ballet of elderly chairs that twice a day come and settle around the table cloth, laid on the table as if on an altar where food lovers cele-

[40] Ibid., 372.
[41] Ibid., 373.
[42] Ibid., 374.

brate their holy days, and on which in the heart of the oysters, a few drops of gleaming water linger as if in small stone fonts; I would try to find beauty in places where I had never imagined it was to be found, in the most common of objects, in the profound existence of still lifes.[43]

In those inanimate objects that are the subject of still life, in other words, can be found life at its most intense and at its most subjective. The French term *nature morte,* literally "dead nature," brings out this apparent oxymoron all the more powerfully, in ways that English speakers can recuperate by thinking of "still" as it appears in the expression "still born." That presence in the still life, that transformation of the object into subject, is one of the factors that most attract attention in both its painted and written versions, and I want to argue that it provides an illuminating clue to reading both modernist and postmodernist novels.[44]

"What can 6 apples *not* be?" Like Proust's exploration of the insights provided by Elstir's still life, Virginia Woolf's question haunts modernism, finding a further reflection in the German poet Rainer Maria Rilke, who asserts in one of a series of remarkable letters inspired by the Cézanne exhibition of 1907: "In Cézanne they [apples] cease to be edible altogether, that's how thinglike and real they become, how simply indestructible in their stubborn thereness."[45] "All of reality," he argues in another letter, still inspired by Cézanne, "is on his side: In this dense quilted blue of his, in his red and his shadowless green and the reddish black of his wine bottles. And the humbleness of all his objects: the apples are all cooking apples and the wine bottles belong in the roundly bulging pockets of an old coat."[46] Rilke himself took up the challenge in his requiem for an artist friend, Paula Modersohn-Becker, who had painted herself pregnant and nude:

[43] Proust, *RTP,* 1:869.

[44] I am using this term in a broad sense. As several recent commentators have argued, many texts associated with modernism reveal postmodernist tendencies, just as postmodernist texts bear the unmistakable imprint of modernism.

[45] Rilke, *Letters on Cézanne,* ed. Clara Rilke, trans. Joel Agee (New York: Fromm, 1985), 32–33 (October 8, 1907).

[46] Ibid., 29 (October 7, 1907).

For that, you understood: ripe fruit.
You laid them out in bowls before you,
and weighed their worth in terms of colors.
And like fruit, too, you saw all women;
like fruit their children, molded from within
into the shapes of their existence.
And finally you saw yourself as fruit,
Peeled off your clothes, and brought
yourself before the mirror, plunging in
up to your gaze, which stared wide-eyed ahead
and did not say: That's me; no: this is.[47]

Finding a way of saying "this is," of underlining the stubborn thereness of humans and their world, has been a central part both of modernism and, more playfully perhaps but no less urgently, of postmodernism.

In exploring its manifestations, I want therefore to focus on the last century and a half, and particularly on points marked by the irruption of images of contingency and rapid change in the fields of art. That sense of contingency springs in large measure from the modernist awareness that there could be no religious or transcendental assurances that what we believe is beautiful, just, or true really is so, an awareness that sees as hollow Pope's confident and resounding assertion, "One truth is clear, 'Whatever is, is RIGHT.'"[48] One of my concerns lies with the ways in which the still life, written or painted, both evokes and attempts to deal with that sense of contingency.

Through its depiction of rapid and unpredictable change, of what T. J. Clark terms "the malleability of time and space,"[49] and of the multiplicity of beings that Proust shows us making up an individual progressing through time, modernism

[47] From "Für eine Freundin." The full German text is available at www.rilke.de/gedichte.

[48] Alexander Pope, "An Essay on Man," in *The Poems,* ed. John Butt (New Haven: Yale University Press, 1963), 515.

[49] T. J. Clark, *Farewell to an Idea: Episodes from a History of Modernism* (New Haven: Yale University Press, 1999), 10.

may seem to gaze more to the future than to the moment. It will, however, be my contention that still life, in art and in literature, becomes a means for transferring the anxiety aroused by the contingency of a society in flux and in search of new secular values onto objects whose stubborn thereness is at once a reality and an illusion. A still life apple seems to capture the eternal essence of appleness at a time when scientific discoveries, the horrors of war, the flattening progress of global capitalism, and a growing secularism forced radical changes in previously held concepts of the self.[50] Because there were and could be no guarantees concerning the nature of beauty and truth, there were no longer any prerogatives to depicting the grand subjects previously held to contain or embody them. A bunch of asparagus, a dying trout, a vase of flowers, a row of Heinz soup cans, could speak more to the modern condition than depictions of Greek warriors or sublime landscapes of waterfalls and mountains. What this pushed into prominence is a force that had always been present but that had tended to be overshadowed by the subject itself: what Michael Ann Holly terms "the transforming power inherent in the beholder's visual experience, a power in Proust's novel that is tantamount to mastery."[51]

The 1880 still life of a bunch of asparagus that Manet painted for the collector Charles Ephrussi, whom Proust had met through Princess Mathilde's salons and who would make it possible for the future author of *In Search of Lost Time* to write for *La Gazette des beaux-arts*,[52] offers an unblinking example of the presence of its subject. This canvas places the bunch of asparagus just slightly off-center, in such a way that it seems to loom over the beholder, as monumental and as incontrovertibly present as a cathedral or a mountain (fig. 3). Lying on a bed of intense green foliage, it seems to offer, but not to impose, the kind of metaphorical transformation the narrator of *In Search of Lost Time* so admires in Elstir: a bundle of logs floating down a river, or a castle within its moat, the stalks of asparagus, delicate though their colors

[50] On this, see in particular Charles Taylor, *Sources of the Self* (Cambridge: Harvard University Press, 1989).

[51] Michael Ann Holly, *Past Looking: Historical Imagination and the Rhetoric of the Image* (Ithaca: Cornell University Press, 1996), 176.

[52] On their relationship, see, for instance, Jean-Yves Tadié, *Marcel Proust* (Paris: Gallimard, 1996), 394.

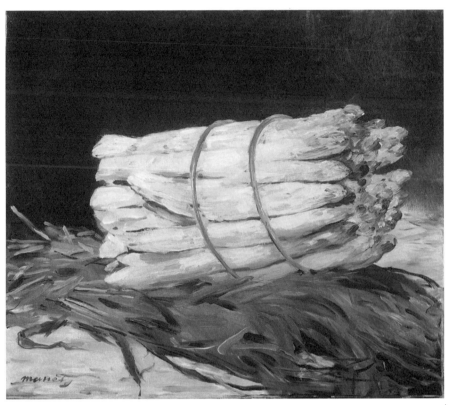

FIGURE 3. Edouard Manet, *A Bunch of Asparagus,* 1880. Wallraf-Richartz-Museum, Cologne.
Photo: Erich Lessing / Art Resource, NY

may be, and short-lived though their individual slim selves might appear, nevertheless command comparison with the monumental and the eternal. The featureless black background, which is a frequent device in traditional still lifes as well as in those of Manet, further thrusts his subject into the realm of the imagination, refusing to associate it with the kitchen, as Antoine Raspal does in his exuberant *Provençal Kitchen*[53] in the Musée Réattu in Arles, or with the marketplace, as Gustave Caillebotte would do—for instance, in his *Fruit Displayed on a Stand* (1894: Boston Museum of Fine Arts). It lies there, open to transformation by the viewer's imagination, but at the same time insisting simply on its presence, on its existence in one of what Proust would term "those rare moments when we see nature as it is."[54]

Manet's mastery here, his elevation of the humble vegetable to a subject commanding the beholder's gaze, may well have been one of the instigating forces behind Proust's own asparagus still life, perceived by the narrator when, as a young boy, he visits Françoise's kitchen:

> But what particularly delighted me was the asparagus, steeped in ultramarine and pink, and whose tip, delicately brushed in mauve and sky-blue, tails off little by little down to the foot—still dirty however from the soil of the garden bed—in rainbows not of this earth. It seemed to me that these celestial nuances revealed the presence of those delicious creatures who had playfully transformed themselves into vegetables and who, through the disguise of their edible, firm flesh, let you see in these colors of early dawn, in these sketchy rainbows, in this dying away of blue evenings, that precious essence that I recognized again when, through the nights that followed a dinner when I'd eaten them, they delighted in farces as poetic and vulgar as a Shakespearean fantasy in metamorphosing my chamber pot into a bottle of perfume.[55]

Proust's transformation in this passage, every bit as playful as that which he attributes to the asparagus spirits, conveys just as powerfully as Manet's more sober still

[53] I have not been able to establish a precise date for this painting, but the painter's dates are 1738–1811.

[54] *RTP,* 1:835.

[55] Ibid., 1:121.

life the value of the object on which each has cast his gaze. It sheds light both on what is seen, and on the viewer, whose youthful imagination is given free rein here. Read retrospectively, moreover, after we learn that if the family ate so much asparagus that year it was because this particular vegetable gave the kitchen maid asthma and thus allowed the chef, Françoise, to drive her away, this still life also becomes the ironic correlative both of the kitchen hierarchy and of the cruelty that is part of Françoise's intricate personality. It is a passage that reveals all three levels that can be detected in still lifes—the representation of objects; the metaphorical reflection of cultural and psychological concerns; the technological and rhetorical—for whatever else is going on here, we are also left in no doubt that the young Marcel, and the older Proust looking over his shoulder, are delighting in the metamorphosis of what is seen into what can be read, transforming the painterly metaphors of Elstir to make them accessible to their own medium.

In exploring written still lifes, I begin with an analysis of lists and catalogues of still life objects before contrasting the realist attempt to use still life to capture a moment and a society, to set it so to speak under glass, with that of writers and painters intent on conveying less the object than the effect it produces. Still life's ability to reflect on the artist is seen in a chapter in which still life appears as self-portrait, while gender forms the basis of a further chapter. Still life's unexpected capacity to convey time and place dominates my last chapter.

1

CATALOGUING THE WORLD

Heaped up on the floor [. . .] were turkeys, geese, game, poultry, brawn,
great joints of meat, sucking-pigs, long wreaths of sausages, mince pies, plum-
puddings, barrels of oysters, red-hot chestnuts, cherry-cheeked apples, juicy
oranges, luscious pears, immense twelfth-cakes, and seething bowls of punch.

CHARLES DICKENS, *A Christmas Carol*

In 1979 the Galeries Numage in Auvergne, Switzerland, mounted an imaginative
exhibition showing a variety of artists' works, each of which had been inspired by,
and painted in the presence of, a favorite object. In each case, a photograph of the
object itself was also displayed. Anya Staritsky, best known, perhaps, for her collab-
orations with poets to produce artists' books, was represented by a photograph of a
plum crate and by her illustrations for an object-poem by the French writer Michel
Butor. Staritsky's choice of a plum crate shows that objects need not be intrinsically
beautiful or obviously significant to inspire reveries. Indeed, Gustave Flaubert ar-
gued in an early letter, "For a thing to be interesting, you have only to gaze at it for
a long time," a conviction he later intensified by adding: "The most banal of objects
produces sublime inspirations."[1] Moreover, as Svetlana Alpers asserts in her influ-

[1] Flaubert, *Correspondance,* ed. Jean Bruneau (Paris: Gallimard, 1973), 1:192, 427.

ential book *The Art of Describing,* the role of objects in the human imagination and in works of art is not necessarily symbolic, as iconography argues, but often reflects a much more straightforward descriptive pleasure. The French painter, novelist, and art critic Eugène Fromentin was well aware of this when he admired in Dutch painting "an art which adapts itself to the nature of things, a knowledge that is forgotten in the presence of special circumstances in life, nothing preconceived, nothing which precedes the simple, strong and sensitive observation of what is."[2] And, as Sybille Ebert-Schifferer reveals:

> Whatever its specific character, the modern still life made its appearance in European centers where artists possessed the technical and cognitive skills required for the precise reproduction of natural objects, and where there were patrons capable of appreciating their paintings both as aesthetic triumphs and as complex moral statements. In these few places, the carefully placed, meticulously rendered inanimate object took on such significance that it replaced the human figure as the chief subject matter for art.[3]

Many still lifes, painted and written, reflect the inspirational power of objects, and many also convey the delight felt in listing objects, creating catalogues that may reflect on the social status or personal inclinations of those who possess them, or may simply take pleasure in effects of accumulation or contrast or parallelism.[4] It is a pleasure that is closely akin to that experienced when we look at the arbitrary juxtapositions of objects in antique malls or curio stores, a pleasure Walter Benjamin acknowledges almost despite himself in a passage from the Arcades project:

> As rocks of the Miocene or Eocene in places bear the imprint of monstrous creatures from those ages, so today arcades dot the metropolitan landscape like caves

[2] Eugène Fromentin, *Les Maîtres d'autrefois,* ed. Pierre Moisy (Paris: Garnier, 1972), 148. See also Alpers, *Art of Describing.*

[3] Ebert-Schifferer, *Still Life,* 91.

[4] On the functions of the written list, see Robert Belknap's captivating article "The Literary List: A Survey of Its Uses and Deployments," *Literary Imagination* 2, 1 (2000): 35–54. My thanks to John Hollander for drawing this to my attention.

containing the fossil remains of a vanished monster: the consumer of the pre-imperial era of capitalism, the last dinosaur of Europe. On the walls of these caverns their immemorial flora, the commodity, luxuriates and enters, like cancerous tissue, into the most irregular combinations. A world of secret affinities opens up within: palm tree and feather duster, hairdryer and Venus de Milo, prostheses and letter-writing manuals. [. . .] These items on display are a rebus: how one ought to read here the birdseed in the fixative-pan, the flower seeds beside the binoculars, the broken screw atop the musical score, and the revolver above the goldfish bowl—is right on the tip of one's tongue.[5]

Many painted still lifes, from Netherlandish collection paintings to those of the present, offer such accumulations. One might think of Juan Sánchez Cotán's elegant list of fruit and vegetables, *Quince, Cabbage, Melon, and Cucumber* (c. 1602; see fig. 2), or James Ensor's variations on the knickknacks and masks inherited from his mother's souvenir shop (for example, the 1906–7 *Still Life with Chinese Knickknacks* at the Koninklijk Museum voor Schone Kunsten in Antwerp), or Wolfgang Matthauer's *Garden Bench* of 1963 in the Staatliche Galerie Moritzburg, Halle, in which a double row of red and yellow fruit and vegetables is aligned on a garden bench with nails, a file, a mallet, and a pair of pliers. The French painter Arman has produced series of still lifes with such titles as *Accumulations* and *Poubelles* (garbage cans), with multiple examples of a single object such as a coffee jug or a medicine dropper. His book *Realism of Accumulation* argues that human conquest of the world has reached one of its last phases, one in which duplication in all its forms has become our definitive mode of expression.[6]

A form of social or metaphysical protest, a record of the human desire to collect,

<hr/>

[5] Walter Benjamin, *The Arcades Project,* trans. Howard Eiland and Kevin McLaughlin (Cambridge, Mass.: Belknap Press of Harvard University Press, 1999), 540. On collections, see also the remarkable work by Maurice Rheims, *La Vie étrange des objets: Histoire de la curiosité* (Paris: Plon, 1959), and Elizabeth Honig's article "Making Sense of Things: On the Motives of Dutch Still Life," *RES* 34 (Autumn 1998): 166–83.

[6] Quoted in Ebert-Schifferer, *Still Life,* 388. Arman's 1961 accumulation of coffee jugs, under the title *Night in the Wild West,* is reproduced in ibid., 390. See also Arman's *Le Nouveau Réalisme* (Paris: Editions du Jeu de Paume, 1999).

or a reflection of the artistic and linguistic challenge of revealing variety in similarity, or resemblance in difference, the list threads its complex path through both of the sister arts, creating a rebus whose reading is every bit as complex and provocative as Benjamin suggests. Grace Cossington Smith takes up the idea of the list and blends it with that of the pots and pans, and mugs and bottles, frequently associated with women's work, to make her wonderfully tongue-in-cheek, energetic still life *Things on an Iron Tray on the Floor* (c. 1928; fig. 4). As the witty title suggests, there is no tidy order here, no hierarchy, and no unnecessary pretense of realism; this is a deliberately messy gathering clearly put together to show off the artist's delight in shape and texture, reflection and opacity, in revealing all these objects in their own quiddity.

A staple of children's books and of mnemonics,[7] lists can offer the combined delight of the pleasures provided by the objects themselves, and the pleasures of the sounds and patterns of the words that evoke them. Yet, because they are most often based on accretion rather than syntactical linking, juxtaposition rather than logical progression, they also draw particular attention to the question of why language should be used to create them at all. The narrator of Thomas Mann's brooding study of evil and creative genius, *Doctor Faustus* (1947), wonders:

> Why words at all, why writing, why language? Radical objectivity had to embrace things, nothing else. And I recalled a satire by Swift, where reform-minded professors, in order to spare the lungs and encourage brevity, abolish words and speech entirely and converse solely by displaying the things themselves—although for discourse to take place, one therefore had to carry about as many such things as possible on one's back.[8]

But of course, as Jonathan Swift would have known only too well, this is to deprive oneself of the pleasure and the sense of control that naming brings, a sense that is particularly prominent throughout the nineteenth century.

[7] Compare Benjamin's assertion that "collecting is a form of practical memory" (*Arcades Project,* 205) and see, above all, Frances Yates, *The Art of Memory* (Chicago: University of Chicago Press, 1966).

[8] Thomas Mann, *Doctor Faustus,* trans. John E. Woods (New York: Random House, 1997), 388. The allusion is to *Gulliver's Travels.*

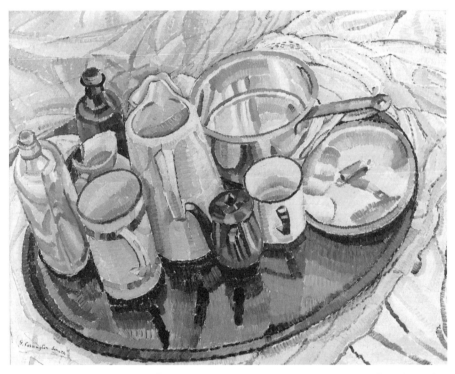

FIGURE 4. Grace Cossington Smith, *Things on an Iron Tray on the Floor,* c. 1928. Oil on plywood, 54 × 69.5 cm. Purchased 1967. Collection: Art Gallery of NSW © AGNSW. Photograph: Brenton McGeachie for AGNSW [acc# OA9.1967].

Goethe certainly knew it, as Margaret Drabble briefly reminds us in her novel *The Seven Sisters* (2002), in which lists play an important role. Here she not only alludes to but also shares with us Goethe's pleasure in observing and naming the objects of the natural world in a higgledy-piggledy order that is in itself delightful: *"starfishes, sea urchins, serpentine, jasper, obsidian, quartz, granites, porphyries, types of marble, glass of green or blue. Indian figs, narcissus, adonis, pomegranate, myrtle, olive.* He had been fond of lists and multiplicity."[9] And Drabble reveals here that, like many writers, she is fond of the sounds and rhythms, the patterns and reverberations, that such lists suggest, as she also indicates when her narrator describes a wool shop "filled with a cornucopia of colours, with lavish festoons of indigo, mauve, rust, grape, teal, rose madder, umber, amber and sap green yarn, in smooth and shaggy and rubbed and slubbed and silken strands."[10] The lavish abundance of words suggesting different shades combines in this passage with the writer's ability to give them further rhetorical color through the combinations of sounds, the assonance of *cornucopia* and *colours,* the rhymes of *rubbed* and *slubbed,* the phonetical similarities of *amber* and *umber,* while the insertion of the repeated "and"s serves to slow the list down, restraining the galloping enjoyment evident in the accumulation of colors so that we have time to feel and distinguish among the different textures.[11]

Other list makers are driven by the comic or obsessive nature of accumulations of objects and words—one thinks of Laurence Sterne and his inventory of articles of ancient dress ("The Toga, or loose gown. The Chlamys. The Ephod. The Tunica or Jacket. The Synthesis. The Paneula. The Lacema, with its Cucullus. The Padludamentum. The Praetexta. The Sagum, or soldier's jerkin. The Trabea; of which, according to Suetonius, there were three kinds. And so on.")[12]—and of Robert Bur-

[9] Margaret Drabble, *The Seven Sisters* (New York: Harcourt, 2002), 245.

[10] Ibid., 295.

[11] A similar delight is conveyed by the narrator's discovery of the beauty of bricks: "Roman bricks, yellow stock bricks, red string courses, creamy-blueish bricks, moss-covered bricks, kiln-dried bricks, painted bricks, bricks set in herring bone patterns. Coping stones, corner stones, arches, crenellations" (ibid., 134).

[12] Laurence Sterne, *Tristram Shandy* (1759–67; reprint, New York: Modern Library, 1950), 458–59.

ton, in his *Anatomy of Melancholy* (1632), obsessed with including every smallest symptom or cure or reference, often after the most fulsome of lists adding an "etc." for good measure:

> for what a world of books offers itself, in all subjects, arts, and sciences, to the sweet content and capacity of the reader! In arithmetic, geometry, perspective, optics, astronomy, architecture, *sculptura, pictura,* of which so many and such elaborate treatises are of late written; in mechanics and their mysteries, military matters, navigation, riding of horses, fencing, swimming, gardening, planting, great tomes of husbandry, cookery, falconry, hunting, fishing, fowling, etc., with exquisite pictures of all sports, games, and what not?[13]

Here the excitement of all the books, and especially the joy in listing them, is contagiously conveyed in that bulging list, which Burton brings only reluctantly to a conclusion—a conclusion, moreover, that rather than wrapping up opens out on that wonderfully colloquial and inclusive hand-wave: "and what not."

In exploring the function of both objects and their cataloguing, I want to begin with their association with portrayals of childhood and suggest some of the ways in which painters and writers have drawn inspiration from what might seem a particularly domestic topic. Two paintings in a recent exhibition of impressionist still lifes seize the attention with their beautifully intense yet understated evocations of the role of objects in the imaginative life of children, what Henry James calls "the wonder of consciousness in everything."[14] Both Berthe Morisot in *Sous la véranda*[15] and Paul Gauguin in his *Portrait de Clovis Gauguin,*[16] each of which dates from 1884, emphasize that the powerful role Flaubert attributes to objects seems immediately evident to children, who enter into those sublime inspirations with apparent ease. As Walter Pater puts it in his evocative short piece "The Child in the House," this is

[13] Robert Burton, *The Anatomy of Melancholy* (New York: New York Review of Books, 2001), 2:88.

[14] Henry James, *Autobiography,* ed. Frederick W. Dupee (New York: Criterion Books, 1956), 4.

[15] This work, which is in a private collection, is reproduced in Eliza E. Rathbone and George T. M. Shackelford, *Impressionist Still Life* (New York: Abrams, 2002), 151.

[16] Also in a private collection. Reproduced in ibid., 153.

part of the law that makes the material objects about them loom so large in children's lives.[17]

By depicting her daughter, Julie Manet, deep in silent contemplation of a flower, Morisot's painting plays, both in its title and its representation, on questions of thresholds: the veranda is that liminal space between the house and the outside world, just as the child's meditation situates her both within the confines of the real world and in the vast reaches of the imagination. She, too, hovers on the threshold between childhood and womanhood, looking into the heart of the flower at a point where she is still free from at least most of the cultural and experiential baggage that adults inevitably bring to such contemplation.

Spatially the work reinforces the concept of thresholds. The outside world is seen through the glass windows of the veranda, windows that are suggested by the structural supports rather than by any hint of physical presence, a theme quietly echoed in the glass pitcher, with its spiral fluting hinting at a possibility of movement counteracted by the motionless state of the water. Julie is seen in profile, her eyes hidden from us both by the position of her face and by the fall of a chestnut curl. As onlookers, particularly adult onlookers, we cannot enter her imaginative world, although we are invited to enter our own, to recover that wonder at objects that marks the child, and that Flaubert too urges his correspondent to rediscover.

Gauguin's painting is more decorative and less representational than Morisot's, a choice both justified and enabled by the fact that the child is depicted as sleeping, his hand still clutching a copper pot. The background wallpaper with its intense blues and its indications of flowers and leaves hovers between the realistic and the imaginary, providing the same kind of link between the two that Morisot offers with the suggestion of glass windows in her painting. Looking is replaced here by dreaming, in a way that may exclude the viewer from the specific dream yet nevertheless focuses on the notion of dreaming and on its source in objects.

Numerous evocations of childhood touch on, or explore at greater leisure, the objects children have gathered, either in random accumulations or in more serious and voluntary hoards. Tom Sawyer's booty, carried in his pockets, is a case in point: "a

[17] Walter Pater, *Imaginary Portraits,* ed. Eugene J. Brzenk (New York: Harper & Row, 1964), 17.

lump of chalk, an india rubber ball, three fish-hooks, and one of that kind of marbles known as a 'sure 'nough crystal.'"[18] Equally evocative, and a more searching comment on the value systems of boys in Tom's world and time, is the list of objects Tom acquires by allowing other boys to whitewash the fence for him: an apple, a kite in good repair, a dead rat and a string to swing it with, "twelve marbles, part of a jew's harp, a piece of blue bottle-glass to look through, a spool-cannon, a key that wouldn't unlock anything, a fragment of chalk, a glass stopper of a decanter, a tin soldier, a couple of tadpoles, six fire-crackers, a kitten with only one eye, a brass door-knob, a dog collar—but no dog—the handle of a knife, four pieces of orange-peel, and a dilapidated old window-sash."[19] The pleasure of the list here lies partly in its disparate nature, partly in the value attached to objects that have no obvious purpose and therefore remain rich in possibilities (the key that wouldn't unlock anything but just might be the very key you need to open something you don't yet own; the dog collar that has as yet no dog, allowing you to imagine whatever dog you like to fill it). And the pleasure of these objects is further enhanced by the presence of that piece of blue glass that lets you see them all differently, adds to them, in other words, an additional series.

Norman Lindsay, an equally great painter of boyhood, offers further variations on the theme in the wonderfully titled *Halfway to Anywhere* (1947), through a description of his hero's bedroom, in which his hero Bill is faced with

> a knotty problem in stowage to find space for his home-made cabinet of mineral specimens and birds eggs, his bookcase, his padlocked desk, his stuffed birds, possums, and lizards, and fourteen candle boxes containing a lifetime's collection of rubbish. An impassioned property owner, his doom was that he could never bear to throw anything away. Added to all that were bottles of chemicals stowed on every available projection.[20]

The breathless syntax of this list, together with the (as yet) unrevealed contents of the fourteen candle boxes, conveys the excitement of collecting, but also the extent

[18] Quoted, with an inspired commentary, by Belknap, "Literary List," 37.

[19] Mark Twain, *The Adventures of Tom Sawyer* (1876; reprint, London: Thomas Nelson & Sons, n.d.), 18.

[20] Norman Lindsay, *Halfway to Anywhere* (1947; reprint, Sydney: Angus & Robertson, 1979), 27.

to which the collection itself comes to take over not just the boy's imagination but his very living space. And when the candle boxes are at last opened, they are shown to convey the concentrated essence of his own past: "Among the magpie hoard of his candle boxes were the spring pop guns, clock worked toys, tin trumpets, jew's harp, and other trivia of his nonage."[21] Bill's adolescent self sees this collection merely as a convertible treasure, objects he can exchange for things he now values more. In doing so, he reveals the catalogue reduced to its most basic form: a series of objects whose purpose is solely that of allowing its owner to obtain other and more valued objects that in their turn will also be exchanged. Central to these catalogues is their sense of not being bound by any adult sense of purpose or utility: Rudyard Kipling's depiction of Kim's game is entirely different, for there the objects are gathered merely in order to sharpen and test memory, not for any intrinsic pleasure or memory-arousing capacity of their own. They are not so much a source of memories as a resource of memory.

Pierre Loti's lonely childhood, at least as he depicts it in his autobiographical *Roman d'un enfant* (1890),[22] took on shape and meaning through his accumulation of objects that acted precisely as sources of memory for him. What is immediately striking to a reader of this work is the deeply nostalgic nature not just of the telling of the story, a mood that frequently typifies accounts of childhood, but also of the subject of the story, the experience itself, as though Loti's child were constantly aware of the brevity and fragility of his existence as child and were trying to shore up that existence by accumulating objects that seemed less ephemeral than he. His nostalgia focuses above all on the little museum he has created: "Very nostalgic now, the impression that my museum aroused in me, when I went up there on winter Thursdays,[23] after I had finished my homework or my impositions, and always somewhat late; the light was already diminishing, the glimpse out over the great plains which were being covered with a grayish pink mist was extremely sad."[24] In this passage,

[21] Ibid., 35.

[22] See also Loti's more straightforwardly autobiographical *Prime Jeunesse* (Paris: Calmann-Lévy, 1919).

[23] Thursday, during this period, was a half-holiday in the French school system.

[24] Loti, *Le Roman d'un enfant* (1890; reprint, Paris: Garnier-Flammarion, 1988), 196.

the word "now" acts as a hinge between the present of the narration and the present of the narrative, the adult writer's nostalgia blending with and intensifying the child's sadness as winter draws in and the objects in his little museum come increasingly to represent sites of memory. "Nostalgia for summer and the South, brought on by all those butterflies from my uncle's garden, butterflies lined up here under glass, by all those fossils from the mountains, which had been collected down there."[25] The fragility and mobility of butterflies, the vast spans of time suggested by the fossils, the initial desire to preserve time and memory by collecting these objects—all these aspects are fused into a profound sense of longing, what Loti goes on to describe as "the foretaste of the longings for *elsewhere* that later, after long voyages in warm lands, would spoil my homecomings, my winter homecomings."[26] Objects, in this dense and beautiful passage, become the focus of a network of images and sensations associated with time and place, and above all with a melancholy that stems from the desire to be somewhere else, at a different time, knowing that this present moment, this place, will also inevitably become the time and place to which he longs in vain to return.

Of all the objects that Loti's childhood self has assembled in his personal museum, the little butterfly known as the "citron aurore" is the most heavily freighted with this complex burden of recalling the past.[27] Part of the reason lies in the strange beauty of the name, for names are also like objects in their talismanic power to induce reverie. Like Proust's Marcel, he finds the objects associated with a nexus of memories drawing on various senses, the songs of the mountain people that he heard when he captured them, the sight of the white porch at the home in which he was staying.

The fossils in his museum are also sources of dream for him, and become even more productive in conjunction with a book he receives as a New Year's present (and

[25] Ibid., 197.

[26] Ibid., 196.

[27] The topic of museums created by children especially in the late nineteenth century when science was grappling with questions of evolution is worth an article on its own, particularly in light of the rise of the museum from the initial *Wunderkammer* to today's technological museums, and of the recent questioning of the function of the museum, as evidenced, for instance, in the periodical *Meanjin* 60, 4 (2001), issue titled *On Museums: Art or Mart*. An obvious comparison would be with Edmund Gosse.

who better than Loti can evoke the child's joy at gifts?), an illustrated book "whose subject was the world before the Flood."[28] As W. J. T. Mitchell has claimed, in a *Critical Inquiry* number devoted to "Things":

> Fossil and totem are windows into deep time and dream time respectively, into the childhood of the human race at the earliest stages of its planet. Fossilism is modernized natural history, based in comparative anatomy, systematic notions of species identity, and a mechanistic model of animal physiology. Totemism is *primitive* natural history, [...] a combination of magical lore and empirical folk wisdom.[29]

Loti fuses these two windows in his account of childhood, making the totemic butterfly, which stands for a dream of an idyllic summer in a lost *elsewhere,* combine with the fossils that allow a connection with ages long ago. Gazing at the illustrated book, the child rediscovers these creatures: "those somber animals," as he calls them, "who, in geological ages, shook the primitive forests under their heavy step, had long raised my concern—and here I found them all in their habitats, under their leaden sky, amidst their tall ferns."[30] These become the subjects of his dreams and reveries, the objects that most powerfully launch him into another world, or more precisely into the active creation of that other world, for, as he explains, as soon as the reverie reached the point of becoming "a real vision" it gave off "a nameless sadness, which was like its exhaled soul—and immediately it was over, it faded away."[31] "The contemplation of beautiful objects always makes you feel sad for a certain time," Flaubert wrote in a letter to his friend Louis de Cormenin. "It is as if we are able to support only a certain dose of beauty, and a little bit more wearies us."[32]

In Loti's novel, the child's response is to draw on another of his games, a toy theater for which he creates backdrops, characters, and costumes, attempting to give

[28] *Le Roman d'un enfant,* 199.

[29] W. J. T. Mitchell, "Romanticism and the Life of Things: Fossils, Totems, and Images," *Critical Inquiry* 28 (Autumn 2001): 178.

[30] *Le Roman d'un enfant,* 199.

[31] Ibid., 200.

[32] Flaubert, *Correspondance,* 1:209.

permanence to these fleeting dreams. In fact, as Loti implies but never specifies, this is what prepares the ground not only for the endless travels of his adult life but, more vitally still, for the attempt to transform things into language, to convey his dreams in some form that would convert them from evanescent into enduring, to catalogue them in some meaningful and permanent manner. Unlike Lewis Carroll's Bruno and Sylvie, he does not dream of a map whose proportions would be exactly those of the land it stood for; unlike Gulliver, who, as we have already seen, made the satirical suggestion that, "since Words are only Names for *Things,* it would be more convenient for all Men to carry about them, such *Things* as were necessary to express the particular Business they are to discourse on . . . which hath only this Inconvenience attending it; that if a Man's Business be very great, and of various Kinds, he must be obliged in Proportion to carry a greater Bundle of *Things* upon his Back,"[33] Loti's child has learned the totemic value of objects, discovering how to perceive them as metaphors. The sadness comes from the realization that objects, bearers of fossils and totems though they may be, can never bring back the past, which seems dead and beyond recall.

Here one seems to overhear Proust's powerful question and response: "Dead forever? Possibly."[34] This is the point at which he launches into his famous explanation of how, under certain circumstances, the past can return: "It's a waste of time for us to attempt to summon it forth; all the efforts of our intelligence are useless. It is hidden beyond the domain and reach of intelligence, in some material object (in the sensation that this material object may give us) which we don't suspect. It all depends on chance whether or not we'll meet that object before we die."[35] The adult Marcel will find an array of objects that restore the past to him, but only, it seems, because as a child he was already so intensely susceptible to the evocative power of objects, and already attempting, like the child Loti, to "delve deeper and attempt to understand"[36] the sensations they provoked in him.

[33] Quoted in Peter Schwenger, "Words and the Murder of Things," *Critical Inquiry* 28 (Autumn 2001): 99.

[34] Proust, *RTP,* 1:44.

[35] Ibid.

[36] *Le Roman d'un enfant,* 196.

Pater suggests an identical approach in his own account of a lonely child wandering through a large house and finding "on the top of the house, above the large attic, where the white mice ran in the twilight—an infinite, unexplored wonderland of childish treasures, glass beads, empty scent-bottles still sweet, thrum of coloured silks, among its lumber."[37] And of course, like Loti, he is aware of how arbitrary are the objects, and their associated colors, that will later trigger memory, as he reveals in a typically concise passage: "Coming in one afternoon in September, along the red gravel walk, to look for a basket of yellow crab apples left in the cool, old parlour, he remembered it the more, and how the colours struck upon him because a wasp on one bitten apple stung him, and he felt the passion of sudden, severe pain."[38]

What is at issue here is the role of an object perceived in childhood and remembered in adulthood, something around which there accumulate crystals of memories that may well be greatly distorted or even largely invented, but that nevertheless function as indications of a moment when the child's observation was so intense as to allow the sponge of memory to absorb an image that can then be interpreted in adulthood. Henry James would argue that "from the moment it is a question of projecting a picture, no particle that counts for memory or is appreciable to the spirit *can* be too tiny, and that experience, in the name of which one speaks, is all compact of them and shining with them."[39]

Gauguin, through his depiction of a child dreaming of an object—or, better, around an object—like Morisot showing her daughter's rapt contemplation of the flower, makes visible what many others who have attempted to re-create childhood in autobiography or fiction also indicate: the child's wonder at the world, and the child's ability to transform even what to adults may seem banal into a source of intense experience or the basis of never-ending storytelling, a storytelling that may be as apparently reductive as the simple recital of a list. More important still, perhaps, the object becomes a way of understanding the metaphorical function of language: a water lily a way of comprehending neurosis; a butterfly a means of encapsulating the richness of summer holidays; a toy horse lost in the move to adulthood a vehicle for

[37] Pater, *Imaginary Portraits,* 18.
[38] Ibid., 28.
[39] James, *Autobiography,* 15–16. The "sponge of memory" is James's striking expression (ibid., 37).

comprehending how part of us dies when we lose touch with aspects of childhood. In other words, for children objects need not be named to speak, and need no language to do so. As W. H. Auden puts it in his 1956 sonnet "Objects," "All that which lies outside our sort of why, [. . .] / Makes time more golden than we meant to tell."[40]

Yet, while lists may be capable of delighting and touching both children and adults, they need not necessarily have anything childlike about them. Take, for instance, that indisputably adult painting *The French Ambassadors of King Henry II,* by Hans Holbein the Younger (1533; fig. 5). Commenting on it, Christopher Braider makes this suggestion:

> Gathered, moreover, in confused profusion on the table and bench between the two ambassadors are a host of still-life objects, an astrolabe, a celestial globe, a solar clock, a terrestrial globe, a treatise on arithmetic, a T square and compasses, a hymnal, a lute: insignia of the arts and sciences, secular as well as divine, asserting everything the human mind has and will have achieved and representing the material world over which humanity claims dominion. The arresting reality of the ambassadors' visual appearance is thus substantiated, both concretized and authenticated by the assembled tokens of their practical accomplishments.[41]

The accumulated power and wealth suggested by these objects is of course thrown sharply into question by the presence at the ambassadors' feet of an object that will render all the others pointless: the anamorphic skull signifying death, which holds dominion over "everything the human mind has and will have achieved." Many texts include such lists, although not necessarily with that grim message hanging over them.

Some merely suggest an observer's and a linguist's delight in the world's bounty, as is the case in Isabel Colegate's beautifully realized *Winter Journey* (1995), in which we find the following description: "Green beans overflowed their baskets, small potatoes spilled out of sacks, there were glossy plum-coloured aubergines, bunches of feathery green coriander, wicker trays piled high with broad beans, pyramids of

[40] W. H. Auden, *Collected Poems,* ed. Edward Mendelson (New York: Vintage, 1991), 624.
[41] Braider, *Refiguring the Real,* 115.

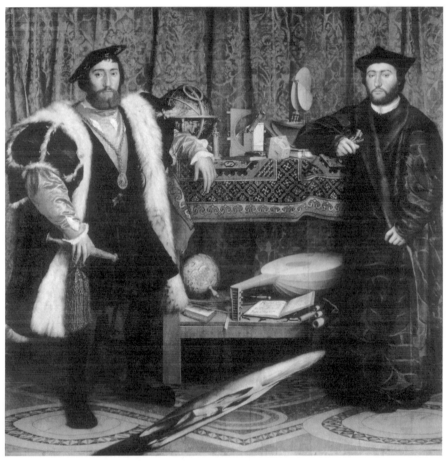

FIGURE 5. Hans Holbein the Younger, *The French Ambassadors of King Henry II at the Court of the English King Henry VIII,* 1533. Oil on canvas. National Gallery, London. Photo: Erich Lessing / Art Resource, NY

small round cabbages."[42] Here the list, focused through the eyes of a photographer, is little more than an enumeration, but each element in it is concisely identified and linked to some other broader context: bounty, in the depiction of the green beans overflowing their baskets, and becoming liquid in doing so; intensity of shade when the eggplants recall the color of plums; architecture when the cabbages are piled up like pyramids. Other such lists can act more as commentaries on the collectors themselves, as A. S. Byatt shows in evoking an elderly spinster's "bitty collection of objects" in terms that are part teasing and part tender:

> Cut glass candlesticks, tin teacaddy with Gloire de Dijon roses, Japanese silk pincushion, conical Benares brass vase with two peacock feathers, three biscuit barrels (rotund glass, floral china and wicker, wooden keg with brass knobs), Florentine leather sewing bag, scissors with enamelled handles representing a crane stalking, a miniature Spode cup, six sugar-pink grey-tinged Woolworth's teacups, a pile of apostle spoons, half a loaf of bread, half a pot of lemon curd, a pile of bills weighed down with a plaster of Paris hand, an ebony and silver crucifix, a crocheted beret, a bundle of lisle stockings, a bottle of ink, a jam-jar of red pencils, pussywillow and a Palm Sunday cross from the Holy Land. . . .[43]

But these lists are doing other things as well, for just as many painted still lifes openly refer back to earlier still lifes, so those of Colegate and Byatt recall the techniques of a variety of realist and naturalist novelists. One thinks above all of Emile Zola energetically deploying them in his 1873 novel of the Paris central market, *Le Ventre de Paris,* with his lists of vegetables and cheese, fish and meat. There is a rarely-matched exuberance in Zola's writing, a generosity in the description, a bravado in the creation of the metaphors, that make such lists one of the joys of reading Zola. This is the case in the well-known catalogue of butters and cheeses:

> Around them rose the stench of the cheeses. On the stall's two display shelves, at the back, were rows of enormous blocks of butter; Brittany butters flowed over

[42] Isabel Colegate, *Winter Journey* (London: Hamish Hamilton, 1995), 25.
[43] A. S. Byatt, *The Virgin in the Garden* (New York: Vintage, 1992), 109.

their baskets; Normandy butter, wrapped in cloth, recalled rough drafts of stomachs over which the sculptor had thrown damp linen; other blocks, broken into, cut by broad knives into abrupt cliff faces, full of valleys and chasms, were like summits destroyed by a landslide, gilded by the pallor of an autumn evening. Under the display table with its red marble veined in grey, baskets of eggs added a chalky whiteness, and in the packing cases, on straw racks, bung cheeses were placed end to end, Gournay cheeses as flat as medals were lined up, adding darker patches flecked with greenish tones. But it was above all on the tables that the cheeses were piled up. There, beside pound blocks of butter, in pear leaves, spread a giant Cantal, as if slashed with ax-blows; then came a Chester, the color of gold; a Gruyere, like a wheel fallen from some barbarian chariot; Dutch cheeses as round as severed heads, streaked with dried blood, with that hardness of empty skulls that earns them the name of Death's Heads.[44]

Zola, in a characteristic crescendo, works up here from the mild butters and the less pungent cheeses, gradually intensifying his metaphors from scenery to battlegrounds until eventually he will reach a cheese so intensely pungent that flies drop dead around it.

Bounty can also be expressed in terms of the artificial, and in that case it can bring with it a sense of overwhelming and pointless multiplicity, the kind of awareness that Arman conveys in his still life accumulations of abandoned objects. Honoré de Balzac's *La Peau de Chagrin* (1830), a work that explicitly and forcefully ties together the standard *memento mori* themes of materialism and wasted life, reveals this with particular power when the central character blunders into a bric-a-brac store:

Stuffed crocodiles, monkeys, and boas smiled at church windows, seemed eager to bite busts, pursue lacquers, climb on candelabras. A Sèvres vase, on which Mme Jacotot had depicted Napoleon, stood next to a sphinx dedicated to Sesotris. The beginning of the world and events of yesterday intermarried with grotesque good humor. A roasting spit had been placed on a monstrance, a republican saber on a medieval blunderbuss. [. . .] Instruments of death, daggers, curious pistols, arms

[44] Emile Zola, *Le Ventre de Paris,* in *Les Rougon-Macquart,* ed. A. Lanoux and H. Mitterand (Paris: Gallimard, 1963), 1:821.

with secret compartments, were thrown higgledy-piggledy over instruments of life: porcelain soup tureens, Saxony plates, diaphanous cups that had come from China, antique saltcellars, feudal sweet boxes. An ivory ship under full sail made her way across the back of a motionless turtle. A pneumatic machine poked the emperor Augustus in the eye, while he remained majestically impassive.[45]

Precisely because such lists so often invoke the world's bounty or humanity's excess, the technique can also be used to suggest how little an individual may have succeeded in extracting from life. In the following list of material objects gathered together for refuse, Margaret Drabble conveys an impression of someone who has failed to extract life's true spiritual or intellectual or moral riches: "small one-person-size low-fat yoghurt cartons, the peelings from two potatoes and a carrot, some onion skin, coffee grounds, tea bags, baked-bean tins, cheese rind, bacon rind, margarine pots, dead flowers, banana peel. Husks and crumbs and scraps."[46] Where Colegate, like Zola, drew on metaphor to transform and enhance vegetable bounty, Drabble remains resolutely realistic here, offering an unadulterated list whose cumulative effect is, ironically, to reduce and trivialize. The absence of any linking terms in the first sentence, in which the objects are simply gathered together, intensifies the repeated "and" of the second sentence, which sums them all up in three categories that are in fact a single category: garbage.

Other lists can suggest the disorder of life, the way it sets before us objects that might have a meaning for us, could we only read them, but whose signification remains jeeringly opaque. This is the case in Hermann Broch's novel *The Sleepwalkers* (1932), where the protagonist of the novel's first section, Joachim, rejected by his mistress, "had sunk on to a chair beside the wash-basin; his mind could grasp nothing, he knew only that this was one of the trials sent by God, and he stared at the half-open brown drawer of the toilet-table, in which the attendant's few possessions—handkerchiefs, a corkscrew, a clothes-brush—were bestowed higgledy-piggledy."[47] The higgledy-piggledy grouping of these disparate objects reflects back on the

[45] Balzac, *La Peau de chagrin* (1831; reprint, Paris: Garnier-Flammarion, 1971), 71–72.

[46] *Seven Sisters,* 110.

[47] Hermann Broch, *The Sleepwalkers,* trans. Willa and Edwin Muir (New York: Vintage, 1996), 125.

viewer's life, his own incoherent emotions and desires in a life that lacks both direction and ambition. Such messiness is also symptomatic of a world to which Darwin's *Origin of Species* (1859) had brought such a profound sense of contingency, and such questioning of a universe previously held to be coherent and meaningful, even if that meaning proved inaccessible to mortal intelligence. Broch's novel, as it reveals the disintegration of society, draws on such subtle resources as the still life to suggest ideas that the protagonists themselves are not capable of expressing.

Collections of objects also suggest a psychological reality, the tendency in moments of stress to turn to the apparent solidity of objects to set against the formlessness of existence. In *The Sea, the Sea* (1978), Iris Murdoch's retired theater director, unable to make people act as he wants them to in real life, turns to the stones he finds around his seaside house and attempts to impose on them an order that proves as labile and as meaningless as his other efforts. They acquire significance only when he at last begins to make sense of his life and realizes that the stones are not symbols of order but rather mnemonics: "Weighing down my letters and papers [. . .] are two stones, the mottled pink chequered stone which I gave to Hartley, and the brown stone with the blue lines which I gave to James. I was glad to find that lying here when I arrived. I often handle these stones."[48] Stones as part of a rebus recur in Murdoch's writing, most notably in her late novel *The Green Knight* (1993), where the adolescent Moy, gradually growing more and more disturbed by the awareness that, in her collecting enthusiasm, she has taken stones from their natural surroundings, tries to return one to the exact spot from which she removed it. The dog Anax reveals to her that she has misplaced it, while at the same time indicating to us the necessity of reading the scene as a hieroglyph. "Anax, running ahead of them, had climbed up onto the flat-topped rock where Moy had left the conical lichen stone. He was sitting in profile, his front paws extended, beside the stone, looking at it. 'Look, Moy, he's just like something out of ancient Egypt!'"[49] Anax's hieratical stance pulls the landscape into shape all the more forcefully in that he and Moy have just escaped from the chaos of the sea, the "long grey form" of Anax indeed crawl-

[48] Iris Murdoch, *The Sea, the Sea* (1978; reprint, Harmondsworth: Penguin, 2001), 476.

[49] Iris Murdoch, *The Green Knight* (Harmondsworth: Penguin, 1994), 469–70.

ing "out of the chaotic foam and the wildly running shallows"[50] before taking shape not just as a dog but as Anubis, the jackal-headed Egyptian god. At Anax's direction, Moy is able to read the landscape correctly and replace the stone at the foot of a rock, on which she caresses "the mysterious messages of its crisscross cracks" in a gesture that frees her to move into adulthood.[51]

While stones might suggest permanence, glass epitomizes transience. The role of glass in still lifes is something to which I want to return,[52] but within the written list it can often have the same function as in painted still lifes, where its presence can indicate, according to Liana Cheney, "human hopes as fragile as glass."[53] Perhaps the most extravagant use made of the topos occurs in Peter Carey's novel of fragile human hopes, *Oscar and Lucinda,* with its central themes of scientific discovery, gambling, and glass making. Much of Oscar's childhood, which Carey bases on that of Edmund Gosse, is focused on his father's attempts to refute Darwinism through his own scientific observations of sea creatures neatly housed in glass-topped display cases.

The boy's own attempt to impose a different and varying order on the world is represented by his collection of buttons, defiantly kept in a wooden tray intended to house beetles or shells: "There were small round ones like ladybirds with single brass loops instead of legs. Others were made of glass. There were metal buttons with four holes and mother-of-pearl with two. He drilled these buttons as other boys might drill soldiers. He lined them up. He ordered them. He numbered them." His father's reading of the collection is strictly scientific: "You have reclassified your buttons, I see [. . .]. The taxonomic principle being colour. The spectrum from left to right, with size the second principle of order."[54] But Oscar's desires being far from transparent, it is little wonder that he finds escape in the chaotic and unpredictable world of gambling.

[50] Ibid., 469.

[51] Ibid., 470.

[52] See chapter 2.

[53] Liana DeGirolami Cheney, ed., *The Symbolism of "Vanitas" in the Arts, Literature, and Music* (Lewiston, N.Y.: Edwin Mellen Press, 1992), 121.

[54] Peter Carey, *Oscar and Lucinda* (1988; reprint, New York: Vintage, 1997), 9.

Lucinda's acquisition of the glass factory suggests a different form of ordering again, as she gazes at the sample bottles that represent her entry into a male-dominated world: "My bottles, she thought. Blue, amber, clear; bottles for acid, pickles, poison, beer, wine, pills, jam, bottles with vine leaves, laughing jackasses, flowers, gum nuts, serpents and PROPERTY OF imprinted on their underside."[55] The exuberance of the list here, its swift transitions from the bottles themselves to what they contain to their acknowledgment of her ownership corresponds to her own exuberant delight in them while at the same time foreshadowing the rushing waters of the river in which Oscar, trapped in the glass church, will drown. In Carey's novel, then, collections point to glass as the medium that allows the observation of creatures of a different sphere from our own, glass as the barrier between women's sphere and men's sphere, glass finally as the symbol of the church's transformation into prison, as it slowly sinks in the river with Oscar trapped inside it.

Seashells seem to promise a similar possibility of communication between marine and terrestrial worlds, but just as the conviction that we hear the sea in them founders against the realization that we really hear only our own blood, so their presence in painted and written still lifes is far more complex than it might initially seem. A. S. Byatt suggests this elliptically when she includes on an academic's wall, as a kind of *mise en abyme,* Rembrandt's only etched still life, "a conical shell, *Cons marmorens,* its spiral closest to the onlooker's eye, its surface patterned like a dark net thrown over bone."[56] Learning to read the patterns and nets that individuals use to shroud their own mortality is central to the plot of this novel, a plot as convoluted as the *Cons marmorens* itself.

Elements of the *vanitas* motif in that their beautiful forms are empty of the life they briefly housed, shells become, in Paul Valéry's exemplary essay, pretexts for meditations on humanity and nature. "If there were a poetry of the marvels and emotions of the intellect (something I have dreamed of all my life)," claims Valéry:

> it could find no subject more delightful and stimulating than the portrayal of a mind responding to the appeal of one of those remarkable natural formations

[55] Ibid., 126.
[56] A. S. Byatt, *A Whistling Woman* (New York: Knopf, 2002), 30.

which we observe (or rather make us observe them) here and there, among the in-numerable things of indifferent and accidental form that surround us. Like a pure sound or a melodic system of pure sounds in the midst of noises, so a *crystal,* a *flower,* a *sea shell* stand out from the common disorder of perceptible things. For us they are privileged objects, more intelligible to the view, although more mysterious upon reflection, than all those which we see indiscriminately.[57]

Valéry stresses here the contrast between the apparent order offered by crystals, flowers, and seashells, and the disorder of what we normally perceive, and he suggests that it is this sense of inherent order that draws our attention to them, makes us observe them, as he declares.

Many written catalogues of still life objects also suggest this sense that we do not so much look at them of our own volition as respond to some imperative (narrative or existential) to observe them. But that observation would be frivolous and pointless if it did not include both senses of the word: that we look at these objects and that we make observations about them, that we collect our thoughts in response to the collection we are invited to explore in order also to explore our collected thoughts.

Part of that imperative to observe, as Valéry's essay makes clear, includes a need to describe, to translate visual and tactile sensations into language:

> If I examine a whole collection of shells, I find a marvelous variety. The cone length-ens or flattens, narrows or broadens; the spirals become more pronounced or merge with one another; the surface is incrusted with knobs or spines, sometimes strik-ingly long, radiating from a center; or it may swell, puffing out into bulbs separated by strangulations or concave gorges where the curved lines meet.[58]

This is in part a finger exercise, an attempt to find words precise enough to convey shape and varied enough to convince a reader of the variety within the shells them-selves. But it is also an intensification of the act of looking: How can you describe to

[57] Paul Valéry, *Sea Shells,* trans. Ralph Manheim (Boston: Beacon Press, 1998), 21. Valéry's italics.
[58] Ibid., 25.

someone else that difference between various shells if you haven't look closely, followed the ridges and furrows, the flanges and curves, with eyes and fingers that have come sharply alive?

There is also in this extended description the delight of the poet finding form in nature and aligning that form with the poetic desire to create a form that forces the idea into expressing itself with greater intensity. Parallels are created, partly for the fun of doing so but partly also to provide a structure for ideas: "as we say a 'sonnet,' an 'ode,' a 'sonata,' or a 'fugue,' to designate well-defined forms, so we say a 'conch,' a 'haliotis,' a 'porcelain'—all of the names of shells; and each one of these words suggests an action that aims to make something beautiful and succeeds."[59] But while this assertion of a creative force may correspond to notions of beauty, it collides with notions of utility—as Valéry insists in a passage that reinforces the parallels between shell forms and poetic forms by rejecting the concept of usefulness: "Still less do we understand the oddly shaped complexities that some shells disclose; or those spines and spots of color, to which we vaguely ascribe some utility that escapes us, without even stopping to think that, *outside of man's little intellectual sphere, our idea of the useful has no meaning.*"[60]

An essay on a collection of seashells reveals itself to be an essay on artistic form; indeed, it has clearly always been that, because the initial source of inspiration was Henri Mondor's exquisite series of drawings of seashells. It is this that allows Valéry, through a series of twists and convolutions as lovely as those of the seashells he describes, to conclude that "perhaps what we call *perfection* in art (which *all* do not strive for and some disdain) is only a sense of desiring or finding in a human work the sureness of execution, the inner necessity, the indissoluble bond between form and material that are revealed to us by the humblest of shells."[61]

Benjamin argues that "in every collector hides an allegorist, and in every allegorist a collector."[62] Valéry highlights in the closing passage of his essay the way in which a collection of objects, like a nun's rosary beads, can be an accumulation of al-

[59] Ibid., 43.
[60] Ibid., 74. Valéry's italics.
[61] Ibid., 91–92. Valéry's italics.
[62] Benjamin, *Arcades Project,* 211.

legories allowing the viewer to remember or imagine or meditate on something quite different:

> I shall throw away this thing that I have found as one throws away a cigarette stub. This sea shell has *served* me, suggesting by turns what I am, what I know, and what I do not know Just as Hamlet, picking up a skull in the rich earth and bringing it closer to his living face, finds a gruesome image of himself, and enters upon a meditation without issue, bounded on all sides by a circle of consternation, so beneath the human eye, this little, hollow, spiral-shaped calcareous body summons up a number of thoughts, all inconclusive. . . .[63]

It is in the nature of collections to be incomplete and the thoughts they arouse to be vast but inconclusive. As Norman Lindsay's adolescent protagonist knows, the makers of cigarette cards include in every series at least one card of which very few copies are printed, making it all but impossible to complete the series. If it were otherwise, where would be the challenge and the pleasure of collecting them? Pockets may bulge and rooms fill up with property, but there is never the sense of satiety—a catalogue is always merely a segment of its possible self, cut off by the picture frame or by ellipses.

The solution to this pleasurable dilemma comes through reflection in both senses of the word: intellectual reflection on the objects, mirror reflections of the objects. This is what Rilke suggests in yet another passage from his letters on art, where he discusses a shell in a still life painting before moving out from the shell to cast his particularly lucid gaze on the work as a whole, revealing the way in which objects, through their shapes and colors and through their solid material presence, transform the space around them, demanding a sustained reflection from those who gaze upon them:

> Its inward carmine bulging out into brightness provokes the wall behind it to a kind of thunderstorm blue, which is then repeated, more deeply and spaciously, by the adjoining gold-framed mantel-piece mirror; here, in the mirror image, it again

[63] *Sea Shells,* 101. Valéry's italics.

meets with a contradiction: the milky rose of a glass vase, which, standing on the black chimney-clock, asserts its contrast twice (first in reality, then, a little more yieldingly, in reflection). Space and mirror-space are definitively indicated and distinguished—musically, as it were—by this double stroke; the picture contains them the way a basket contains fruits and leaves.[64]

Finding a form to contain not just the still life but a society in flux has been central to the endeavors of many writers whose works contain embedded still lifes reflecting a longing to hold the moment safe under glass. It is to such writers that my next chapter turns.

[64] Rilke, *Letters on Cézanne,* 88–89.

2

CAUGHT UNDER GLASS

REALISM AND THE STILL LIFE

"Reality is what is beautiful in words and ideas. The reality in a photo, a book, or a piece of music. It's to beauty that we are always drawn, it's what we desire. Any fragment, any old stone, any corner of a sidewalk or a wall, however much of a nonentity, however neutral or abandoned it might be, how lovely, how eloquent, how full of strength and sweetness and thought!"[1] Thus the French writer J. M. G. Le Clézio, paying tribute in 1978 both to the beauty of reality and to its transposition into art, seemingly unaware of, or at least unimpressed by, what Christopher Prendergast has termed the apparent "eclipse of the mimetic."[2] Le Clézio at least seems convinced

[1] J. M. G. Le Clézio, *L'Inconnu sur la terre* (Paris: Gallimard, 1978), 31.

[2] Christopher Prendergast, *The Order of Mimesis* (Cambridge: Cambridge University Press, 1986), 3. This is a brilliant exploration of the mimetic seen through a postmodernist perspective, arguing forcefully that mimesis "embodies more complex tensions and requirements" than Barthes allows for in his denigration of it.

that language can lead us step by step "on the real footpaths of the earth."[3] In this chapter I want to look at the ways in which that conviction of the beauty of reality, however complex and variable the understanding of "reality" might be, however slippery its transmutation into text or onto canvas, inspires a series of written still lifes from the writings of Balzac to those of contemporary novelists.

Georges Bataille, in his lengthy attack on Sartre, suggests that language is not transparent but opaque, that authentic communication takes place only when everyday communication (what Bataille terms "communication in the weak sense of the term"[4]) proves vain. Objects, he argues, cannot communicate with us, as Sartre himself, indeed, reveals in *La Nausée*. Literature thus has meaning only insofar as it confronts that impossible situation of closing the gap between experience and consciousness.[5] Many modernist writers, and many still life artists, seem to respond to the challenge to close the gap by simultaneously offering us objects and placing between our gaze and those objects a pane of glass that, with its flaws, its reflections, and its distortions, suggests the role of language.

In 1866, Monet produced a beautiful and unusual still life, known simply (and this is one of the immense attractions of still life: the inevitability and apparent banality of the titles) as *Bocal de pêches* (Jar of Peaches) (Staatliche Kunstsammlungen; fig. 6). On a black marble table veined in white, five ripe peaches lie next to a glass jar of preserved peaches. The jar and the loose peaches are reflected in the marble surface, compounding the play of reflection and light and increasing our awareness of volume and texture. Capturing glass, one of the many standard symbols of the fragility of life in *vanitas* and *memento mori* paintings, is one of the great challenges and delights of the painted still life, given new emphasis through the developments in glass manufacture that came about as a result of the industrial revolution. The enthusiasm inspired by the Crystal Palace when it was built to allow London to host the Great Exhibition of 1851 can be found in many works of the time, at a period when shop windows, railway stations, and department stores were

[3] *L'Inconnu sur la terre,* 10.

[4] Georges Bataille, *La Littérature et le mal* (Paris: Folio, 1957), 149ff. Bataille engages here in a somewhat vitriolic polemic with Sartre.

[5] See Prendergast, *The Order of Mimesis,* 18, for an extended discussion of these points.

incorporating the new discoveries. Robert Browning's poem "Shops" responds to these discoveries:

> So, friend, your shop was all your house!
> Its front, astonishing the street,
> Invited view from man and mouse
> To what diversity of treat
> Behind its glass—the single sheet.[6]

Indeed, recent inventions in the production of glass, leading both to humble and monumental creations, had fired the imaginations of artists and writers, suggesting new metaphors for vision as well as a different relationship between city dwellers and their world, as small windows with thick glass were gradually replaced by larger windows using much clearer glass. The invention of the aquarium in the 1850s brought the ocean indoors, adding to that transformation of vision that marks the century. As *The Times* proclaimed in response to the 1851 Exhibition: "We want to place everything we can lay our hands on under glass cases, and to stare our fill."[7] What is more, as Baudrillard argues, glass, that "degree zero of matter,"[8]

> offers possibilities of accelerated communication between interior and exterior, but at the same time creates an invisible and material division that prevents that communication from becoming a real opening onto the world. Indeed, modern "glasshouses" are not open to the outside world: on the contrary, it is the outside world, nature, the countryside, that, thanks to the glass or to the abstract notion of glass, appear in the intimate world, in the private domain, and "play freely" there as elements of the surrounding atmosphere.[9]

Yet Monet's still life also seems to be punning about the nature of still life painting itself, for still life seems to offer the world's bounty, eternally preserved for our de-

[6] Robert Browning, *Selections from the Poetical Works* (London: Smith, Elder, 1886), 289–90.

[7] *The Times* (London), October 13, 1851. Quoted in Andrew H. Miller, *Novels behind Glass: Commodity Culture and Victorian Narrative* (Cambridge: Cambridge University Press, 1995), 52.

[8] Baudrillard, *Le Système des objets,* 56.

[9] Ibid., 57.

light, but through that very act of preservation makes it impossible for us to enjoy it other than visually. Whereas a jar of peaches preserves the fruit, making it possible to eat these glowing simulacra of the sun even in the depths of winter, the painting of a jar of peaches eternally sets between the viewer and the peaches that invisible glass barrier that alone ensures that they will always be there.

While many artists began incorporating such structures in their paintings, few still lifes manage to suggest as powerfully as Monet's does an architectural creation held in place by nothing more than light. We know the glass must be there—the title as well as our knowledge of how fruit behave at least helps us realize that—but we cannot see it. Embedded in Monet's apparently simple little study of fruit, with its focus on just those apparently banal details that Hegel designates as the prose of the world, are several layers of suggestion, but most obviously, perhaps, the combined idea of protection and restriction. The glass can be read here as a metaphor for all those practices and beliefs, conventions and rules that control our actions, restricting and restraining us but also enabling us to negotiate society and understand our place in it. If in some moods we see those rules as limiting and binding, in others we cannot fail to recognize that these restrictions are what allow us to develop our capacities without destroying ourselves.

Typical of this function is a standard element of nineteenth-century domestic decoration: the dried flowers preserved under a glass bell. We find them, for example, in Balzac's novel *César Birotteau,* where he describes a living room with "a yellow piece of furniture with rosettes, a carpet, a bronze chimney piece without gilding, a painted chimney front, a table with a vase of flowers under glass, a round table with a rug on which was a liqueur tray."[10] The flowers here are preserved both under glass and within the sentence structure itself, padded round with references to other more permanent objects. Safe within their glass, the flowers appear to live on in borrowed time, offering a bouquet that never dies but that also is far removed from the flowers of nature: one thinks of Huysmans's Des Esseintes in *A Rebours* (1884), preferring those natural flowers that look artificial, or Proust's Odette, loving the cattleya orchids because they look as if they have been cut out of velvet. In this

[10] Honoré de Balzac, *César Birotteau* (1837; reprint, Paris: Garnier, 1967), 129.

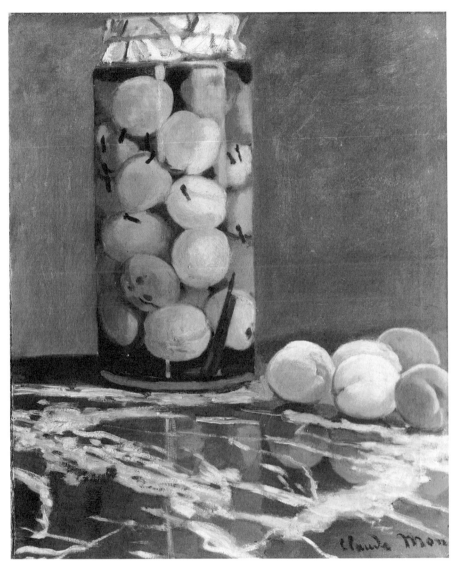

FIGURE 6. Claude Monet, *Jar of Peaches,* 1866. Galerie Neue Meister, Staatliche Kunstsamm-
lungen, Dresden.

description, Balzac is seizing a moment in time and a tendency of bourgeois society by focusing on the flowers under glass, but he is also commenting obliquely on what he himself is doing in *La Comédie humaine:* preserving under the glass of the novel elements of society, or architecture, or customs that may soon disappear completely. This is still life calling attention to itself as artifact, and thus to the role of the artist who produced it.

Balzac provides another example in his novel *Splendeurs et misères des courtisanes* when he describes a "gold medallion in which could be seen under glass a little temple made of hair, one of those adorable sentimental trivialities that reassure humanity, just as a scarecrow terrifies sparrows. Most people, like the animals, are terrified and reassured by trivialities."[11] Here the hair, that fragment of ourselves that lives on after us, or safeguards the memory of our childhood selves, is preserved under glass, a metonymical fragment recalling the whole, a metaphorical figment in which the transience of human life is transformed into the architectural and religious promise of eternity.

These are early examples, suggesting a desire for permanence that is universal rather than arising from the sense of contingency we might associate more closely with modernism, but, as Naomi Schor points out in *Reading in Detail,* Erich Auerbach's fascination with Balzac's mimesis, like Georg Lukács's sense of it as exemplary, although swept aside by more recent theoretical approaches, nevertheless points to "the revolutionary thrust, that is, the modernity of the Balzacian detail."[12] Balzac was certainly aware of the forward thrust of progress; his careful dating of his stories, together with his emphasis on the need to capture Paris as it is now, reveals the extent to which part of his project was that of seizing a world he knew to be on the point of changing irrevocably. "Civilization's chariot," he asserts in *Le Père Goriot* (1835), "like that of the Juggernaut, barely slowed by one heart that's less easy to crush than the others and that has stuck in its wheel, soon shatters it and continues its glorious march."[13] It is worth recalling that, in his challenge to his contem-

[11] Honoré de Balzac, *Splendeurs et misères des courtisanes,* ed. Antoine Adam (1838; reprint, Paris: Garnier, 1958), 134.

[12] Schor, *Reading in Detail,* 141.

[13] Balzac, *Le Père Goriot* (Paris: Garnier-Flammarion, 1966), 26.

poraries to respond to the winds of modernity, Charles Baudelaire held Balzac up as a supreme example.[14]

Balzac is also fascinated by the ways in which objects reflect on social class and by how class differences alter over time. The showy displays of the Restoration, abandoned for a far more austere and moralistic mentality among those of the following generation, captures his attention in both *Le Père Goriot* where the action takes place during the Restoration, and in *La Cousine Bette* (1846) and *Le Cousin Pons* (1848), where the two generations confront each other across a seemingly unbridgeable divide. A scene from *Le Père Goriot* highlights the double "luxury of the table," which, Balzac stresses, occurs both at the level of the containers and at the level of what is contained, and uses it to reflect on the psychological state of a social climber: "Seeing this sculpted silverware and the thousand little details of a sumptuous repast, admiring for the first time a table service carried out without any noise, it was difficult for a man with a burning imagination not to prefer this constantly elegant life to the life of privations he had wanted to embrace only that morning."[15] Objects in Balzac's novels thus reflect his desire to reveal timeless psychological truth through physical detail, but they also underpin his determination to portray contemporary French life in full flux.

That same creative tension between freedom and containment, between the object as timeless presence and the object as emblematic of change, energizes several still lifes written in prose, focusing on objects trapped or protected under glass. Think, for instance, of the moment in *Madame Bovary* (1857) when Emma, recently married but already dissatisfied with married life, goes to the ball at the Vaubyessard chateau and during dinner sees that some women have not put their gloves in their glasses. Putting your gloves in your wine glass indicated to the waiter that you would not be drinking wine, a procedure taken almost as axiomatic for women in Emma's class, a means of protecting themselves against the dangerous effects of wine but also of binding themselves within the sexually dimorphic conventions of contemporary society. But here are women who dare to drink with the boys, who use their glasses

[14] Baudelaire, *OEuvres complètes,* ed. Claude Pichois (Paris: Gallimard, 1975), 2:496.
[15] *Le Père Goriot,* 121–22.

to make transparent a desire, while the others use theirs to conform to a norm. It is a tiny moment, a brief focus on a couple of standard still life objects—a pair of gloves and a wine glass—that are an intricate part of the *effet de réel* in this scene but that also use mimesis to comment on that reality.

Just before that discovery, Flaubert provides a lush still life of the dinner:

> As she walked in, Emma felt herself enveloped in a warm air, a mixture of the scent of flowers and fine linen, the aroma of meat and the odor of truffles. The candles in the candelabra stretched their flames on silver bells, the facets of the crystal ware, covered with a dull steam, sent back pale rays; bouquets lined up along the entire length of the table, and in the plates with their wide borders, the napkins, folded like a bishop's miter, each held in the gap of their folds an oval roll. The red claws of lobsters spilled over the dishes; plump fruit in open-ware baskets were piled up on moss; the quails still had their feathers, steam rose up. On the big porcelain stove with its copper pipes, a statue of a woman draped to the chin stared motionlessly at the room full of people.[16]

Here we have a plethora of those objects we associate with still life: the candlelight reflected in silver and glassware, the bouquets of flowers, the lobsters and quails, the steam rising, and, in the background, a statue of a woman, here clothed, whereas the still life usually prefers her naked. And while Emma is not wrapped in glass here, she is bound about like the statue bound to the chin, both by social conventions and by her own misconceptions of what life and love might have to offer, conventions and misconceptions countered here in Flaubert's text by the warm air that envelops her as she enters a room that offers pleasures and values that are different from those to which she is accustomed. One of the things Flaubert is exploring in this novel is the effect of the collision between a world vision based on experience and one that arises from reading, particularly reading the kind of fiction promoted by the rise in newspapers, by cheaper printing methods, by less expensive paper, and by the use of advertising to cover most of the production costs. At the time Flaubert wrote his

[16] Gustave Flaubert, *Madame Bovary,* ed. C. Gothot-Mersch (1857; reprint, Paris: Garnier, 1971), 49–50.

novel, this kind of text had only recently become widely available. The distorting glass such writing held out to women of Emma's class is an intrinsic part of the modern world Flaubert re-creates. And it is that distorting glass that alters and perverts her reading of the world, in ways mirrored by the little still lifes he interpolates into his text.

Even Victor Hugo, whose novels we might associate more with movement and psychology, takes time to offer still lifes, embedded in his texts. In his superb and underrated novel *Les Travailleurs de la mer* (1866), he focuses on the creatures of the sea and more particularly on the ways in which we attempt to control the unknown by naming it, categorizing it, keeping it safe under glass, a technique particularly favored, moreover, in the mid-nineteenth century, when public museums were coming into vogue:

> Scientists begin by rejecting these strange animals, following their habits of excessive prudence even when faced with facts, then they decide to study them. They dissect them, classify them, catalogue them, label them. They seek out samples, expose them under glass in museums, enter into nomenclature, qualify them as mollusks, invertebrates, radiata. Scientists assign connections: somewhat on the far side of the squids, or this side of the cuttlefish. They find these saltwater hydras an analogous freshwater form, the argyronecte. They divide them into large, medium, and small species, happier to accept the small than the large species, which moreover is the tendency of science in all regions, for it is more willing to be microscopic than telescopic. They look at the construction of these animals and call them cephalopods or count their antennae and call them octopods. That done, they let the matter drop. Where science abandons them, philosophy takes over.[17]

Long before *Les Travailleurs de la mer,* in the 1826 preface to his poetry collection *Odes et Ballades,* a twenty-four-year-old Hugo had already proclaimed that the creative spirit, which sees everything from on high, creates order, and that the imitative spirit, which sees everything close up, regularizes. In this still life, the multivalent vision of Hugo, capable of looking into the far distance as well as close up, offers us a dynamic

[17] Victor Hugo, *Les Travailleurs de la mer* (1866; reprint, Paris: Ollendorff, 1911), 374–75.

dual focus: he focuses at once on the creatures captured under glass and on those who put them there, the scientists whose mania for collection and for nomenclature can see these exotic creatures only as objects and only in relation to one another, and have no interest in going beyond, progressing into the realm of speculation in which Hugo himself wanders so far afield. Hugo's fascination with these creatures is quite different in kind. For him they are all reflections on and of human vices and virtues, all invitations to the thinker to speculate on what their message to us might be, or on what human characteristics they represent, what former human life might here be living out its punishment or its path to enlightenment. The glass cases, like the delimiting and limiting nomenclature, are for him distorting aids to vision: his vision is inward, the vision of meditation, and the glass Hugo prefers is that of the prism, splitting the object into multiple images and manifold possibilities. Science in Hugo's marine still life quoted above imposes arbitrary schemas on objects, linking them to creatures that may not be related to them at all, placing them in changing categories depending on whether what matters today is heads or legs. Hugo seeks an order that can both account for difference and focus on what is most vitally important.

The naturalist writer Emile Zola, perhaps more than any of his contemporaries, with the possible exception of the decadent novelist Joris-Karl Huysmans, is fascinated by objects and inspired to depict them by a fierce rivalry with his painter friends. His novel about the Paris marketplace, *Le Ventre de Paris,* contains what is perhaps his most exuberant series of still lifes, giving him the chance to describe fruit, vegetables, cheese, fish, and meat as only he can do, each description of which builds up to a crescendo that perhaps only Rossini can rival. In one passage, indeed, he provides not just a written still life but a *transposition d'art,* an example of a technique many nineteenth-century writers loved, taking a work of visual art and transforming it into prose or poetry as Philostratus transformed the figs in *Imagines.* Here Zola begins describing the sign that advertises the market stall belonging to the central family, before moving joyously on to the display itself. It is a long quotation, but so exuberant, so much a work of art, that I hesitate to cut it:

> The sign, on which the name Quenu-Gradelle gleamed in large gold letters, in a frame of branches and leaves, drawn on a delicate background, was made of a

painting covered with a glass pane. The two side panels of the shop window were also painted and under glass. They represented fat-cheeked little cupids, playing amidst boars' heads, pork chops, garlands of sausages, and these still lifes, ornamented with banderoles and rosettes, were painted in such delicate watercolor that the raw meat took on the pink shades of preserves. Then, in this attractive frame, the display rose up. It was set on a bed of fine trimmings of blue paper; here and there were fern leaves, delicately arranged, transforming certain plates into bouquets surrounded with greenery. It was a mass of good things, melting and fatty. First, right at the bottom against the window, was a row of jars of potted pork, interspersed with pots of mustard. Above them were boned knuckles of ham, with their good round faces, yellow with breadcrumbs, their leg bone ending in a green pompom. Then came the main meals: the Strasbourg stuffed tongues, red and gleaming, bleeding beside the pallor of sausages and pigs' feet. There were black blood puddings, rolled up like well-behaved snakes; chitterling sausages, piled up in pairs, bursting with health; sausages, looking like cantors' spines, in their silver capes; pâtés, good and hot, carrying the little flags of their labels; the big hams, the large pieces of veal and pork, glazed with a jelly as limpid as sugar candy. And there were large terrines in the depths of which slept meat sliced and ground, in lakes of set fat. Between the plates, between the dishes, on the bed of blue paper, were jars of pickles, purées, and preserved truffles, terrines of foie gras, shimmering tins of tuna and sardines. A box of milky cheeses and another box, full of snails stuffed with parsley butter, were arranged in the two corners, negligently. Finally, right on top, falling from the wolf-like teeth of a huge fish, necklaces of sausages, metwurst, saveloys, hung down symmetrically, like the cords and tassels of luxurious hangings. Meanwhile, at the back, shreds of pork fat added their lacework, their backdrop of white and fleshy guipure. And there, on the last shelf of this chapel to the stomach, in the middle of the scraps of fat, between two bouquets of crimson gladioli, the altar was crowned with a square aquarium, decorated with rocks, in which two goldfish swam, unceasingly.[18]

To some extent here Zola seems to be attempting to match the exuberance of Charles Dickens, but in a less determinedly joyous and more robustly gritty way.

[18] Zola, *Le Ventre de Paris,* 1:636–37.

In *A Christmas Carol* (1843), Dickens shows the fruiterers' shops "radiant in their glory":

> There were great, round, pot-bellied baskets of chestnuts, shaped like the waist-coats of jolly old gentlemen, lolling at the doors, and tumbling out into the street in their apoplectic opulence. [. . .] There were pears and apples, clustered high in blooming pyramids; there were bunches of grapes, made, in the shopkeepers' benevolence, to dangle from conspicuous hooks, that people's mouths might water gratis as they passed; [. . .] there were Norfolk Biffins, squat and swarthy, setting off the yellow of the oranges and lemons, and, in the great compactness of their juicy persons, urgently entreating and beseeching to be carried home in paper bags and eaten after dinner. The very gold and silver fish, set forth among these choice fruits in a bowl, though members of a dull and stagnant-blooded race, appeared to know that there was something going on; and, to a fish, went gasping round and round their little world in slow and passionless excitement.[19]

The intensity of description, the anthropomorphism, and the insertion of the gold-fish bowl link these two generous evocations of the pleasures of food. But Zola's description also shows him flexing his muscles in competition with painters: those from the rich tradition of Dutch and Italian still lifes (one thinks of the butcher's scenes of Pieter Aertsen or Joachim Beuckelaer or Bartolomeo Passerotti, or of Rembrandt's slaughtered ox, or Frans Snyders's exuberant scenes of markets and kitchens) as well as those of friends like Gustave Caillebotte, whose display of fruit (*Fruit Displayed on a Stand,* 1881–82: Boston Museum of Fine Arts) seems strangely inanimate compared with Zola's metaphorically enriched version, with its striking finale focusing on the aquarium, as if to throw down the gauntlet not just to painters but also to the Parnassian poets who frequently chose the aquarium as the subject of a sonnet.[20] Meat here begins by assuming the shades of jams and jellies before being transformed into bouquets of flowers. The transformative power of simile turns black

[19] Charles Dickens, *A Christmas Carol* (1843), in *Christmas Books* (London: Collins, 1962), 51.

[20] One might think of José-Maria de Heredia's sonnet "Le Récif de corail," included in his volume *Les Trophées* (1893), a sonnet his son-in-law Henri de Régnier subsequently pastiched in his free-verse version, "Il est un port."

puddings into benevolent snakes, sausages into spines, before Zola changes gear and direction to introduce a series of comparisons between the meat and material, building up through this evocation of tassels and lace to that typically provocative affirmation of the meat stall as a chapel to the stomach. This is part of his flamboyant reading of contemporary architecture, both humble and monumental, as recording a move away from the sacred to the profane.

Zola is indeed deeply inspired by the transformation in architectural styles, by the recently acquired capacity to set those objects in buildings whose soaring shapes and whose use of glass and steel rivaled those of Labrouste, the architect to whom Paris owes the Bibliothèque nationale on the rue Richelieu and the Bibliothèque Sainte-Geneviève. Within the glass and steel structure of the department store Au Bonheur des dames, for instance, women are protected from the elements but not from the entrepreneurs who seek to prey on their consumerism, free to indulge in their longing to acquire objects but not protected of course from their appetites, and Zola makes sure that under that glass dome, those objects are set out in the most appetizing way possible.

Indeed, in *Au Bonheur des dames* (1883), translated as *The Ladies' Paradise,* this novelistic analysis of the rise of the department store and the resultant collapse of specialist shops, Zola reveals the intricate relationships between politics and urban space, between commerce and erotics, between seduction and shopping, between the class and gender that bought and the class and gender that sold. This shift, both in social structures and in the categories in which commodities had previously been placed, is reflected in the parallel that is established with the visual arts, for *Au Bonheur des dames* also shows Zola vying with his artist friends not so much through the topoi of the landscapes and cityscapes that dominate *Germinal* (1885) or *L'Assommoir* (1877), for instance, as through still life. Moreover, whereas in *Le Ventre de Paris* his still lifes, focused as they are on food, have an element of the classic in them, here he moves into the still life underworld of underwear, descending even further into the depths of rhopography, the depiction of debris, bringing him closer to Baudelaire's image of the poet as ragpicker. Furthermore, at significant points in the novel the action stops to allow the focus to settle, often unsettlingly for the reader, on the displays at which the shop's owner and the driving force behind this radical alteration

in shopping, Mouret, is so artistically gifted. Consider, for example, this interpolated still life, in which the sunshades, set out under the glass dome of the department store, mirror that glass shape:

> It was the display of the sunshades. Wide open, round as shields, they covered the entrance hall, from the glass bay of the ceiling to the varnished oak of the beams. Around the arcading of the upper floors, they traced festoons; they slid down the columns in garlands; on the balustrades of the galleries and even onto the stairs themselves they threaded their way in serried rows; and everywhere, in symmetrical rows, they daubed the walls in red, green and yellow, like great Chinese lanterns, lit for some colossal festival. In the corners there were complex motifs, stars made of thirty-nine-sous sunshades, their bright shades of pale blue, creamy white, tender rose burnt with the softness of a nightlight; while above them immense Japanese sunshades, where cranes the color of gold flew in a crimson sky, flamed with the reflections of a conflagration.[21]

Metaphor is the central trope here, with the parasols, like all the objects in Mouret's displays, standing for other things, shields and stars, garlands and Chinese lanterns, as the displays themselves are less accumulations of objects on sale than a constant reminder of the commoditization of desire, metaphorically alluded to by the closing image of fire, representing the burning desire to possess that drives many of these women. Language is brought to its knees before this exuberance: one shopper can merely stutter, "It's like fairy land!"[22] just as later, faced with the dazzling spectacle of the shop's display of white—a cunningly manipulative transformation of the virginal into the erotic—female customers are reduced to repeating: "Oh! extraordinary,"[23] as though language itself has become outmoded, incapable of evaluating or responding to the metamorphoses articulated by the rapacious goals of modern commerce. Still life in this instance becomes an exceptionally potent vehicle for exploring the mid-nineteenth century's rapidly changing social and sexual mores and for

[21] Emile Zola, *Au Bonheur des dames* (Paris: Flammarion, 1971), 265.
[22] Ibid., 265.
[23] Ibid., 410.

indicating, through its constant suggestion that nothing is what it seems, that the very fabric of Second Empire existence is a sham, an optical illusion on the point of disintegration.

Similarly, in *La Curée,* Zola uses the glass dome of a hothouse to suggest an architecture paralleling the heated desires of his characters, and he gives us an extraordinary little still life that brilliantly allows him to turn his heroine Renée into both an object and a subject of desire:

> But what struck the eye, from whichever curve in the paths you approached it, was the great Chinese Hibiscus, whose immense layer of greenery and flowers covered the entire side of the house to which the glasshouse was attached. The broad crimson flowers of this gigantic mallow, endlessly reborn, lived only a few hours. You would have said they were the sensual mouths of women, mouths that opened, showing the red lips, soft and moist, of some giant Messalina, flowers whose kisses bruised and which were always returning to life with their eager and bleeding smile.[24]

The hibiscus is alive here, so perhaps not strictly speaking the subject matter of still life, but it nevertheless speaks of the transient and the ephemeral because each flower lives only a few hours. The rhetorical trope Zola so powerfully and unsettlingly deploys is that of a comparison which has only to be made in order to transform the object seen into the object with which it is being compared. "On eût dit"—You'd have said—although Zola carefully refrains from telling us who this *on* is, who the *you* brought into the passage like a plant in an audience, to provide the right simile, might be, but we can hazard a guess at his gender. The comparison that does not need to be made explicit is suggested through a pun. The flowers are constantly reborn, *renaissent,* just as Renée, through her illicit relationship with Maxime, is reborn. Desire rises in her, the longing for pleasure that comes from the presence of these tropical plants under that glass dome, which Zola now terms the enclosed nave, finding yet another modern transformation of the cathedral, as he does in the department store and in the railway stations. But while the glass house enables exotic

[24] Emile Zola, *La Curée,* ed. Claude Duchet (Paris: Garnier-Flammarion, 1970), 74.

flowers like the hibiscus to flourish, their lives are brief, and Renée too, exotic creature that she is, is doomed to die young of acute meningitis.

The glass house of the nouveau riche may preserve Renée from suffering and from aging, but it does so by restricting her to a stereotype, that of woman as desire; the glass dome over the department store favors a different kind of desire, that of consumption. If the central female character of *Au Bonheur des dames* escapes the fate handed out to Renée and seizes control of the shop and its owner, it is because she is no hothouse flower, because she knows how to break free from the glass dome that both protects and inhibits.

The renewed yet transformed fascination with mimesis that came about in the middle of the twentieth century through the French new novelists' questioning of the role of the novel also leaves its mark on the still lifes embedded in their texts. Nathalie Sarraute offers telling examples in her novel *Le Planétarium* (1959), with its minute observation of the slips and slides in the characters' emotional and psychological states. Thus, one character, surrounded by familiar objects, finds an initial response—tentatively designated as "well-being"—disintegrating into a longing to be freed of these trappings that, while allowing her to find her bearings in the world, also pin her down as a type: "Newspapers are piled up on the parquet floors, there are books everywhere, on furniture, under beds, the hangings are faded and worn, the silk of the armchairs is flaking off, the leather of the old divan has the scars of cat's talons, the edges of the rugs are chewed by the teeth of young dogs."[25] Through such details, together with tiny facial gestures or changing tones of voice, Sarraute builds up what she designates as not yet discovered: "The language that could explain immediately what you can see at a single glance."[26] A different kind of realism from that of either Balzac or Zola, Sarraute's nevertheless draws on objects, often those familiar to painted still lifes, to convey these tiny psychological changes that she calls "tropismes."[27]

J. M. G. Le Clézio, in a remarkable tribute to the world's beauty, his 1978 *L'Inconnu sur la terre,* emphasizes a desire to parallel not so much painting as music:

[25] Nathalie Sarraute, *Le Planétarium* (Paris: Livre de Poche, 1959), 16.

[26] Ibid., 31.

[27] On this, see Sarraute's *Tropismes* (Paris: Editions de Minuit, 1971).

All I would like to do is this: create music with words. I'd like to set off for a land where there would be no noise, no pain, nothing that disturbs or destroys, a land without war, without hatred, full of silence, full of sunshine. There, I would only make music with my words, to embellish my language and allow it to rejoin the other languages of the wind, insects, birds, flowing water, crackling fire, the rocks and pebbles of the sea.[28]

But in several lyrical passages, Le Clézio combines this determination to re-create the language of objects through that of music with his exceptional ability to suggest both the objects and the "dazzling light" in which they bathe. It is this blend of intense light and an awareness of the power of suggestion embedded in objects that makes Le Clézio's writing most like the still lifes of both late impressionism and hyperrealism. Take, for instance, the following tribute to vegetables:

If I were to collect anything it would be vegetables. I love to see them on market stalls, heaped up or aligned and calibrated in boxes of white wood. Oh, vegetables aren't serious! They don't put on airs, sometimes they make you laugh with their bizarre colors, their exocentric forms, their leaves chewed by slugs, their tranquil, somewhat soup-like air. But those that really move me are the corn cobs. Like all other vegetables they're funny and have no false dignity, with their great yellowing leaves that wrap them about, and their fine chestnut hair. But if you unclothe them, by making the leaves crackle under your hands, the cob can be seen, and it is certainly one of the loveliest fruit that humanity has invented. The seeds in their pyramid rows, almost round and smooth, gleaming, yellow, regular, hard, lodged in their sockets, I look at them and I touch them and suddenly I have the sense of a divine presence.[29]

The playful nature of this presentation, and above all the constant hesitation between the aesthetic and the erotic, makes the sudden awareness of the divine all the more striking. Le Clézio's tribute to the numinous in even the most humble objects of the earth uses the techniques of still life painting in its invitation to us to look more

[28] Le Clézio, *L'Inconnu sur la terre,* 309. Le Clézio defines this work as an "essai."

[29] Ibid., 266–68.

deeply at the objects on display but also to respond to them as metaphors and symbols corresponding to deeper human needs.

What is more, Le Clézio's written still lifes present a further parallel with painted still lifes in that they too ask to be read within a series of other such works. His depiction of oranges, for instance, offers itself as an artful pastiche of Francis Ponge's prose poems, which, as his best-known title implies, claim to take the side of things (*Le Parti pris des choses,* 1942). The accumulation of negatives, the contrast with other fruits, the subject itself, because one of Ponge's most remarkable prose poems (which I examine in chapter 4) is devoted to an orange, the very rhythm of the sentences all point clearly to the source of the pastiche while at the same time attempting to seize in language the essence of orangeness:

> You don't open an orange without a certain degree of ceremony. But it's not a complicated act as it is for the peach or the mango. It doesn't take a long struggle like the pineapple or an effort like the hazelnut. You need a good knife and then also perhaps a spot somewhat removed from the crowd. Then the orange takes you far away, to a place you couldn't imagine reaching without it.[30]

The knife that initiates you into the essence of the orange and in doing so takes you elsewhere is a common element of the still life, its position at the edge of a table or counter making it the essential link between the viewer and what is seen, the invitation to enter the elsewhere of the painting.

Later variants of the realist still life can be less invitations to enter the elsewhere of dreams than ironic commentaries on present food production methods as metonymic of the modern condition. A. S. Byatt, for instance, presents us with just such a vision, intensified, as so often in her writing, by a playfully postmodernist self-reflexivity. Here she is in an exuberant passage that seems to be a sardonic doffing of the cap to such writers as Dickens and Zola, a doffing of the cap that moves at times from pastiche to parody:

> Allenbury's shop window was, in its way, a work of art. It is not possible, with meat, to create the symmetry, the delicate variation of colour and form that a fishmonger

[30] Ibid., 254–55.

can make on marble or ice with a wheel, or an abstract rose, of his proffered goods. But Allenbury's window had a compensating variety. It combined the natural, the man-made, the anthropomorphic and the abstract in a pleasingly eclectic way. It had its own richness.

From a glittering steel bar on elegantly curved hooks hung the chickens, with plump naked breasts and limbs, and softly feathered stretched necks. The ducks, in line, had their webbed cold feet tucked neatly along their sides, gold beaks, black eyes, neck feathers scarlet on white. Beneath them the display counter was lined and fringed with emerald green artificial grass. On this miniature meadow capered various folklorique figures and mythical creatures. [. . .]

On the next layer, white marble below the brilliant green, were enamelled dishes of more recondite goods, alternating in colour and texture. A block of waxy suet, a platter of white, involuted, honey-combed and feathery tripe. Vitals: kidneys both stiff and limp, some wrapped still in their caul of fat, the slippery bluish surface of meat shining through slits in the blanket, the cords dangling: iridescent liver; a monumental ox heart, tubes standing out above it, a huge gash in one side, darkening yellow fat drying on the shoulders. . . .

If all flesh is grass, all flesh at some other extreme is indeed geometry. The consuming human, with his ambivalent teeth, a unique mouthful, herbivore and carnivore, is an artist in the destruction and reconstruction of flesh, with instruments for piercing, prying, tidying, analysis and palatable rearrangement. Man the artist can reconcile under golden skies the jocund pig and the plump and tubular sausage, if he can create, from sweated suet, mangled breast of calf, chopped parsley, bread and beaten eggs an incurving sculptural spiral of delicate pink and white and green and gold.[31]

The way in which this passage begins with an apparently exuberant tribute to the artistry of the butcher, bringing us through aesthetics and folklore to the unvarnished vision of butchery and decay becoming such artistry, is of course a *tour de force* compelling us to look directly at elements of the still life that are generally overlooked when aesthetics take precedence over pragmatics. In many respects it recalls Cornelis de Vos and Frans Snyders's *Fish Market* (c. 1618–20; fig. 7), in which the

[31] Byatt, *The Virgin in the Garden,* 90–91.

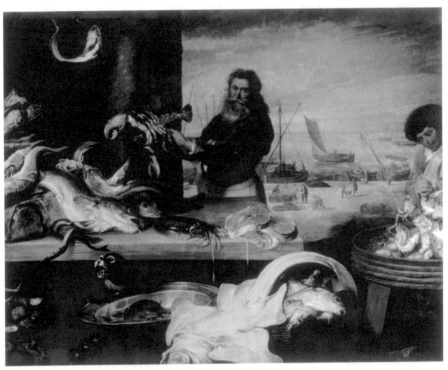

FIGURE 7. Cornelis de Vos and Frans Snyders, *A Fish Market,* detail, c. 1618–20. Kunsthistorisches Museum, Vienna. Photo: Erich Lessing / Art Resource, NY.

huge fish sprawled across the bench points unmistakably down to the wide-eyed seal, still alive but doomed.

The desire to find a language rich in metaphorical and phonetic suggestions, in reminiscences of other works and in links to a thickly evoked context, a language capable of capturing the objects of everyday existence and giving them permanence, has been one of the dominant threads in novel writing, but there is another, an approach equally important in the visual arts and in literature, that promotes suggestion over description, that invites readers not so much to contemplate as to re-create for themselves, and it is this thread that forms the subject of the next chapter.

3

NOT THE OBJECT BUT THE
EFFECT IT PRODUCES

To have recognized that artistic beauty is and has been a means of
resolving the contradiction between abstract mind and actual nature
must stand as one of the great achievements of modern times

HEGEL

Turning away from the mimetic ambitions pursued in very different ways by both
the realist novelists and the Parnassian poets, Stéphane Mallarmé promoted a dif-
ferent vision of modernism when he argued in a letter of 1864 that the writer's task
was to depict not the thing but the effect it produces,[1] a program on which he elab-
orated when he maintained that poets should no longer attempt to "include on the
subtle paper of the volume anything other than for instance the horror of the forest,
or the silent thunder scattered through the leaves, not the intrinsic dense wood of
the trees."[2] Nature exists, nothing can be added to it, except, he proposes half-iron-
ically, cities, railway lines, and the other inventions that make up our material exis-
tence, but the essential task for the writer evoking nature is to seize the connections

[1] *OEuvres complètes,* 1:663.
[2] Ibid., 2:210. Mallarmé revised and added to his original text for this study, working on it between
1886 and 1896.

and correspondences between the outer world and the inner state that the particular aspect of that outer world produces. It is a matter, he adds, of simplifying.[3] To name an object, according to Mallarmé, is "to suppress three quarters of the pleasure of a poem which results from guessing little by little: *suggesting* it, that's the dream. Evoke an object little by little to show a state of mind, or conversely, choose an object and make it reveal a state of mind, deciphering little by little."[4] This artistic credo, which was to have an immense impact on art and writing in the twentieth century, leaves its unmistakable mark on still lifes.

An early and enthusiastic supporter of impressionism, with its own series of decipherings, Mallarmé insisted in an 1876 article, "The Impressionists and Edouard Manet," on the way in which Manet's paintings allow nature to speak through the painter by focusing precisely on the effect produced, the impression created:

> Everywhere the luminous and transparent atmosphere struggles with the figures, the dresses, and the foliage, and seems to take to itself some of their substance and solidity; whilst their contours, consumed by the hidden sun and wasted by space, tremble, melt, and evaporate into the surrounding atmosphere, which plunders reality from the figures, yet seems to do so in order to preserve their truthful aspect. Air reigns supreme and real, as if it held an enchanted life conferred by the witchery of art.[5]

And, in a letter written in 1886 he pointed to a new vision of literature, one that would better correspond to the cult of the modern already thrust into prominence by Charles Baudelaire: "I believe that literature, if we take it back once more to its source in Art and Science, will provide us with a Theater, whose performances will be the true modern cult, and a Book, the explanation of humanity, sufficient for our most beautiful dreams."[6]

[3] Ibid., 2:67.

[4] Ibid., 2:700.

[5] Originally published in English translation in *The Art Monthly Review and Photographic Folio,* the original French article has been lost. The English version is reproduced in Carl Barbier et al., eds., *Documents Stéphane Mallarmé,* 7 vols. (Paris: Nizet, 1968–80), 1:75. Both the English version and its translation back into French appear in Marchal's edition of the *OEuvres complètes,* 2:444–70.

[6] Stéphane Mallarmé, *Correspondance: Lettres sur la poésie,* ed. Bertrand Marchal (Paris: Folio, 1995),

This new vision, in which mimesis would be replaced by suggestion, is reflected in the modernist use of objects to convey not so much their tangible reality as the effect they create. The idea is not, of course, completely new: Coleridge, praising Titian—

> Who like a second and more lovely Nature
> By the sweet mystery of lines and colours
> Changed the blank canvas to a magic mirror,
> That made the absent present; and to shadows
> Gave light, depth, substance, bloom, yea, thought and motion—[7]

already suggests a transformation of reality into a heightened awareness of its effect on the viewer, the ability of mere shadows to evoke "thought and motion." But the surge in popularity of still lifes in the last century depends in part on a heightened conviction that objects can, if we are willing to interpret their multiple layers, reveal more than the thought and the motion of nature: they can convey states of mind. This is the kind of connection that E. M. Forster suggests in *Howards End* (1910) when he refers to a belief that "round every knob and cushion in the house sentiment gathered, a sentiment that was at times personal, but more often a faint piety to the dead, a prolongation of rites that might have ended at the grave."[8] Objects accumulate such associations, as Proust also indicates in his list of objects capable of resuscitating the past. It is the task of both writer and reader to perceive and interpret those associations.

The way in which objects can be made to yield up their power of suggestion depends on many aspects, but central to them is the nature of the light that makes them visible, light that can suggest particular moments of the day or year, particular emo-

593. This letter was originally published by its recipient, Vittorio Pica, in his article "I Moderni bizantini," *Gazzetta letteraria,* November 27, 1886, reprinted as "Les Modernes byzantins" in *La Revue indépendante* 18 (1891). Baudelaire's call for artists and writers to respond to the winds of modernity first appeared in his review of the art salon of 1846.

[7] This passage, appended to Coleridge's play *Remorse,* is quoted in John Hollander, *Gazer's Spirit,* 91.

[8] E. M. Forster, *Howards End* (New York: Vintage, 1989), 156.

tions or desires.[9] A vital element of Mallarmé's artistic credo concerned what he called the tetralogy of the year,[10] a poetic representation of the effect of the seasons, the changes they bring in the quality of light, the tasks and pleasures associated with them, the sunsets and star patterns that belong to them. Spiritual yearnings would be satisfied, in this vision, not by the hidebound traditions of the church but by a constantly renewed response to the rituals of nature transformed into aesthetics, and obliquely and suggestively captured in writing.

Similar responses can be found among a wide variety of other writers of the time, whatever their own aesthetic beliefs. Thus Walter Pater, in his powerful little evocation of childhood, subtly suggests the extent to which the changing quality of light through the year impinges on the senses and emotions:

> Our susceptibilities, the discovery of our powers, manifold experiences—our various experiences of the coming and going of bodily pain, for instance—belong to this or the other well-remembered place in the material habitation—that little white room with the window across which the heavy blossoms could beat so peevishly in the wind, with just that particular catch or throb, such a sense of teasing in it, on gusty mornings; and the early habitation thus gradually becomes a sort of material shrine or sanctuary of sentiment; a system of visible symbolism interweaves itself through all our thoughts and passions; and irresistibly, little shapes, voices, accidents—the angle at which the sun in the morning fell on the pillow—become parts of the great chain wherewith we are bound.[11]

That acute sense of the effect of light and air within a room is beautifully and quietly stated here, in a passage that illuminates many impressionist still lifes, with their suggestions of shifting sunlight and breezes, of light as a central presence conveying a state of mind. The phenomenologist Gaston Bachelard would argue that "every great and simple image reveals a state of mind. The house, even more than a landscape, is a 'state of mind.'"[12]

[9] Freud, in *Beyond the Pleasure Principle,* may argue that painted light conveys sexuality itself, but this seems reductive as a means of responding to the multiple aspects of light in still lifes.

[10] *OEuvres complètes,* 2:241.

[11] Pater, *Imaginary Portraits,* 20.

[12] Gaston Bachelard, *La Poétique de l'espace* (Paris: Presses Universitaires de France, 1957), 77.

A later passage in Pater's book illustrates Bachelard's claim through its intensified response to changes brought about in a room through the changes of the seasons:

> So he yielded himself to these things, to be played upon by them like a musical instrument, and began to note with deepening watchfulness, but always with some puzzled, unutterable longing in his enjoyment, the phases of the seasons and of the growing or waning day, down even to the shadowy changes wrought on bare wall or ceiling—the light cast up from them now, bringing out their darkest angles; the brown light in the cloud, which meant rain; that almost too austere clearness, in the protracted light of the lengthening day, before warm weather began, as if it lingered but to make a severer workday, with the schoolbooks opened earlier and later; that beam of June sunshine, at last, as he lay awake before the time, a way of gold-dust across the darkness; all the humming, the freshness, the perfume of the garden seemed to lie upon it.[13]

Bachelard would argue that much of the pleasure we derive from such a response to light in a room comes from the fact that "from the very first words, at the first poetic opening, readers who 'read a room' suspend their reading and start thinking of some former dwelling place."[14] In similar ways, readers of still lifes may suspend their reading—consciously or not—to connect the objects depicted or described with elements of their own experience, to use the objects as mnemonics allowing access into a past that might otherwise be lost.

It is perhaps for related reasons that many of the still lifes embedded in modernist writing seem attempts to create effects rather than merely evoke the objects themselves. The metaphorical imperative is clearly at work when Rilke, for instance, transforms two pomegranates into an open-ended series of other possibilities in a reading of natural objects that places the play between outer form and inner reality in an exuberantly positive light. In a letter dated September 29, 1907, he wrote:

> What you experienced with the Portuguese grape is something I know so well: I am feeling it simultaneously in two pomegranates I recently bought from Potin;

[13] Pater, *Imaginary Portraits*, 27–28.
[14] Bachelard, *La Poétique de l'espace*, 32.

how glorious they are in their massive heaviness, with the curved ornament of the pistil still on the top; princely in their golden skins with the red undercoat showing through, strong and genuine, like the leather of old Cordovan tapestries. I have not yet tried to open them; they probably aren't ripe yet. When they are, I believe they easily burst of their own fullness and have slits with purple linings, like noblemen in grand apparel.[15]

More subtly and less exuberantly, Forster, in a brief passage in *Howards End,* conveys the ephemeral nature not just of the character portrayed but also of the objects she gathers around her and the social structures that have supported her: "She was sitting up in bed, writing letters on an invalid table that spanned her knees. A breakfast tray was on another table beside her. The light of the fire, the light from the window, and the light of a candle-lamp, which threw a quivering halo round her hands, combined to create a strange atmosphere of dissolution."[16] Those three sources of light come together not so much to illuminate as to suggest and indicate, to invite speculation. Forster's novel, after all, was completed in 1910, the very year to which Virginia Woolf famously attributed a remarkable change in human nature,[17] and Forster himself records, with a wryly observant gaze that is far more pessimistic than Woolf's seems to have been, the radical alterations in class and gender expectations, and in the physical appearance of England, whose rapidly changing beauty is a central theme of his work. The dissolution referred to in Forster's passage is initially that of the woman herself, as death approaches, but it is also the dissolution of much that was taken for granted in contemporary definitions of society and of the individual. Spelled out, Forster's vision would hang prosaically from the plot, whereas his subtle evocation creates lasting and powerful reverberations in the reader's mind.

However different its aspirations, purposes, and theories, cubism's use of still life also endows objects with a power of suggestion concerning society and the individual. As Margaret Preston observed in one of her many aphorisms, "one group of cu-

[15] Rilke, *Letters on Cézanne,* 13.

[16] *Howards End,* 70.

[17] "Character in Fiction," *The Essays of Virginia Woolf,* vol. 3: *1919–1924,* ed. Andrew McNeillie (New York: Harcourt Brace Jovanovich, 1989), 421.

bists loves structure, such as those who love the definite cubic element in a tree, in a landscape, a human body, in the firmness of its cubic anatomy, and the other line of cubism leads away from reality to spiritual expression; it follows the inner lead of any natural object through a maze of angles and balanced lines; it searches for the inner meaning of natural objects."[18] Francis Ponge probably comes as close as any writer to finding a verbal equivalent to cubism's metamorphosis of matter, its play with what Picasso, however provocatively, called cubism's essence, a "base kind of materialism."[19] Picasso's fascination with the world of objects, conveyed in such paintings as his 1911 *Glass with Straws* (Stedelijk Museum, Amsterdam) or the 1912 *Architect's Table* (Museum of Modern Art, New York) is also reflected in what T. J. Clark terms the "positive inventory" that the artist produced in describing his work: "a still life of a glass with a lemon-squeezer, half a lemon and a little pot with drinking straws and the light."[20] Clark wonders what "the light" refers to, suggesting a bulb or a table lamp,[21] but I would propose that Picasso is referring here to the light that falls on the objects, an essential element in all still life paintings and one that plays a crucial role in enabling and directing our response to them. Picasso's attention to objects and to their multiple surfaces is itself a development of earlier Dutch still lifes, with what Svetlana Alpers refers to as the

> practice of opening, in order to reveal to our sight, the makings of the objects. [. . .] Whether it is edibles such as cheese, a pie, herring, fruit, and nuts, or collectibles such as shells, vessels and watches, we are offered the inside, or underside, as well as the outer view. Cheeses are cut into, pies spill out their fillings beneath the shelter of crust, herring are cut to reveal flesh as well as gleaming skin. Shells and vessels of precious metal or glasses topple on their sides (occasionally we even see the jagged edge of a broken goblet), and watches are inevitably opened to reveal their works.[22]

[18] Quoted in Butel, *Margaret Preston,* 37. This is Preston's Aphorism 67.
[19] On this, see Clark, *Farewell to an Idea,* 179.
[20] Quoted in ibid., 183.
[21] Ibid., 424.
[22] Alpers, *Art of Describing,* 90–91.

Zola had already responded, with characteristic enthusiasm, to this tendency to reveal multiple facets of the objects depicted when, for instance, he described the marketplace cheeses cut into, collapsing, and overflowing.[23]

Ponge, playing with and going beyond cubism's own variation on the theme, offered a series of prose poems in which objects are opened up and subjected to the same kind of revealing and intense scrutiny. In these pieces he focuses on objects that are frequently found in painted still lifes: oysters, fruit, packing crates, seashells. Almost all these pieces are also comments on writing itself, on the relationship between language and what it attempts to convey, on the search to find ways of depicting not the thing, or at least not just the thing, but also the effect it produces. Ponge's prose poems therefore illustrate that third category for still lifes, the self-reflexive work that draws attention to its presence as painting. Thus, in portraying that staple element of traditional still lifes, an oyster, Ponge, with characteristically witty seriousness, begins with a precise description of its outside surfaces, comparing and contrasting it with a pebble, denoting it an "obstinately closed world" before playfully moving into an equally careful depiction of how to open it, followed by an evocation of the world one finds within:

> À l'intérieur l'on trouve tout un monde, à boire et à manger: sous un *firmament* (à proprement parler) de nacre, les cieux d'en-dessus s'affaissent sur les cieux d'en-dessous, pour ne plus former qu'une mare, un sachet visqueux et verdâtre, qui flue et reflue à l'odeur et à la vue, frangé d'une dentelle noirâtre sur les bords.
>
> Parfois très rare une formule perle à leur gosier de nacre, d'où l'on trouve aussitôt à s'orner.

> [Inside, you find a complete world, to drink and eat: under a *firmament* (in the strict sense of the word) of mother-of-pearl, the skies above collapse on the skies below, forming a mere pond, a viscous greenish envelope, that ebbs and flows for the nose and the eye, fringed along the edge with a blackish lace.
>
> Sometimes, but very rarely, the pearl of an expression adorns its nacreous throat, providing you instantaneously with a means of adornment.][24]

[23] See chapter 2.

[24] Francis Ponge, *OEuvres complètes,* ed. Bernard Beugnot et al. (Paris: Gallimard, 1999), 1:21.

Just as Picasso's obvious brushstrokes draw our attention to the painted surface of his work, and both his twisted geometrical planes and his inclusion of words such as "Ma Jolie" emphasize the still life as something not just to observe passively but to read and interpret, so Ponge here insists on the poem as a verbal construction both by the invitation to examine the literal meaning of "firmament" and by the (largely untranslatable) pun on the verb *perler* in the last sentence. *Firmament,* from the Latin *firmare,* is that which strengthens, and, in the case of the oyster, the strengthening provided by the hard shell surrounding the liquid interior. *Perler* means to complete a work (a poem or a speech, for instance) with minute attention to details, but it also means to make pearls, as an oyster creates pearls to protect itself from grains of sand. The poem, Ponge suggests, recalls the oyster in that it can be entered only with difficulty, but if you succeed you will find in it a whole world that occasionally offers you a priceless ornament.

The movement Ponge suggests between inner and outer worlds and the way in which art invites new forms of vision are also very much at issue in a more extensive piece significantly titled "Notes pour un coquillage" (Notes for a Shell). The opening sentence of this prose poem highlights the possibility an artist possesses of transforming an object by changing the angle of vision or the point of comparison. The shell, Ponge agrees, is a small thing, but its size can be transformed if you take a handful of sand and look at each grain. By comparison with those grains, the shell will now appear like an enormous monument, like the temple of Angkor, or the cathedral of Saint-Maclou, or the pyramids of Egypt. Yet these monuments are less revealing than the shell because the relationship between them and their architects and builders lacks all proportion; when a cathedral door opens, for instance, all that comes out is a crowd of tiny ants, whereas the shell is perfectly proportioned to the creature that made it with its own secretions:

> De ce point de vue j'admire surtout certains écrivains ou musiciens mesurés, Bach, Rameau, Malherbe, Horace, Mallarmé—, les écrivains par-dessus tous les autres parce que leur monument est fait de la véritable sécrétion commune du mollusque homme, de la chose la plus proportionnée et conditionnée à son corps, et cependant la plus différente de sa forme que l'on puisse concevoir: je veux dire la PAROLE.

[From this point of view I admire above all certain measured writers and musicians, Bach, Rameau, Malherbe, Horace, Mallarmé—, above all the writers because their monument is made of the true secretion common to the human mollusk, the thing most in proportion with and conditioned by their body, and yet the most different imaginable from their form: I mean to say the WORD.]

Ponge's reworking of the traditional still life theme of the shell, and his humorous twisting of the subject back to the self-reflexive emphasis on language, also recalls those still lifes that contain reflections or photographs of the artist or letters received or sent by the artist.[25] There is something akin, too, to Picasso's *Man with a Pipe* (1911: Kimbell Art Museum, Fort Worth, Texas), where the human subject is transformed into a profusion of objects—pipe, sleeve, stopper, buttons, pencil, jar with handle, and so forth—that make of him a "compound of metaphors," in T. J. Clark's term.[26] This stew of metaphors is central to Ponge's praxis, in a work that reveals the intimate interplay between object and subject, still life and viewer.

That play with metaphors, which Ponge shares with many contemporaries but in the use of which he is exemplary, is also in evidence in another element of his complex analysis and transformation of objects: his ability to take up a traditional aspect of the *vanitas* and make it something unique. The little piece entitled "L'Allumette" (The Match) is at once a discourse on the brevity of life and an imaginative play on the forms of light:

> Le feu faisait un corps à l'allumette.
> Un corps vivant, avec ses gestes,
> son exaltation, sa courte histoire.
> Les gaz émanés d'elle flambaient,
> lui donnaient ailes et robes, un corps même:
> une forme mouvante, émouvante.

> Ce fut rapide.

[25] For more details on this, see chapter 4.
[26] *Farewell to an Idea,* 215.

La tête seulement a pouvoir de s'enflammer, au contact d'une réalité dure,
—et l'on entend alors comme le pistolet du starter.
Mais, dès qu'elle a pris,
la flamme
—en ligne droite, vite et la voile penchée comme un bateau de
 régate—
 parcourt le petit bout de bois,

Qu'à peine a-t-elle viré de bord
finalement elle laisse
aussi noir qu'un curé.

[The flame lent the match a body.
A living body with its gestures,
Its exaltation, its brief history.
The gasses emanating from it flamed,
Gave it wings and dresses, even a body.
A moving form,
Moving.
It was swift.

The head alone can burst into flames, on contact with harsh reality,
—and then you hear what sounds like a starting gun.
But, once caught,
The flame
Moving straight ahead, fast and its sail heeling over like a
 regatta boat's—
Runs all over the little bit of wood,
Scarcely has it heeled over
Than finally it turns
As black as a priest.][27]

[27] Ponge, *OEuvres complètes,* 1:457–58.

Both destructive and creative, the flame takes on human form, suggests a transformation of wood into ship, and then, like the poem itself, disappears in its swift transformation of an object and the equally abrupt departure of that object. Ponge's use of prose poetry and free verse rather than prose to create his still lifes makes them appear as isolated elements of a total world vision. Separated out from one another in isolated pieces rather than as a continuous narrative, they place a particular emphasis on the interpenetration of object and subject, on the shuffling of outer and inner surfaces, on the ways in which giving priority to objects inevitably reveals the human mind's inability to escape from its own parameters. But novelists writing at this time frequently make similar points, even if, embedded within a narrative and presented not through mimesis but through evocation, they risk being overlooked.

Novelists also reveal that if the different ways in which light falls on objects can suggest change and impermanence, objects themselves can imply certain aspects of character, whether permanent or part of a transitory mood. Djuna Barnes, for instance, as *Nightwood*'s (1937) gathering tension builds to its grindingly slow conclusion, holds off her garrulous doctor's extended monologue long enough to evoke his room as the essence of masculinity unleavened by feminine influence:

> A pile of medical books, and volumes of a miscellaneous order, reached almost to the ceiling, water-stained and covered with dust. Just above them was a very small barred window, the only ventilation. On a maple dresser, certainly not of European make, lay a rusty pair of forceps, a broken scalpel, half a dozen odd instruments that she could not place, a catheter, some twenty perfume bottles, almost empty, pomades, creams, rouges, powder boxes and puffs. From the half-open drawers of this chiffonier hung laces, ribands, stockings, ladies' underclothing and an abdominal brace, which gave the impression that the feminine finery had suffered venery. [. . .] There is a certain belligerence in a room in which a woman has never set foot; every object seems to be battling its own compression—and there is a metallic odor, as of beaten iron in a smithy.[28]

"Every object seems to be battling its own compression": Barnes's telling formulation here abruptly pulls all this incoherent trivia into focus, showing it as the result

[28] Djuna Barnes, *Nightwood* (1937; reprint, New York: New Directions, 1961), 78–79.

of items accumulated over time, mementos perhaps of unique events, but, seen from the outsider's perspective, stripped of that dimension that memory or use adds to them, reduced here to a rebus that has none of the inviting allure of the lists we considered earlier. These objects are seen and presented not as treasures, rich in possibilities or reminiscence, but as the impedimenta of a debased existence. There is no sense here that, if only we had the key to it, this riddle would suddenly clarify the central enigma of the doctor's life; there is much more the growing certainty that what we are looking at is a life without enigma because it is all surface, as these two-dimensional objects hint.

In striking contrast to this deeply skeptical portrait, published on the eve of the Second World War, is Richard Hughes's 1961 depiction of a time when Hitler was coming to power, a time seen through eyes incapable of understanding the inexorable movement the narrative reveals. His central character is first revealed to us through a group of objects that suggest his nature, together with his mistaken but deeply held if unconscious conviction of harmony between inner and outer worlds. It is not that the moment thus evoked is a happy one for the protagonist—on the contrary, he has just discovered the body of a dead child. What is at issue here is not anything as simple as happiness; it is more a relationship between his inner and outer worlds that will be forever shattered by the events he is about to witness, however uncomprehendingly. And if we see these objects in such a positive light it is because, unlike the case with Barnes's jaundiced vision from an outsider's viewpoint, here we see this still life through Augustine's eyes:

> In a corner of the room stood the collection of his fishing-rods. Their solid butts were set in a cracked Ming vase like arrows in a quiver; but he felt now as if their wispy twitching ends were tingling like, like antennae—his antennae. Above them the mounted otters'-masks on the peeling walls grinned. The tiny wisp of steam from the ever-simmering kettle on the round coke-stove seemed to be actively inviting the brown teapot that stood on the shelf above—the loaf, and the knife, and the pot of jam. In short, these guns and rods of his, and even the furniture, the kettle, and the loaf had suddenly become living tentacles of "him."[29]

[29] Richard Hughes, *The Fox in the Attic* (1961; reprint, New York: New York Review of Books, 2000), 11.

This is very much a traditional hunter's still life, reminiscent of Joshua Reynolds's account of those he saw on his trip to Flanders and Holland;[30] the Ming vases reduced to the humble task of holding fishing rods, the faces of the dead otters, the tiny wisp of steam—all are staple elements of that masculine form of still life that encapsulates the pleasures of the male outdoor life, tempted back to the warmth of the kitchen only for eating and drinking. There is nothing refined about the eating and drinking, either; a loaf of bread, a pot of jam, a knife for dealing with both. But the quiet perfection that this scene might have acquired in the hands of, say, Chardin or Oudry is denied here by the pressure Hughes brings constantly but almost imperceptibly to bear on the knowledge we have of what awaits Augustine and his generation.

Pär Lagerkvist, in *The Dwarf,* a work first published in 1945 that gives the reader, through an apparent depiction of Renaissance court life, a bitter vision of a society built on hypocrisy and pretence, uses the model of ostentatious still lifes to suggest that nothing is what it seems, just as none of the members of the court of the Renaissance principality to which he is attached are what they seem:

> Gold sturgeon, carp and pike were borne in on immense majolica dishes, receiving great applause for their skillful dressing, mighty galantines adorned with wax ornaments so that one could not see what they really were, pasties shaped like the heads of deer and calves, sucking pigs roasted whole and gilded, and sugared and perfumed dishes composed of fowls, quails, pheasants and herons. At last came two pages clad as hunters carrying an entire wild boar, as gilded as the rest, with flames issuing from its jaws which had been filled with a burning substance that smelled most foully.[31]

Pasties looking like animals, savory meats transformed into sweet dishes, pages dressed as hunters—all point to a scene of deception in which peace offerings pro-

[30] Reynolds, *Journey to Flanders and Holland.* See, for instance, pp. 21 and 116, where the slightly weary tones relating the numbers of dead swans and hares contrast with the painter's admiration for the fact that technically at least they were "most remarkably excellent."

[31] Pär Lagerkvist, *The Dwarf,* trans. Alexandra Dick (New York: Hill & Wang, 1958), 136–37.

vide an opportunity for murder. In creating his study of a bellicose feudal past, Lagerkvist draws heavily here on the traditions of the sumptuous still lifes that flourished in seventeenth-century Netherlandish art. But the novel constantly invites comparison with the time in which it was written, using the superabundance of objects in the ducal court to suggest a society in the process of disintegration, a society based on unvarying deceit that the hypersensitive dwarf persistently smells out.

Objects can also be depicted in ways that evoke anxiety, reflecting the state of mind of whichever character arranged them. A. S. Byatt uses this device with particular force in her 2002 novel, *A Whistling Woman,* when a young man is embellishing his house in preparation for a visit from a woman he loves but who is considerably less interested in him:

> He arranged his trophies in carefully casual drifts and heaps, inside the window alcoves, along the benches. A group of shells, *Cepaea hortensis, Cepaea nemoralis,* some tiny flat ramshorns, a few giant white *Helix pomatia.* An interesting collection of *Vertigo.* A scalariform monstrosity. The silk anemones on the dresser in a plain jam jar. The empty medicine bottles on a carefully washed shelf in the bathroom, where he had put up a new mirror, framed in pale wood. Heaps of seaside pebbles, rows of ancient stones side by side, like families of strange lumpen creatures, or those rows of elephants brought back from the ex-colonies. Some dried fern leaves. Three skulls—fox, badger, shrew. He put his oil-lamps—big ones with chimneys and mantles, little ones, Kelly lamps, with thin glass spouts and heavy bases, so that their thick gold light fell and shone on what caught it—wrinkled silk and sheen of feather, gleam of stone and lacquer of shell, ribbed glass and white bone.[32]

Here we have an accumulation of objects to each of which singly it would be over-reading to attribute particular symbolic meaning, but which together are made through the breathless syntax to exhale, despite their intrinsic beauty, an unmistakable air of anxiety.

The sense that Luk, the arranging character, has of a lack of order in his existence comes across in sentence patterns based not on any kind of logical link but on mere

[32] Byatt, *Whistling Woman,* 176.

accretion. Most important, perhaps, Byatt chooses to place these objects under a par-
ticular light, the light of oil lamps that bring out their shapes and the reflecting sur-
faces in ways highly reminiscent of painted still lifes. Jacqueline will not appreciate
them, but a later arrival, Frederica, will see their beauty and accept them for what
they are, both physically and as reflections of Luk's character. Part of Luk's problem
is that his scientific interest in organisms that reproduce by nonsexual means imposes
a different kind of order on his awareness of what he is doing here. He sees himself
as a bowerbird, that compulsive collector that gathers objects together merely in or-
der to attract females long enough to mate with them before ejecting them in favor
of other females. Luk's collecting impulse is thrust into further prominence by the
analogies he perceives between his own actions and those of animals: "male birds,
strutting and bowing, with worms, with gobbets of flesh, with wriggling silvery fish
and eels. Waving rumps, distended throat-balloons, perky crests."[33]

This is Benjamin's conviction of the relationship between collector and analogist
writ uncomfortably large. But the evocation of anxiety by means of still life objects
indicates how powerful a method Mallarmé's "paint not the thing but the effect it
produces" can be, and points to another form of evocation, that of the self. Indeed,
as the next chapter shows, still life can also be a form of self-portrait, both in words
and in images.

[33] Ibid., 180–81.

4

PORTRAIT OF THE AUTHOR
AS STILL LIFE

The glass chose to reflect only what he saw
Which was enough for his purpose: his image
Glazed, embalmed, projected at a 180-degree angle.

ASHBERY, "Self-Portrait in a Convex Mirror"

Rainer Maria Rilke, in his remarkable series of letters on Paul Cézanne, offers the following telling response to one of the painter's self-portraits:

> How great this watching of his was and how unimpeachably accurate, is almost touchingly confirmed by the fact that, without even remotely interpreting his expression or presuming himself superior to it, he reproduced himself with so much humble objectivity, with the unquestioning, matter-of-fact interest of a dog who sees itself in a mirror and thinks: there's another dog.[1]

The ability to see oneself as object, through transforming oneself from the subject who watches into the object simultaneously watched and watching, proves to be essential if not inevitable for every artist, as for every writer, who tackles the task of

[1] Rilke, *Letters on Cézanne,* 85.

giving us a self-portrait, or more generally a portrait of the artist. In this regard, moreover, the Italian maxim according to which *ogni dipintore dipinge se* (all painters paint themselves and thus each portrait of the other is also a portrait of the self) seems particularly apt.

According to Yves Bonnefoy, indeed, in his 1999 book, *Lieux et destins de l'image,* which offers us a wonderfully seductive reflection of his poetry course at the Collège de France, "all great artists, even those eager to know the Other, operate and repeat choices that capture them in the network of their own language, transforming portraits into self-portraits, their *eros* which is the staging of the self, disturbing their perception of the object."[2] The best one might hope for, it seems, in this vision of a world in which no one, whatever the medium chosen, can escape from the noose of language (language used here in its broadest meaning of a network of signs), is a conscious awareness that there is no *hors-moi,* no means of escaping that staging of the self.

Jasper Johns illustrates these ideas with disconcerting simplicity in his *trompe l'oeil* still life *Souvenir* of 1964 (collection of the artist, reproduced in Ebert-Schiferer, 385), in which he sets against a roughly painted blackboard, and projecting out from it on a small shelf, a Japanese souvenir plate with his photograph from an automatic machine (the work of art in the age of mechanical reproduction, as Benjamin would say). Apparently hanging from the blackboard are a flashlight, for illuminating distant views, and a rear vision mirror. Caught between *trompe l'oeil* and self-portrait, as between the future suggested by the flashlight and the past epitomized by the rear-view mirror, Johns, like his painting, presents the viewer with a blank black surface onto which we are challenged to project our own images. It is a playfully ironic depiction of the way in which we look at others, focused above all by a clever deployment of familiar objects.

What happens when the object is taken as the subject of a painting or a written text? What if still life, restored to something of its former value for our era above all by Manet and Cézanne following in the steps of any number of realists and impressionists, were not so much that somewhat despised genre, the genre relegated to the lower echelons of the artistic canon, but rather an opportunity that is at once subtle

[2] Yves Bonnefoy, *Lieux et destins de l'image* (Paris: Seuil, 1999), 165.

and subversive for commenting on society, the individual, the division of male and female tasks, or other elements that shape and delimit the individual within a particular moment and society? The heterogeneous grouping of objects in Alphonse Legros's *Portrait of the Artist's Father* (1856: Musée des beaux-arts de Tours), the folded sheet of paper, the inkwell, the key, the knife, the pencil, and the quill, quietly reinforce the suggestions more obviously embedded in the father's scholarly pose and his absorption in his task. Manet's *Hat and Guitar* (1862: Musée Calvet, Avignon), conceived as a decoration over the entrance to the artist's studio, is, as George Mauner asserts, "an effective condensation of Manet's Hispanophilia and an announcement of the transfer of the spirit of Spain to his own studio in Paris," a self-portrait as effective as, and arguably more evocative than, a standard head and shoulders, because that can show only a physical reality rather than a reflection of a mind or temperament.[3] Or we might take by way of example the Australian modernist Nora Heysen's eminently self-possessed self-portrait of 1932 (fig. 8). What seizes the viewer's attention, in addition to that highlighting of woman as a force of nature that is typical of Nora Heysen's work, is that little still life incorporated into the portrait as a *sotto voce* commentary both on the painting and on the traditional image of male and female roles. Gathered together at the bottom of the canvas, these objects—which at a first, cursory, glance recall the teacups and wine bottles that are the attributes of woman as servant or as woman, precisely, of the interior space—prove on closer inspection to be instruments of work, the brushes and tubes of paint that define the woman not merely as the painted object but also as the painting subject, painting herself at once as individual and as professional. The little still life asks therefore to be read as a self-portrait stepping on stage to overthrow preconceived notions both of the hierarchy of artistic genres and of the function of the object, and it makes its own contribution to the self-portrait in which it initially seems such a small element.[4]

One purpose of this book is to explore the presence of still life as a commentary that may be understated but that is all the more potent for being that quiet voice. Be-

[3] George Mauner, *Manet: The Still Life Paintings* (New York: Abrams, 2001), 54.

[4] On Nora Heysen, see Lou Klepac's exhibition catalogue, *Nora Heysen* (Canberra: National Library of Australia, 2000), and his *Nora Heysen* (Sydney: Beagle Press, 1989).

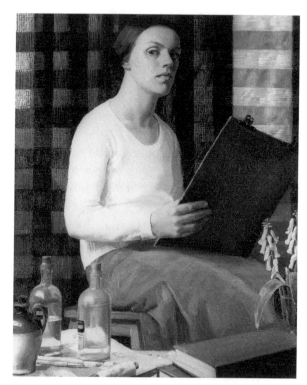

FIGURE 8. Nora Heysen, *A Portrait Study,* 1932. Collection: Tasmanian Museum and Art Gallery, Hobart.

cause my aim is to investigate the extent to which the still life can act as a mirror reflecting both author and reader, artist and viewer, I turn now to an analysis of ways in which certain written still lifes are also self-portraits. After all, despite its primary focus on the object, any still life, written or painted, is also at some level a portrait of the artist, if merely through the choice of objects depicted, their disposition, and the attention paid to highlights and emphases created by light or shadow. Moreover, a strong tradition going back at least to seventeenth-century Dutch painted still lifes includes a tiny reflected image of the painter at work on the painting, caught on the surface of a jug or in a mirror or, more obliquely, conveyed through a manuscript letter or signature in depictions of letter racks, or in a *trompe l'oeil* photograph, as in John Frederick Peto's *Toms River* (1905: Museo Thyssen-Bornemisza, Madrid).[5] Thus, Margaret Preston's *Still Life with Teapot and Daisies* (c. 1915; fig. 9) with its tea set and its vase of flowers arranged under a blazing summer sun, shows us the artist reflected on the bulging surface of the teapot, painting under the protection of a white sunshade. As Baudrillard asserts, "Like the source of light, the mirror is a privileged place in the room. As such, wherever it appears in well-heeled domesticity it plays an ideological role of redundancy, superfluity, reflection. [. . .] We could say more generally that the mirror, an object of symbolic value, not only reflects the features of an individual, but accompanies in its rise the historical rise of the individual consciousness."[6] The presence of a reflective surface in a still life offers the possibility both of an affirmation of personal and social identity and of a symbol of that individual consciousness. Moreover, most of the mirrors in still lifes are not straightforward mirrors, but convex or concave forms, frosted or misted surfaces on which appears a deliberately distorted but all the more suggestive reflection. As Pär Lagerkvist's disturbing dwarf claims—self-reflectively, because he himself is a distorting mirror—"human beings like to see themselves reflected in clouded mirrors."[7] Written still lifes also have the capacity to be portraits and self-portraits,

[5] On these, see, for instance, Celeste Brusati, "Still Lives: Self-Portraiture and Self-Reflection in Seventeenth-Century Netherlandish Still-Life Painting," *Simiolus* 20, 1 (1990–91): 168–82, and Jonathan Miller, *On Reflection* (London: National Gallery Publications, 1998).

[6] Baudrillard, *Le Système des objets,* 31. See also Taylor, *Sources of the Self.*

[7] Lagerkvist, *The Dwarf,* 225.

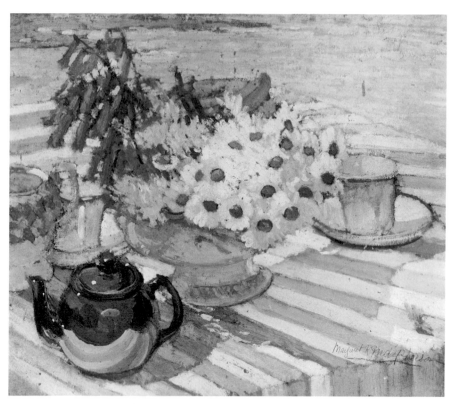

FIGURE 9. Margaret Preston, *Still Life with Teapot and Daisies,* c. 1915. Oil on hardboard, 44.5 × 51.2 cm. Gift of the W. G. Preston Estate 1977. Collection: Art Gallery of NSW. © 2003 Artists Rights Society (ARS), New York / VISCOPY, Sydney. Photograph: Christopher Snee for AGNSW [acc# 192.1977].

frequently seen through some distorting or clouded medium, some limited vision that both confines our vision and challenges us to perceive more.

Thus, in an unexpected *mise en abyme* embedded within the novel *A Whistling Woman*, A. S. Byatt depicts a moment in a television show in which her character, Frederica Potter, sits with her guests at a table set for a tea party. "A huge silver teapot could be shown to be mirroring the three faces, like a distorting mirror in a gallery, making Frederica into a beaky witch, Miller into a curly Bacchus with great cheeks, and Gregory into a cavernous Pluto. On the tea-table were various dishes, silver and glass, which turned out to contain caterpillars walking on mirrors, segmented, striped and bristling, with sooty eyes and horny proboscis, orange, gold and green."[8] One of the many self-reflexive jokes in this exuberantly postmodernist episode is that the "Miller" referred to is Jonathan Miller, whose exhibition and catalogue on mirrors and reflection, *On Reflection* (London: National Gallery Publications, 1998), had appeared at the time Byatt wrote this passage but not yet at the text's moment of 1968.[9]

What I want to explore in this chapter are the ways in which the reader is invited, provoked, or challenged to look beyond the mirror that a still life projects on the outer world and to contemplate what is being suggested about the inner world on which that still life also, if less self-evidently, reflects. While we might be tempted to glance too quickly at what is offered, letting our eye rest on the bloom on the fruit, we should also notice the worm already active in the flesh, the caterpillars within the various reflective dishes.

In that great novel of evil and creative genius, *Doctor Faustus* (1947), for example, the German writer Thomas Mann includes a brief passage that is both a tiny still life and a portrait of the artist. Drawing on many still lifes whose subject matter is the attributes of literature and music (one thinks, for instance, of Anne Vallayer-Coster's 1769 *Attributes of Painting, Sculpture, and Architecture* [Louvre, France], with its palette, its sculpted head, its plaster torso and its scrolls and folios, or of William

[8] Byatt, *Whistling Woman*, 141.

[9] Of course, Miller's interest in reflection was already in evidence then, but this does not reduce the ludic element created by the complex time schemes, a further essential element not only of this novel but also of the tetralogy to which it belongs.

Michael Harnett's 1889 *The Old Cupboard Door* [Sheffield Galleries, England], with its violin and bow, its scores, its books, and its *vanitas* motifs of candle and faded rose),[10] Mann sketches the books and drafts on Adrian Leverkuhn's table and lectern in what is also a sketch of Leverkuhn's personality:

> On the table lay a few books: a small volume of Kleist, with a bookmark inserted at the essay on marionettes, plus the inevitable sonnets of Shakespeare, and another volume of plays by the same poet—*Twelfth Night* was one, *Much Ado about Nothing,* and if I am not mistaken, *Two Gentlemen of Verona.* What he was working on at present, however, lay on the lectern—loose sheets, rough drafts, beginnings, notations, sketches at various stages of completion.[11]

Sources of inspiration and modes of working are offered here as a shorthand depiction of the artist, a depiction that the reader is subtly invited to explore, expand, and analyze. The narrator's self-deprecatory nature, recalled in that little insertion "if I am not mistaken," reminds us that we are seeing all this from the outside, mediated by someone else's sympathetic but limited vision. It is a passage that suggests a portrait in the guise of a still life, one based on the things that define the artist as artist but that also, albeit obliquely, reveal something about Mann as artist too.

Furniture and interiors can play a similar role, reflecting on the individuals and social classes that have selected them, as Baudrillard argues when he maintains that "the configuration of the furniture is a faithful image of family and social structures of an epoch,"[12] or as Balzac insists in *Le Père Goriot,* when he underlines the way in which Mme Vauquer and the boardinghouse she runs reflect each other, and as E. M. Forster hints when he describes his character Stephen in *The Longest Journey* (1907) as "extremely sensitive to the inside of a house, holding it an organism that expressed the thoughts, conscious and subconscious, of its inmates."[13] That sensitivity can be replicated by a particularly acute attentiveness that a written passage

[10] Reproduced in Ebert-Schifferer, *Still Life,* 257, 273.

[11] Mann, *Doctor Faustus,* 312.

[12] Baudrillard, *Le Système des objets,* 21.

[13] E. M. Forster, *The Longest Journey* (1907; reprint, Harmondsworth: Penguin, 1967), 159.

may stimulate in the reader by its focus on what might at first seem banal, quotidian, even trivial.

Romantic poets may well, as M. H. Abrams so powerfully puts it, have been engaged in revealing "the charismatic power in the trivial and the mean,"[14] but those who followed them, however much they were determined to show the trivial and the mean precisely as trivial and mean, were also, in their very different ways, revealing its charismatic and revelatory power. For post-Revolutionary poets, the revalorization of the self that can be seen illustrated with such force in a wide array of poems from Wordsworth's "The Prelude" or Byron's "Childe Harold" or Hugo's "Tristesse d'Olympio" to Baudelaire's "Les Sept Vieillards," informs, either in serious vein or in more ironic or even parodic terms, a whole series of poems that at first seem to offer us nothing more than little still lifes depicting humdrum objects. If capturing the moment is in part the purpose of still life, some of these apparently banal still lifes invite or at least support readings that throw into question readerly preconceptions of the genre as the domain of the object. After all, as the self-portrait series of a Rembrandt or a Van Gogh make movingly clear, portraits are also concerned with capturing the moment.

Baudelaire's poem devoted to an everyday object, "La Pipe" (1857), for instance, seems to lend itself willingly to being "overlooked," to use Norman Bryson's term, hidden as it is in the section of "Spleen et Idéal" between the great love poems and the more specifically splenetic poems—and more precisely between "Les Hiboux," with its illustration of the general human characteristic that "l'homme ivre d'une ombre qui passe / Porte toujours le châtiment / D'avoir voulu changer de place"[15] (man, intoxicated by a shadow that passes, / Bears forever the punishment inflicted / for having sought to change places), and "La Musique," in which the maritime images seem to set up in rivalry with those of Hugo and Wagner in suggesting what the great poet can do when trespassing into other genres, seascapes, and still lifes among them. But this irregular sonnet, which returns to a well-worn motif both of poetry and of still lifes, appears not so much to mark a weak beat as to present itself

[14] M. H. Abrams, *Natural Supernaturalism: Tradition and Revolution in Romantic Literature* (New York: Norton, 1971), 391.

[15] Charles Baudelaire, *OEuvres complètes,* ed. C. Pichois (Paris: Gallimard, 1976), 1:67.

as an essential link between the commentary on humanity in general that we find in "Les Hiboux" and that exploration of an ardently individual taste that dominates "La Musique."

It is the pipe that is held to speak here, or perhaps it is the poet transformed into pipe, but in the same spirit as Magritte's title "Ceci n'est pas une pipe" one could maintain that what speaks here is the poem, a poem whose only function then would be to rock the master's soul, inducing an intoxication that is utterly different from that of the intoxicants offered by the artificial paradises, those of wine, hashish, or opium. As matchmaker bringing together the individual and his pleasure, the pipe also links the mouth to the external world, serving as a conduit for the poet's exhalations just as the poem itself does.

> J'enlace et je berce son âme
> Dans le réseau mobile et bleu
> Qui monte de ma bouche en feu,
>
> Et je roule un puissant dictame
> Qui charme son coeur et guérit
> De ses fatigues son esprit
>
> [I wrap myself around his soul
> And rock it in a moving web,
> A net of blue that from my mouth
> Climbs upward from its bed of fire,
> And rolls a powerful dittany
> That charms his heart and heals it of
> The weariness that plagues his mind.][16]

Just as the poet wraps the reader in the web of his words, so the pipe, with its powerful herb, wraps the poet in its smoke. The final rhyme, moreover, where *guérit* locks with *esprit* to liberate the word *rit,* meaning "laughs," thus whispers to us the possibil-

[16] Ibid., 1:68.

ity of reading this poem as game, a game that would have as its ostensible object that of offering us an apparently banal and impersonal subject, but that proves on closer inspection to present the portrait not of a pipe but rather of a poet and of poetry itself.

The youthful Mallarmé, great admirer of Baudelaire that he was, clearly did not allow the smoke to dim his vision when he offered his own variant on the motif of the pipe. His prose poem, which is titled simply "La Pipe" (1864), could have allowed Proust, if only he had been less eager to seize a stronghold for himself through attacking the obscurity of the symbolist movement,[17] to discover a madeleine *avant la lettre:* "I had not touched the faithful friend since my return to France, and all of London, London as I lived it entirely and for myself alone, a year ago, emerged."[18] The pipe that offers a direct link to memory, an attribute of the poet that lends itself to be read by metonymy as the poet himself, therefore sets before us yet another portrait of the artist as still life.

Even more striking as still life transforming itself into self-portrait is the erotic and melancholy poem "Surgi de la croupe et du bond," which dates from 1887, eight years after the death of Mallarmé's young son Anatole, of whom the poet was to say in the notes he scribbled down for a never-completed commemorative memorial poem that he was the "son re-absorbed, not gone."[19] "Surgi de la croupe" evokes a still life that, if it could be completed, would have as its subject the traditional theme of flowers in a vase depicted by so many of Mallarmé's artist friends, from Renoir and Redon to Manet and Monet. But despite the energy of the opening lines, the vase's "col ignoré s'interrompt" (ignored or overlooked neck stops short) without achieving its offering of flowers. The narrative voice in the second stanza—as it happens, the voice of the sylph, that spirit of the air that would have found its physical manifestation in the flowers produced by the vase—explains this absence in the following terms:

> Je crois bien que deux bouches n'ont
> Bu, ni son amant ni ma mère,

[17] See Proust, *Contre Sainte-Beuve,* 393–95.
[18] Mallarmé, *OEuvres complètes,* 1:419.
[19] Ibid., 1:515.

Jamais à la même Chimère,
Moi, sylphe de ce froid plafond.

[I well believe two mouths have never,
Neither her lover's nor my mother's,
Drunk from a fantasy they were sharing,
I, sylph of this cold ceiling.]

The notes prepared for a never-completed poetic monument for Mallarmé's young son Anatole open on a commentary that is just as bitter as the evening summoned up in the sonnet's first stanza: "Child issued from the two of us—showing us our ideal, the path—showing us! Father and mother who survive him in our sad existence, like the two extremes—poorly linked in him and moved apart—hence his death—canceling this little childhood being."[20] The pure vase therefore offers itself not just as an idealized still life but, more important, as a symbol of Mallarmé himself and of the poet in general, who, through his failure to find the ideal beloved, the one who would share the same fantasy, produces only a sylph in lieu of a child, and in lieu of a work of poetry, merely the announcement of "une rose dans les ténèbres" (a rose in the shadows), one of those innumerable flowers doomed to blush unseen, as Baudelaire had put it in a line appropriated from Thomas Gray.[21] If Mallarmé was never able to complete his great memorial monument for the lost child, the little still life of "Surgi de la croupe" nevertheless asks to be read as the vase that collects the child's ashes and portrays the poet as grieving father.

The extraordinarily inventive Jules Laforgue, whose premature death deprived French poetry of one of its most original and imaginative voices, takes up the image of vases and ornaments to depict himself in his sardonically witty still life "Complainte des pubertés difficiles":

Un éléphant de Jade, oeil mi-clos souriant,
Méditait sous la riche éternelle pendule,

[20] Ibid., 1:516.
[21] In Baudelaire's poem "Le Guignon" (Ill Luck).

Bon bouddha d'exilé qui trouve ridicule
Qu'on pleure vers les Nils des couchants d'Orient,
Quand bave notre crépuscule.

Mais, sot Eden de Florian,
En un vase de Sèvre où de fins bergers fades
S'offrent des bouquets bleus et des moutons frisés,
Un oeillet expirait ses pubères baisers
Sous la trompe sans flair de l'éléphant de Jade.

A ces bergers peints de pommade
Dans le lait, à ce couple impuissant d'opéra
Transi jusqu'au trépas en la pâte de Sèvres,
Un gros petit dieu Pan venu de Tanagra
Tendait ses bras tout inconscients et ses lèvres.

Sourds aux vanités de Paris
Les lauriers fanés des tentures,
Les mascarons d'or des lambris,
Les bouquins aux pâles reliures
Tournoyaient par la pièce obscure
Chantant, sans orgueil, sans mépris:
"Tout est frais dès qu'on veut comprendre la Nature."

Mais lui, cabré devant ces soirs accoutumés,
Où montait la gaîté des enfants de son âge,
Seul au balcon, disait, les yeux brûlés de rages:
"J'ai du génie, enfin: nulle ne veut m'aimer."[22]

[A jade elephant with half-shut smiling eye
Meditated under the rich eternal clock,
A good, exiled Buddha who thinks it ridiculous

[22] Jules Laforgue, *OEuvres complètes* (Lausanne: L'Age d'homme, 1986), 1:564–65.

To cry towards the Niles about Oriental sunsets
When our twilight is slavering.

But, a fool from Florian's Eden,
In a Sèvres vase where delicate pale shepherds
Offer themselves blue bouquets and curly sheep,
A carnation expired its pubescent kisses
Under the unsmelling [*sans flair*] trunk of the Jade elephant.

To these shepherds painted with pomade
In milk, to that powerless opera couple
Frozen unto death in the Sèvres paste,
A fat little Pan from Tanagra
Held out his utterly unconscious arms and lips.

Deaf to the vanities of Paris,
The faded laurel wreaths of the hangings,
The golden masks of the walls,
The books with their pale bindings
Circled through the dark room
Singing, without a trace of pride, without scorn:
"Everything is fresh once you are willing to understand Nature."

But he, upright before those accustomed evenings
Full of the gaiety of children of his age,
Alone on the balcony, said, his eyes blazing with rage:
"I am a genius, at last: no woman wants to love me."]

Here the accumulated bric-a-brac, the random *objets d'art* of the type frequently as-
sembled in still lifes, take on a life of their own, offering an ironic commentary on
what Laforgue perceived as his own cliché-ridden self. Laforgue as exile pondering
on what he once termed "éternullité"[23] is here sardonically transformed into the jade

[23] Ibid., 1:547.

elephant meditating on "la riche éternelle pendule" (the rich eternal clock) unable to smell the carnation in the Sèvres vase beneath him. "When it's a question of poetry, we should be as distinguished as carnations; we should say everything, everything (it's indeed above all the foul things of life that ought to shed a humorous melancholy over our verse) but we should say these things in a refined manner,"[24] he proclaimed in a letter to his sister Marie, but here the elephant appears too refined to possess the flair necessary for any transformation of the hackneyed Eden the vase presents. The Tanagra Pan, the wall hangings, the gilded masks that embellish the paneling, and the elegantly bound books all add to this sense of a superfluity of objects, all signifying nothing but convention. Unnatural representations of nature, they are shown singing with neither pride nor scorn of the rewards that come to those who study nature.

But if the poem's central persona is thus surrounded by still life objects whose clichéd presence might seem to offer him a background against which to proclaim his own originality, Laforgue is far too wily and far too mocking to allow so facile a solution. Instead, the sophism of his discovery that because no woman loves him he must therefore be a genius, is presented as just another in the long list of trite objects and hackneyed phrases. This is the Laforgue who realized that, unlike Rimbaud, whom he admired for being so remarkably free of attachments to earlier poets,[25] his own originality would have to come from renewing and thus liberating clichés, as his emblem, the *orgue de barbarie* (street organ), implies.

Just as traditional a subject for still life as the pipe or vase of flowers or accumulated knickknacks, dead fish are also to be discerned among poetic as well as painted still lifes. The realist painter Gustave Courbet had depicted himself in the form of a dying trout shortly after being released from prison in 1872, where he had been held on political grounds (fig. 10). He backdated the painting to 1871, during the period of his imprisonment, and inscribed on the lower left-hand side the expression *in vinculis faciebat* (he made it while in chains), reinforcing by these two extra-diegetic devices the autobiographical nature of the picture. The glittering trout, gasping out its

[24] Ibid., 1:821.
[25] Ibid., 1:851.

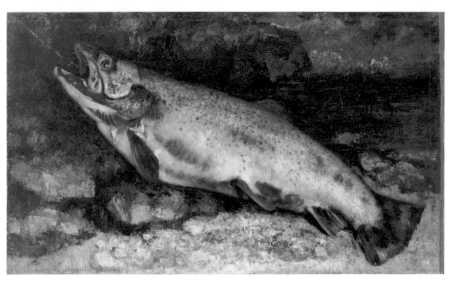

FIGURE 10. Gustave Courbet, *The Trout,* 1871. Oil on canvas, 52.5 × 87 cm. Kunsthaus Zürich. © 2003 Kunsthaus Zürich. All rights reserved.

life in the alien element of the air, offers a potent if histrionic depiction of the painter bound in chains in the alien world of the prison.

A similar play is found in the work of the Belgian artist James Ensor, who on several occasions depicts himself, through a pun on his name, as a *hareng saur* (herring). This is part of what Sybille Ebert-Schifferer refers to as his "habit of referring to his own situation in terms of symbols. [. . .] Specific motifs are constantly repeated in different pictures, among them simple household objects such as a blue pitcher and objects like the Chinese knickknacks and masks that Ensor, having inherited his mother's souvenir shop, actually kept on his mantelpiece. What therefore appear to be only recapitulations of the traditional Netherlandish collection still life are in fact highly personal paintings."[26] In *Still Life with Chinese Knickknacks* (1906–7: Koninklijk Museum von Schone Kunsten, Antwerp) we see the grimacing mask that dominates so many of Ensor's works and stands for his own fears as he confronts an uncomprehending or at least unappreciative public. But the mask itself is only one of the images Ensor offered of himself. His comic painting *The Dangerous Cooks* (1896: private collection, Antwerp) shows a waiter bearing a tray on which is placed Ensor's head, labeled "Art Ensor," and next to the head, a herring. The pun here on the pickled herring (in French *hareng saur)* and on its partial homophone "Ensor" is thus both visual and legible, a further invitation to the viewer to decipher the still life. It is a painting that makes clear the implications of an earlier work, *Still Life with Blue Pot)* (fig. 11), in which a herring lies on a white marble slab next to a pipe and a group of playing cards, those symbols of time disappearing in smoke and frivolous activities, together with the arbitrary nature of human destiny.

Two writers at the end of the nineteenth century took up the challenge of appearing in the guise of a pickled herring, or *hareng saur:* Mallarmé's friend Joris Karl Huysmans and a somewhat lesser-known poet, Tristan Klingsor, whose choice of the theme is in part determined by a play on his name, similar to the one Ensor makes on his name.[27]

In his collection *Le Drageoir à Epices* (The Spice Box), published in 1874, Huys-

[26] *Still Life,* 321.

[27] In addition to these examples, Charles Cros devotes a typically idiosyncratic poem to the "Hareng saur" in *Le Coffret de santal* (Paris: Garnier-Flammarion, 1979).

FIGURE 11. James Ensor, *Still Life with Blue Pot,* 1890–91. Staatsgalerie Stuttgart. © 2003 Artists Rights Society (ARS), New York / SABAM, Brussels.

mans apostrophizes in the following terms a herring that is brought into being by the apostrophe itself:

> Your coat, O herring, has the palette of setting suns, the patina of old copper, the burnished gold of Cordovan leather, the shades of sandalwood and saffron offered by the foliage of fall!
> Your head, O herring, flames like a golden helmet, and your eyes could be black nails hammered into copper rings! [. . .]
> O smoked one, glittering [*miroitant*] and dull, when I gaze on your coat of mail, I think of Rembrandt's paintings, I see again his superb heads, his sun filled flesh, the sparkles of jewelry on black velvet; I see again his burst of light in the night, his trails of gold powder in the shadows, his explosions of suns under black archways.[28]

The key to the poem is handed to us by Huysmans himself, first in the use of the word *miroitant,* in which the concept of something glittering is linked to the idea of the mirror and which is signaled as important by its apparently contradictory juxta-position with "dull," and in the evocation of the painting of Rembrandt, which is also an invitation to us to remember that long and moving series of self-portraits in which the superb heads are those of the artist himself, observed and analyzed over the course of time. The herring, Huysmans indicates, offers just as valuable a mir-ror of the artist as more traditional self-portraits might do in its refraction of light and its associated invitation to dream. But there is, I believe, something else to be seen in this Huysmansian herring: there is something in the rhythm and in the tech-nique that recalls, in a curiously offbeat, one might even say fishy, way a prose poem by Baudelaire, "Un Hémisphere dans une chevelure" (A Hemisphere in a Head of Hair), thus strengthening the parallel between the object illuminated by the still life, on the one hand, and, on the other hand, the poet, either specific or general: "In the ocean of your hair, I glimpse a port bustling with melancholy songs, with vigorous men from all nations, and ships of every shape silhouetting their fine and complex architecture against an immense sky in which eternal warmth loafs."[29] Huysmans's

[28] Bernard Delvaille, *La Poésie symboliste* (Paris: Seghers, 1971), 111–12.
[29] Baudelaire, *OEuvres complètes,* 1:300.

parody, in which the beauty of the head of hair is replaced by the less conventional attractions of the herring, seems moreover less directed against Baudelaire, who can gaze into hair and see the beauty of an exotic port, than against Huysmans himself, for whom such dreams of light derive more humbly from the dead fish lying on his breakfast plate. Parody, in other words, can also become self-portraiture.

This parodic aspect can also be found in another fin-de-siècle herring. Klingsor's still life, a prose poem that seems very obviously to offer itself simultaneously as a notional ecphrasis and as an exploration of the way in which simile operates, also presents itself as the meeting between light and vision, what makes sight possible and the one who sees:

> It's a warm light that filters through the ogival casement window into this dark kitchen from which the servant has left, and sheds on the things that no longer feel themselves under surveillance the air of a scene by Hoffmann.[30]
>
> It lights the apples, as scarlet as little girls from Normandy, and the carrots wearing on their heads the red bonnets of grenadiers with their long green plumes, and the onions as coppery as the guillotined heads of Japanese bonzes with a tuft of hair on the top of their gleaming, bald skulls.
>
> It lights the round squashes, as brown as sketches of African women, and the overturned cabbages, their roots in the air like marionettes in crinolines swollen with skirts, and the coconut with its hairy bark, like a monkey's behind.
>
> But it leaves in the shadow a fine, elegant vase from which rises a rose that looks like the shaggy head of a princess emerging from a silk dress, a sweet Chinese princess who awaits no doubt, by way of lover, some midget mushroom hidden under his white mandarin's umbrella.
>
> And the herring with its thin, multicolored stomach, the bloater stretched out nonchalantly on a flower plate and looking like an old gentleman with a pointed face and a brightly-colored satin waistcoat, the thin herring remains motionless beside a map of Sicily depicted by a pink cutlet, and he calmly watches all this with his little round sardonic eyes in the circles of their golden glasses.[31]

[30] The German writer E. T. A. Hoffmann enjoyed a considerable vogue in nineteenth-century France; see, for instance, my *Baudelaire et Hoffmann: Affinités et influences* (Cambridge: Cambridge University Press, 1978).

[31] The poem's title is "Nature morte." Delvaille, *La Poésie symboliste,* 384–85.

If the main character here is undeniably light itself, which comes on stage in the first paragraph, the one who watches and who tells, the one who, in other words, represents both the poet and the reader, is the herring on which the poem ends. And if the admittedly and determinedly mechanical process that transforms each object into a person seems therefore to offer a highly ironic judgment on the transformation that often lies at the very heart of poetry, it is also this mechanism that allows the entry of the poet disguised as dead fish, as *hareng saur.*[32] A poem on vision and on poetic transformation, this short piece, so it seems to me, also offers a meditation that is just as sardonic as the dead fish's eyes on the poet's fall from the visionary evoked by Hugo, down through Baudelaire's ragpicker, Banville's circus performer, and Mallarmé's chastised clown, to the *fin de siècle*'s reduction of the poet to herring.

With Francis Ponge, writing in the wake of the First World War, the metaphor has become even more humdrum. Just as Ensor and Klingsor played on their names to provide still life images of themselves, or at least of their artistic and poetic personae, so Ponge plays on the similarities between his name and the French word for sponge (*éponge*) to produce an image of the poet as undiscriminating imbiber of everything around him. His counterpoint in the little prose poem he devotes to this notion is the orange, a word also partly reminiscent of his name but suggesting an object familiar to still lifes and kitchens alike that when squeezed gives only one liquid. While this liquid is both colorful and rich in smell and taste, it is, the poem suggests, a less varied and all too passive response to the oppressor than that of the sponge. Ponge's still life is not just about the objects, though; as the puns suggest, it is also very much about language, about how links can be made between the thing and the name by which it is known:

> As in the sponge there is in the orange an aspiration to regain countenance after suffering the trial of expression. But where the sponge is always successful, the orange never is: for its cells have burst asunder, its tissues have been torn apart.

[32] Van Gogh's letters add a further, curious, twist to this series of depictions as *harengs saurs,* or bloaters: "I gave [Signac] as a keepsake a still life which had annoyed the good gendarmes of the town of Arles, because it represented two bloaters, and as you know they, the gendarmes, are called that" (Van Gogh, *Letters,* 3:143).

Whereas the peel alone flabbily restores itself to its former shape, thanks to its elasticity, an amber liquid has been spilt, accompanied, certainly, with refreshment and pleasant smells—but often too with a bitter consciousness of a premature expulsion of pips.

Must we decide between these feeble responses to oppression?—The sponge is merely a muscle and fills itself with wind, clean water, or dirty water according to circumstance: an ignoble gymnastics. The orange shows better taste, but it's too passive,—and that odorous sacrifice—that's really sucking up too much to the oppressor.

But it is not sufficient in speaking of the orange to recall its special way of scenting the air and rejoicing its torturer. One must stress the glorious color of the resulting liquid which, better than lemon juice, forces the larynx to open wide for the pronunciation of the word as for the ingestion of the liquid, without any apprehensive grimace of the fore-mouth whose taste buds it does not set on edge.

What's more, words can't be found for confessing the admiration aroused by the envelope of the tender, fragile, pink oval balloon in that thick damp blotting-paper whose extremely thin but highly pigmented epidermis, sharply tasty, is just rough enough to cling worthily on to the light that falls on that perfect shape of the fruit.

But at the end of an all too brief study, rounded out as far as possible, you have to come to the pip. This seed, in the shape of a minute lemon, offers on the outside the color of the white wood of a lemon tree, and on the inside a green the color of peas or tender seeds. It is in the pip that can be found, after the sensational explosion of the Chinese lantern of flavors, colors, and smells that make up the fruity ball itself,—the relative hardness and greenness (not moreover entirely insipid) of the wood, the branch and the leaf: which when all is said and done is very small, although it is certainly the fruit's reason for existing.[33]

Ponge's imaginative transformation of the orange here, which is also a meditation on poetry, depicts the poet and his poem absorbing the world, yielding up their bounty to the reader willing to put pressure on it, existing only for the wood, the branch, and the leaf that might arise from the little kernel, the little stimulus to the imagination, that they offer. What, Virginia Woolf might have asked, had she read Ponge's poem, can one orange not be?

[33] Ponge, *OEuvres complètes,* 1:19–20.

A transformation of the object into subject in the hands of Baudelaire, an exploration of a child's death in the writing of Mallarmé, a sideways glance at cliché for Laforgue, a showcase for poetic procedures for Huysmans and Klingsor, and in a very different way for Ponge, the portrait of the author as still life takes advantage of its neglected situation to act as annotation, to suggest to an attentive reader the recognition of a truth to which we might have tended to close our eyes. If, as Valéry claims in his best-known poem, "Le Cimetière marin (The Cemetery by the Sea)," "le fruit se fond en jouissance" (the fruit melts into pleasure),[34] in the case of still lifes at least, it is not because of the beauty of their mimetic representation but because that representation pushes us toward the recognition of a deeper truth that may at times be nothing more than the awareness of the worm in the fruit.

Yet what is it that suggests that a still life is more than a depiction of the inanimate? Propertius's loving depiction of the "caerulus cucumis tumidoque cucurbita ventre [. . .] et iunco brassica vincta levi" (the dark-green cucumber, the gourd with the swollen belly [. . .] and the cabbage bound with a flimsy reed)[35] or Virgil's singing in the *Eclogues* of quinces hoary with a delicate down,[36] or Keats's sensuous rendering of the "candied apple, quince and plum and gourd"[37] in "The Eve of Saint Agnes" all pay tribute to the tactile and visual pleasure of objects, but they are not inviting readers to see these objects as self-portraits. Ponge's orange in *Le Parti pris des choses* (1942), on the contrary, leaves us in no doubt: this orange with its desire for expression, for squeezing out its substance, stands in ludic clarity for the poet, even if a closer image still, as the poem suggests in a pun on Ponge's name, would be the sponge, sucking in the world around it as the poet's mind absorbs everything it encounters.

It would seem that the hinge between still life and self-portrait is created partly through the choice of objects. The pipe producing a network of smoke invites parallels with the poet producing a network of words, a parallel strengthened by the

[34] Paul Valéry, *Poésies* (Paris: Gallimard, 1958), 101.

[35] Propertius, *Elegies,* 4.2.43–44 (translation is by Richard Jenkyns in *Virgil's Experience* [Oxford: Clarendon Press, 1999]).

[36] Virgil, *Eclogues,* 2.51–55 (translation is by Richard Jenkyns).

[37] John Keats, *Poems,* ed. Gerald Bullet (London: Dent, 1974), 185.

role the mouth plays in both images. With its knowing and unblinking gaze, the fish focuses attention on the poet's power of seeing and capturing external details. The vase as container—of images or ashes—presents an obvious metaphor for the poet as container of myth, history, and experience. Bric-a-brac suggests a metonymic shift from collection to collector. But in almost all cases there is also some textual indicator, a pun, a word that applies equally to inanimate and animate objects, a playful or mocking reference to another poem, a sudden sharp focus on the act of speaking or writing or observing.

Ponge's ludic prose poems would be too unmistakable for most nineteenth-century manipulators of this subgenre, who aim more at providing for the reader the unexpected pleasure of suddenly detecting the face behind the mask rather than pulling the mask off in the opening lines. The manifest playfulness of Ponge was in any case probably unthinkable to most nineteenth-century poets—there are of course exceptions, like Tristan Corbière, Jules Laforgue, and Marie Krysinska—struggling to find some kind of acceptance or in certain cases to mark their disregard for such acceptance in the portentous seriousness of the Second Empire or the Third Republic. As a result, the nineteenth century's transformation of object into subject is more subtle, more fleeting, perhaps less imaginative and certainly less exuberant, but no less evocative for all that. The twentieth century seems to have had fewer qualms about placing the artistic self on the laboratory table of the still life, and carrying out its aesthetic and psychological investigations in full view of the public.

5

LOOKING IN, LOOKING OUT

OBJECTS IN THE MIRROR

As these still life self-portraits suggest, there are moments when we look at a still life and see, suddenly, not a group of objects submissively waiting for our gaze to fall on them but a subject gazing back at us. Hannah Höch's *Glasses* (fig. 12), for instance, appears to be offering transparency, seems to be a grouping of traditional still life glass objects reflecting back to us our own modes of looking. But look closer and suddenly, caught in one of the vases, there is an inverted image of the artist herself measuring us up, reflecting on our ability to see, overturning not only our expectations but also our image. Such paintings are particularly obvious indications that still life is also a questioning of who looks and who sees that throws into doubt what Robert Hughes refers to as "apprehensible truth,"[1] renders the familiar unfamiliar, and forces us to realize not only that we never see the same object twice but that ob-

[1] Hughes, *Nothing If Not Critical,* 76.

FIGURE 12. Hannah Höch, *Glasses,* 1927. Neue Galerie, Staatliche Museen, Kassel. © Staatl. Museen Kassel.

jects can also be subjects, as capable of looking at us as we are of looking at them. Hannah Höch's glasses are both what is seen and what enables us to look, object and subject, container and contained.

In similar ways, even paintings that do not contain such reflections frequently give the sense that they are looking back at us. Christopher Braider, commenting on Jan Steen's *Oyster-Eating Girl,* suggests:

> The closer we look—and given how small it is, we have to look very closely indeed—the more we realize that the picture *looks back,* driving home how its true subject is neither pleasure nor art taken for themselves, but rather pleasure and art as they exist for the *beholder.* To respond to the work at all, whether in the mode of iconophilic arousal or in that of iconophobic revulsion, is to be implicated in the life it embodies, to be playthings of whatever passions bring us to this magnetic tête-à-tête.[2]

While one might not share Braider's conviction that in this girl's gaze we see the gaze of the modern consciousness, there can be little doubt that many other paintings seem also to gaze directly back, involving the beholder in complex relationships; in their very different ways Manet's *Olympia* and the many iconic images of Christ in which the eyes seem to follow the viewer around the room are cases in point, the second group reinforcing religious orthodoxy (Christ watches [over] you) while the first group challenges orthodox images of female submission.

Some of this awareness of the painting's gaze revolves around what Michael Fried has depicted as a difference between a theatrical art, one that attributes to the viewer an acknowledged and crucial role, and an absorptive art, in which the viewer is not acknowledged and we have the impression that we are spying on, or peeping at, the subject.[3] Even objects in a still life, while they normally constitute absorptive rather

[2] Braider, *Refiguring the Real,* 146–47. This is an argument that others have also developed, one that at the linguistic level works better, as it happens, in French, where the expression "ça me regarde" means both "it looks at me" and "it concerns me."

[3] Although many of Fried's works touch on this topic, his most extended exploration of it is his *Absorption and Theatricality: Painting and Beholder in the Age of Diderot* (Berkeley: University of California Press, 1980).

than theatrical art, can create a painting that appears to gaze directly at us, to reflect back on us, through its subject matter or its treatment.

There is something particularly appropriate to the choice of still life for looking both at gender and at modernist fiction. In terms of gender, the appropriateness comes partly from the association between the conventional subjects of still life and the domestic space to which women have been traditionally relegated. Widespread in antiquity and in the Middle Ages, but long regarded as the lowliest of the pictorial orders, still life, after all, is a genre that, among many other things, seizes the fleeting if banal joys associated with such basic creaturely acts as eating and drinking, or the artifacts that we gather around us in creating a domestic space we call home, acts and artifacts whose care and preparation are linked to the female domain. Its association with the women's sphere also meant that it was more acceptable for women to devote time to still life, rather than to history painting, the highest in the hierarchy. And while painting a naked man might bring opprobrium on the woman artist, naked asparagus and cherries and plums passed muster, whatever they might also be suggesting.[4]

The importance of still life for modernist fiction may seem at first less self-evident than it is for women's art, but I want at this point to recall a quotation from Virginia Woolf that casts a particularly powerful light on links between still life and modernist fiction. It is her well-known assertion that "on or about December 1910 human character changed."[5] Her argument here is subtle and complex, but part of it concerns the need for character to be revealed through internal modes of perception rather than through external details: what she terms the fabric of things, a rewriting, if you like, of Stéphane Mallarmé's famous assertion "paint, not the thing,

[4] Of course, practical concerns also enter into this, given the many periods in history when women were excluded from the life classes that were essential to developing the skills needed for history painting. The long history of women's exclusion from art academies, and particularly from classes teaching students to paint from nude models, has been told by many critics; see, for instance, Griselda Pollock's *Differencing the Canon: Feminist Desire and the Writing of Art's Histories* (London: Routledge, 1999) and her *Vision and Difference: Femininity, Feminism, and the Histories of Art* (London: Routledge, 1988); and Tamar Garb's *Sisters of the Brush: Women's Artistic Culture in Late Nineteenth-Century Paris* (New Haven: Yale University Press, 1994).

[5] Woolf, "Character in Fiction," 3:421.

but the effect it produces,"[6] or Baudelaire's conviction that Delacroix showed how a painting must above all reproduce the artist's intimate thoughts "that dominate the model as the creator dominates the creation."[7] One way of revealing those modes of perception is through shifting the focus to objects that tangentially or metaphorically suggest them, operating a metamorphosis powerful enough to trigger analogous transformations in the mind of the viewer or reader. Throughout the modernist period, women writers and painters were effecting such transformations of how women were constructed in art and literature, and if one of the areas where they did so was in the evocation of objects it is in part as a reaction to male reification of women, the representation of women as objects to be looked at rather than as seeing subjects. For many modernists, after all, something most clearly in flux was the space allotted to women, in art, in literature, and in life. And it is an issue many of them addressed apparently obliquely and metaphorically, through still life, an arena that allowed them to raise the question of the relationship between subject and object, between viewer and viewed, to suggest effects and perceptions rather than describing causes.

If we think of Virginia Woolf, surrounded by painters and art critics, alive to the artistic world of postimpressionism, and vying with her sister to be taken seriously as an artist (she worked standing up, as artists do, to prove to herself and others that she was their equal), we are hardly likely to be surprised to find her putting artists in her novels, Lily Briscoe in *To the Lighthouse* (1927), for instance, or offering us landscapes, as she does so unforgettably in *Orlando* (1928) when she depicts the frozen Thames turning into a raging torrent after a sudden thaw. But she also turns, as her contemporaries so often did, to the enclosed but suggestive world of still life. *Jacob's Room* (first published in 1922) offers several examples, including one that is to my mind especially moving, given that Jacob dies in the Great War.

The objects scattered around Jacob's study in Trinity College, Cambridge, are both a reflection of any student's interests and duties, a random collection of the possessions that in some way define an individual at a particular moment, and a more

[6] Mallarmé, *OEuvres complètes,* 1:663. See chapter 3.
[7] Baudelaire, *OEuvres complètes,* 2:433.

general *memento mori,* a reminder of the transience of those very interests and duties. It could have been a very masculine still life, set within an all-male college (one thinks of Woolf's own encounter with the beadle as she unwittingly walks on a college lawn).[8] But this still life gains its resonance from being seen through female eyes, specifically those of Jacob's mother, in the final brief chapter of the novel. We are not expressly told that Jacob is dead; we just see Betty Flanders imagining that she hears guns booming, and then the last chapter begins with Jacob's aptly named friend Bonamy marveling: "He left everything just as it was. Nothing arranged. All his letters strewn about for anyone to read. What did he expect? Did he think he would come back?"[9] What makes that question so poignant is that, of course, we all think we will come back. Many still lifes seem to invite the same question, suggesting that the owner of the objects we are looking at has stepped away merely for a moment, as in Claude Raguet Hirst's *Companions* of around 1895 (Butler Institute of American Art, Ohio), where pipe and books seem so recently to have been laid down that the tobacco has only just fallen from the pipe bowl onto the table.

Virginia Woolf's narrative voice sums up the emptiness of the room that has lost its inhabitant in the following sentence: "Listless is the air in an empty room, just swelling the curtain; the flowers in the jar shift. One fibre in the wicker arm-chair creaks, though no one sits there."[10] The same sentence appears in the first description of Jacob's student room:

> Jacob's room had a round table and two low chairs. There were yellow flags in a jar on a mantelpiece; a photograph of his mother; cards from societies with little raised crescents, coats of arms, and initials; notes and pipes; on the table lay paper ruled with a red margin—an essay no doubt—"Does History consist of the Biographies

[8] "I found myself walking with extreme rapidity across a grass plot. Instantly a man's figure rose to intercept me. Nor did I at first understand that the gesticulations of a curious-looking object, in a cutaway coat and evening shirt, were aimed at me. His face expressed horror and indignation. Instinct rather than reason came to my help: he was a Beadle: I was a woman. This was the turf: there was the path. Only the Fellows and Scholars are allowed here; the gravel is the place for me." Virginia Woolf, *A Room of One's Own* (1929; reprint, London: Collins, 1977), 7–8.

[9] Virginia Woolf, *Jacob's Room* (London: Hogarth Press, 1990), 173.

[10] Ibid.

of Great Men?" There were books enough; very few French books; but then any-one who's worth anything reads just what he likes, as the mood takes him, with ex-travagant enthusiasm. [. . .] His slippers were incredibly shabby, like boats burnt to the water's rim. Then there were photographs from the Greeks, a mezzotint from Sir Joshua—all very English. The works of Jane Austen, too, in deference, perhaps, to some one else's standard. Carlyle was a prize. There were books upon the Italian painters of the Renaissance, a *Manual of Diseases of the Horse,* and all the usual text-books. Listless is the air in an empty room, just swelling the curtain; the flowers in the jar shift. One fibre in the wicker arm-chair creaks, though no one sits there.[11]

Although these accumulated objects exhale the aura of death that we find in many painted *memento mori* still lifes, the narrative voice's commentary—justifying the absence of French books and explaining the presence of Jane Austen—reduces that sense and imbues the description with a feeling for the personality of the absent owner. That sense of personality is also stamped onto the juxtapositions of books, the *Manual of Diseases of the Horse* cheek by jowl with the Italian Renaissance painters, for instance.

The incredibly shabby slippers, "like boats burnt to the water's rim," recall a still life now very familiar to us, Van Gogh's depiction of a well-worn pair of boots, but they also set up a disquieting echo with the novel's final chapter, when Betty Flan-ders, having lamented that there is "such confusion everywhere"—a cry referring both to the situation within the room and to that in the world at large—asks: "'What am I to do with these, Mr. Bonamy?' She held out a pair of Jacob's old shoes."[12]

Virginia Woolf's still life is a lament for the brevity of life, summed up in dead men's clothes and the pipes and notebooks of the absent. But it is also an exploration of how to read those objects, how, in other words, to *look at* rather than *overlook* still lifes, how to sum up the moment. And the double focalization, through Woolf's eyes (although she urged writers to combine both masculine and feminine characteris-tics) and through those of the dead boy's mother, overlays the still life with a gen-dered subjectivity.

[11] Ibid., 33.
[12] Ibid., 173.

It is revealing to compare this passage with a similar description in E. M. Forster's novel *The Longest Journey,* where Agnes is looking at Rickie's rooms in Cambridge: "On the table were dirty teacups, a flat chocolate cake, and Omar Khayyám, with an Oswego biscuit between his pages. Also a vase filled with the crimson leaves of autumn. This made her smile. Then she saw her host's shoes: he had left them lying on the sofa. Rickie was slightly deformed, and so the shoes were not the same size, and one of them had a thick heel to help him towards an even walk."[13] In this brief and rapidly sketched description we move from a tiny portrait of Rickie perceived through the objects in his room, from the unwashed teacups waiting for the ministrations of the bedder, to the unappetizingly flat chocolate cake, to the copy of the *Rubáiyát* and the unexpected beauty of the autumn leaves. As Agnes's gaze moves from these objects to Rickie's shoe, so the focus shifts from him to her, because her repulsion on seeing the shoe, with its hint of its owner's deformity, turns our attention back to the viewer. The connection Forster is suggesting here is unpleasant, giving a bitter foretaste of the disabling marriage that Rickie will foolishly embark upon with Agnes. The lens[14] we look through here is ground to project a particular image of marriage as something that is both disabling and destructive.

Woolf, using a quite different lens to meditate on the relationship between mothers and sons, provides a further example of a still life when she pauses over a letter that lies, waiting to be read, on a table in an empty house:

> Meanwhile, poor Betty Flanders's letter, having caught the second post, lay on the hall table—poor Betty Flanders writing her son's name, Jacob Alan Flanders, Esq., as mothers do, and the ink pale, profuse, suggesting how mothers down at Scarborough scribble over the fire with their feet on the fender, when tea's cleared away, and can never, never say, whatever it may be—probably this—Don't go with bad women, do be a good boy; wear your thick shirts; and come back, come back, come back to me.[15]

[13] Forster, *The Longest Journey,* 13.

[14] In *Howards End,* Forster on several occasions refers to the glass wall that separates a married couple from their former selves and from the rest of the world.

[15] *Jacob's Room,* 85.

Trompe l'oeil letter racks are a staple of still life, from the Dutch painters of the seventeenth century, through Picasso and Braque to American modernists. One of the functions of such *trompe l'oeil* still lifes is to make us question whether the external world exists outside our own imaginations, whether, in Forster's playful terms from *The Longest Journey,* the cow is there only when we look at her.[16] In other words, if a painting of a letter rack can take the place of a letter rack, what guarantee have we got that the same does not hold true of us as individuals?

In a sense this is true for Woolf's evocation of the unopened letter: the rhetorical gestures ("as mothers do," "mothers down at Scarborough") make Betty and Jacob paradigmatic of mothers and sons everywhere, the letter itself exemplary of all such letters in what it does not and cannot say explicitly but nevertheless conveys to those willing to read between the lines and through the closed envelope. But whereas the painted still life *trompe l'oeil* achieves this by means of a hyperreality that can make the viewer doubt whether what is seen is reality or artifact, specific or general, Woolf's ability to cast doubt on whether the subject has a place in the world is achieved by suggesting endless transferability, by indicating, in other words, that this letter, this mother, and this son stand for and can be replaced by all letters from all mothers to all sons. In a way too that is the function of hyperreality: the painted letter board that represents so perfectly the real letter board suggests the endless transferability between the subject and its representation.

The separation our minds seek to impose between reality and its representation, a separation broken down by hyperrealism, is explored in another passage in *Jacob's Room,* where the narrative voice invites us to

> consider letters—how they come at breakfast, and at night, with their yellow stamps and their green stamps, immortalized by the postmark—for to see one's own envelope on another's table is to realize how soon deeds sever and become

[16] Forster's amusing twist on this philosophical argument in the opening pages of *The Longest Journey* is summed up in these terms: "They were discussing the existence of objects. Do they exist only when there is someone to look at them? or have they a real existence of their own? It is all very interesting, but at the same time it is difficult" (7). In her wide-ranging study *The Vanished Subject* (Chicago: University of Chicago Press, 1991), Judith Ryan explores the ways in which modernist texts confront such philosophical and psychological questions.

alien. Then at last the power of the mind to quit the body is manifest, and perhaps we fear or hate or wish annihilated this phantom of ourselves, lying on the table.[17]

The separation of intellectual and physical being, of mind and body, represented by the letter is something familiar to all of us, from hearing our voices on tape recorders or answering machines, from receiving envelopes we've addressed to ourselves for tickets or reminders about dentist's appointments. Virginia Woolf's sharp focus on the letter as object, venerable and valiant though it may be, thus allows her still lifes to perform the same function as the countless envelopes that appear in painted still lifes, in asking the question of whether words, painted or written, can communicate anything individual or whether they, and with them we, are condemned to communicating only the desire to communicate, like Francis Ponge's autumn trees desperately signaling something but expressing only leaves, leaves, leaves.[18] The letters in a still life, however intensely real they may appear, are always merely painted signs for letters, just as letters themselves are merely a series of signs that represent or are held to represent meaning. By focusing so sharply on the written sign, Woolf is also raising questions about the nature of writing more generally and about the relationship between sign and suggestion, seme and implication.

Many of Cézanne's still lifes featuring fruit allow us to perceive a further aspect of still life's power to throw sight into question; rather than give us the impression that these fruit are part of a domestic scene painted from memory, he underscores their artificial presence in a studio, propped and surrounded by swathes of material or drapes that belong to other scenes but that have been co-opted to display the surfaces and contours of the fruit to best advantage.[19] What is at issue is seeing, more than what is seen. Similarly, the South Australian artist Nora Heysen, whose sculptural portraits convey the strength and monumentality of women and women's power, is less concerned, in the beautiful little still life entitled *White Camellias* (1931: private collection),[20] to explore the weight and volume of the flowers themselves, al-

[17] *Jacob's Room,* 86–87.

[18] The reference is to "La Fin de l'automne" in Ponge, *OEuvres complètes,* 1:16–17.

[19] Consider, for instance, *La Table de cuisine* (1888–90: Paris, Musée d'Orsay).

[20] Reproduced in Jane Hylton, *South Australian Women Artists, 1890s–1940s* (Adelaide: Art Gallery of South Australia, 1994), 24.

though she does do that, than to play on the shades of gray and black that surround them and enhance their greens and whites. It is a painting that tells us far more about color and nuance than about any representational possibilities, just as Jacob's mother's letter speaks less through the words she uses than through what is detectable when we read between the lines. It's saying, in effect, not just that these are camellias, but—and Heysen is very good at doing this—that this is how camellias look to me.

Making the domestic express elements that emphasize personal vision as well as going far beyond what we might initially see as its normal confines is a technique that marks many novels by modernist women. The Irish writer Elizabeth Bowen, for instance, shares Virginia Woolf's interest in the still life embedded in the novel, although her very different sense of wit and its relation to the tragic casts a different light on the device. In *The House in Paris,* first published in 1935, she uses a brief still life to exemplify her conviction, expressed in her *Notes on Writing a Novel,* of the overriding need for everything in a novel to be relevant to the plot, and reveals the degree to which such relevance nevertheless allows room for, perhaps even demands, an excess.[21] But she adds, in discussing the setting of scene, that it "is only justified in a novel where it can be shown, or at least felt, to act upon the action of character. In fact, where it has dramatic use."[22] Karen, exploring her aunt's house, sees both how the house justifies her conviction that if women marry it is because it allows them to "keep up the fiction of being the hub of things,"[23] and how it represents a future shrine to her, something that will remain unchanged after her death:

> Through looped white muslin curtains the unsunny sea daylight fell on French blue or sage-green wallpapers with paler scrolls on them, and water colours of laces that never were. The rooms smelt of Indian rugs, spirit lamps, hyacinths. In the drawing-room, Aunt Violet's music was stacked on the rosewood piano; a fringed shawl embroidered with Indian flowers was folded across the foot of the couch; the writing table was crowded with brass things. In a pan-shaped basket by the sofa

[21] Elizabeth Bowen, "Notes on Writing a Novel," in *The Mulberry Tree,* ed. Hermione Lee (London: Virago, 1986), 35–47.

[22] Ibid., 40.

[23] Elizabeth Bowen, *The House in Paris* (Harmondsworth: Penguin, 1935), 77.

were balls of white knitting wool. Aunt Violet seemed to have lived here always. Each room vibrated with metallic titter, for Uncle Bill kept going a number of small clocks. The rooms looked not so much empty as at a sacred standstill; Karen could almost hear Uncle Bill saying: "I have touched nothing since my dear wife's death."[24]

In this passage, there are elements of the classic still life, especially the still life that functions primarily as a *memento mori:* the sheet music, the fringed shawl, the clocks—objects that speak of an individual and her interests, her knitting, her tastes but that are also universal or unidentifiable—the writing table "crowded with brass things," for example, recalling Grace Cossington Smith's title for her still life, *Things on an Iron Tray on the Floor* (fig. 4). In a sense, this still life is not necessary—perhaps not even relevant—to the complex and multilevel main plot, but in another sense it makes a series of comments about other cultural domains, in the same way that still life painting is encoded so as to suggest other domains, domains of class or gender. The domestic, enclosed life imposed on many women at the time of the narrative is suggested through the enclosed space of the rooms, the sheet music that suggests consumption rather than creativity, the balls of wool that are not attached to any work in progress or associated with anything completed. This is a moment of excess, where the plot stops briefly to allow room for something else—but that something else is an implication about gender that the text everywhere else urges the reader to discover but that the writer refuses to make explicit.

Australian artist Margaret Preston's spiky, aggressive still lifes of flowers suggest a comparable series of encodings. Her uncompromising self-portrait (fig. 13) shows her staring unflinchingly at her audience, against a brick wall whose color reflects that of her skin, her hair sharply crimped around her ears so that it appears as wiry as the flowers nearby, and only a small area of window behind her, a window that, moreover, reveals only blackness. Her countless flower paintings and flat-perspective still lifes offer a surging, restless energy that seems constantly on the point of breaking free from the canvas, as if Preston, whom her fellow artist and former pupil

[24] Ibid.

FIGURE 13. Margaret Preston, *Self-Portrait,* 1930. Art Gallery of New South Wales, Sydney.
© 2003 Artists Rights Society (ARS), New York / VISCOPY, Sydney.

FIGURE 14. Margaret Preston, *Implement Blue,* 1927. Art Gallery of New South Wales, Sydney. ©2003 Artists Rights Society (ARS), New York / VISCOPY, Sydney.

Stella Bowen describes as a "red-headed little firebrand of a woman,"[25] were raging at the relegation of women to lowly realms of life and were determined to show those realms as the domain not of the calm and the obedient but of the transgressive. As she herself argues in her autobiographical piece "From Eggs to Electrolux," which she tells in the third person, "Against all opposition of friends and relatives she painted eggs, dead rabbits, onion, just everything she liked. It was no use for her to explain to people that the standardised beauty for art of landscapes, sunsets and ladies did not interest her; that as she felt no pleasure in them, how could she possibly say anything in pencil or paint that would interest anybody else? So she simply didn't try."[26]

Even a still life like *Implement Blue* (fig. 14), for all its apparent geometrical neatness in the alignment of china and glassware, leaves no quiet center on which the eye can rest; its circles and lines combine with the disquieting, sloping perspective to create instead of the tranquillity associated with the tea ceremony a feeling of distinct unease, a refusal to comply with patterns and shapes handed down by forces outside the individual.

Her flower paintings, especially from 1920 on, when she became increasingly skilled at using color and form to create pattern, reflect the same controlled energy and potential. *White and Red Hibiscus* of 1925 (Art Gallery of New South Wales, Sydney), for example, pulses with life and suggestion, never allowing the eye a place for calm repose, constantly teasing us to distinguish between flower and tapestry, reality and representation, within the painting itself. What I want to suggest here is that in seeming to focus on the contained domestic space apparently allotted to them, women like Elizabeth Bowen and Margaret Preston provocatively invite a contemplation of something much larger and much less contained.

Drusilla Modjeska's beautifully written work of 1994, *The Orchard,* offers a far more overt exploration of still life, an exploration that interweaves, in a postmodernist technique the author favors, fact and fiction, the creative and the critical. In a

[25] Stella Bowen, *Drawn from Life* (London: Virago, 1984), 22.

[26] First written for the magazine *Art in Australia,* Margaret Preston issue, 3rd series, no. 22, 1927, this piece is reproduced in Ian North, Humphrey McQueen, and Isobel Seivl, *The Art of Margaret Preston* (Adelaide: Art Gallery of South Australia, 1982), 74–77. The quotation is on p. 75.

section devoted to the narrator's temporary loss of sight, Modjeska meditates on the art of the modernist Sydney painter Grace Cossington Smith,[27] and in particular the wonderful series of interiors and still lifes painted toward the end of her long life. Whereas Modjeska's meditation is largely concerned with the interiors, what she says serves to focus a reading of the painter's powerfully suggestive still lifes:

> In those late interiors, in the last phase of her work, Grace Cossington Smith was painting out of a daily solitude, living alone in the family house where parents had died and from which siblings had departed. Do we see here the representation of a spinsterly existence: single beds, neat cupboard, empty hallways? Or the riches of solitude: empty rooms filled with possibilities? Doors opening onto hallways, windows opening onto verandahs and gardens, drawers and cupboards allowing us to glimpse their treasures? To my eye these interiors are by way of being self-portraits of a woman who has resolved the tension between her own ability to see and the seeing, or being seen, that is required of her: a woman who has fully withdrawn from the gaze of the world to discover not a defensive retreat but the fullness of a solitude that society deems empty.[28]

Modjeska focuses here on *Interior with Wardrobe Mirror* of 1955 (Art Gallery of New South Wales, Sydney), which certainly invites speculation on what is seen and who looks at it, on what is reflection and what is reality, and on the interrelationship between portrait painting and interiors or by extension still lifes, because still life is contained within this interior. It is a reflection that runs through the whole of *The Orchard,* and Modjeska's choice of this particular canvas is no doubt determined in large measure by that punning and imaginative use of the mirror, reflecting not the face or form of the artist gazing into it but the accumulated possessions and the scene she most often gazes out to, that even more surely reflect her personality.

Nevertheless, it is also true that something rather similar happens in her beautifully understated depictions of tea things, in ways that are perhaps even more in-

[27] On this painter, see Bruce James, *Grace Cossington Smith* (Sydney: Craftsman House, 1990), and Modjeska's more recent work, *Stravinsky's Lunch* (Sydney: Macmillan Australia, 1999).

[28] Drusilla Modjeska, *The Orchard* (Sydney: Macmillan Australia, 1994), 137.

teresting because, unlike the interiors, they seem at first glance self-sufficient, independent of human contact and human vision. Yet, their own subtle encoding solicits symbolic readings. One of these, a group of teacups painted in the months after her mother's death, suggests the absent mother through a saucer bereft of its cup, while the father's bereavement is encoded through a cup turned down on a saucer, and the daughters are represented as cups and saucers forming a circle around the widower. Another, which dates from almost at the end of her long life, shows a pale teacup surrounded by more colorful vases and utensils. It seems to invite a reading in which the pale teacup is Grace Cossington Smith fading away from the more brightly colored utensils that evoke her friends.

Indeed, many of Cossington Smith's still lifes have the exceptional power of stripping the veil of habit from familiar objects and setting them free to signify in powerfully different ways from those convention usually assigns to them. A shell can loom vast and remarkably sexual, or flowers take on an energy suggesting deep conflicts between social expectation and female desire. These are paintings that transform everyday objects by the intensity of the gaze to which they are subjected, but at the same time the objects remain themselves, and if they enable us to see through them to different realities, they also intensify and strengthen our capacity for seeing the external world.

This is what Henry James reveals with such power and subtlety in *The Golden Bowl* (1904), his late novel that has as its enabling sym-bol (as Mary Ann Caws so nicely suggests)[29] yet another element we might associate with the still life. The bowl is presented to us through Maggie's eyes; indeed, much of the novel is focused through her wonderfully healing and perceptive femininity. The prince has noticed the crack in the bowl and turns away in distaste for something lovely but flawed; Maggie, fortunately for him, sees its beauty more than its weakness: "Simple but singularly elegant, it stood on a circular foot, a short pedestal with a slightly spreading base, and, though not of signal depth, justified its title by the charm of its shape as well as by the tone of its surface. It might have been a large goblet diminished, to the

[29] Mary Ann Caws, "What Can a Woman Do for the Late Henry James?" *Raritan* 14, 1 (Summer 1994): 1–17.

enhancement of its happy curve, by half its original height. As formed of solid gold it was impressive."[30]

When Maggie's friend Fanny Assingham realizes that the flawed bowl has come to represent for Maggie the transgressions that threaten her marriage, she responds in a gesture that refuses the reading Maggie has placed on it but at the same time confirms the power of objects to act as witnesses and symbols (a power that Iris Murdoch is also very good at bringing out). James focuses sharply on the quality of the light in this moment, giving the scene, and more particularly the broken shards, that intense luminosity that is one of the defining characteristics of still life:

> So for an instant, full of her thought and of her act, [Fanny Assingham] held the precious vessel, and then, with due note taken of the margin of the polished floor, bare, fine and hard in the embrasure of her window, she dashed it boldly to the ground, where she had the thrill of seeing it, with the violence of the crash, lie shattered. She had flushed with the force of her effort, as Maggie had flushed with wonder at the sight, and this high reflection in their faces was all that passed between them for a minute more.[31]

There is here a characteristic kind of looking and knowing that James associates with the feminine and that he also links to the power of objects in a particularly intense light, a light that at the same time of course suggests realization and insight. In closing on James's high reflection, in both senses of the word, I want to suggest that it takes us back to Margaret Preston's summer tea party and Hannah Höch's glasses, and propose that still life can remind us that when we look into the heart of objects, not just those of painted still lifes but also those captured in words, we may be seeing states of mind, perceptions, and also our gendered selves.

[30] Henry James, *The Golden Bowl,* ed. Patricia Crick (1904; reprint, Harmondsworth: Penguin, 1984), 119.

[31] Ibid., 447–48.

6

TIME AND SPACE

The moment in and out of time

T. S. Eliot

Rien n'aura eu lieu que le lieu
(Nothing will have taken place but the place)

Stéphane Mallarmé

According to Christopher Braider, "with the publication of Lessing's *Laocoön* in 1766, asserting once and for all the unbridgeable ontological rift between the spatial art of the image and the temporal art of verse, *ut pictura*'s long reign as the dominant principle of Western art theory reaches an official close."[1] Of course, as Mario Praz points out, when Ovid formulated the term *ut pictura poesis* he "had only intended to say that like certain paintings, some poems please only once, while others can bear repeated readings and close critical scrutiny," but the expression has become a handy formulation for the comparability of writing and the plastic arts.[2] Lessing's argument claimed that the representation of time and space poses fundamentally differ-

[1] Braider, *Refiguring the Real,* 249.
[2] Mario Praz, *Mnemosyne: The Parallel between Literature and the Visual Arts* (Princeton: Princeton University Press, 1970), 4.

ent challenges in writing and in the plastic arts, challenges that make it impossible for a poem to be like a painting, at least in any simplistic terms: the image's power to convey a vast landscape in the few seconds it takes to focus on the canvas is alien to the nature of verse, just as the complex time structures that the written text can so satisfyingly develop find only a clumsy and schematic equivalent in a painting. And yet, still life, through the objects on which it focuses, is always, however subtly, associated with time. Those objects—the pitchers, jars, pipes, shells, and so forth—have been intimately associated with human dreams and human existence since time immemorial, and they carry with them all the density, all the force, all the *enargea,* of that long and close association. Norman Bryson argues powerfully, "As human time flows around the forms, smoothing them and tending them through countless acts of attention across countless centuries, time secretes a priceless product: familiarity."[3]

Indeed, still life paintings, like their written counterparts, can not only embody time in this way but also suggest time—not just banally in the watches, clocks, and hourglasses that are frequent elements of the *memento mori,* but in more complex ways, by, for instance, juxtaposing flowers that bloom at different seasons, or fruit and vegetables harvested at different moments of the year, or letters bearing a range of disparate dates. Written still lifes can suggest subtle changes taking place over time, or gesture toward a moment that marks the point in a person's life when nothing will be the same again, as happens, for instance, when Edith Wharton's character Lily Bart notices that the flowers in the vase are not fresh, the first inkling she has of her father's bankruptcy:

> In the centre of the table, between the melting *marrons glacés* and candied cherries, a pyramid of American Beauties lifted their vigorous stems; they held their heads as high as Mrs. Bart, but their rose-color had turned to a dissipated purple, and Lily's sense of fitness was disturbed by their reappearance on the luncheon-table.[4]

[3] Bryson, *Looking at the Overlooked,* 138. The much larger implications of Lyotard's assertion that "time is in color, and color is in time" (*Sur la constitution du temps par la couleur dans les oeuvres récentes d'Albert Ayme* [Paris: Edition Traversière, 1980], unpaginated, paragraph 2) exceed the bounds of this study but have a direct bearing on still life, especially that of the postmodernist era.

[4] Edith Wharton, *The House of Mirth* (1905; reprint, Harmondsworth: Penguin, 1985), 31.

Through its focus on elements of time, this still life includes a further suggestion of the luxury in which she was accustomed to live, a luxury obliterating the realities of seasonal changes, because the *marrons glacés* and candied cherries are associated with New Year's customs, indicating that the roses have been grown out of season in hothouses, metaphorically like Lily herself.

Still lifes, written or painted, can, moreover, imply through their apparently random accumulation of objects a trove of memories from diverse points in time, as happens in Joyce's *Ulysses* (1922) when Stephen's memories of his dead mother cluster around such apparently miscellaneous and trivial bits and pieces:

> Her secrets: old feather fans, tasselled dancecards, powdered with musk, a gaud of amber beads in her locked drawer. [. . .] Memories beset his brooding brain. Her glass of water from the kitchen tap when she had approached the sacrament. A cored apple, filled with brown sugar, roasting for her at the hob on a dark autumn evening.[5]

Here, even the sentence "Memories beset his brooding brain," with its heavy suggestions of pastiche and its overliterary alliteration, hints through its own accumulation of literary reminiscences at the ways in which the past gathers in words and objects, making them, however trivial in themselves, sites of memory and repositories of the past. Moreover, as Bachelard points out in *Poétique de l'espace:*

> We sometimes believe that we know ourselves in time, whereas all we know is a series of fixed points in those spaces where our being is stable, a being that does not want to flow away, that even when it sets out into the past in search of lost time, seeks to suspend time's flight. In its thousand honeycombs space holds time compressed. Space serves that purpose.[6]

Space and time, in human imagination, are not entirely separate, and while the techniques of paintings and writing may seem to favor one over the other, each genre has

[5] James Joyce, *Ulysses* (1934; reprint, New York: Vintage, 1990), 9–10.
[6] Bachelard, *La Poétique de l'espace,* 27.

ways, more or less subtle, more or less successful, of conveying both and of allowing one to suggest the other.

One of the ways in which certain still lifes can bring space and time together is through defining our place in the world by accumulating objects that will represent us after death. Thus, objects as reminders of mortality—that staple of still life painting—take on a particular force in modernist written still lifes that explore or reveal notions of time. Herman Broch's *The Sleepwalkers,* for example, suggests how he sees his contemporaries trying to overcome or deny the fragility of human existence that many painted still lifes in the *vanitas* mode convey through the objects they set before the viewer:

> Certainly Elisabeth did not know that every collector hopes with the never-attained, never-attainable and yet inexorably striven-for absolute completeness of his collection to pass beyond the assembled things themselves, to pass over into infinity, and, entirely subsumed in his collection, to attain his own consummation and the suspension of death. Elisabeth did not know this, but surrounded by all those beautiful dead things gathered together and piled up around her, surrounded by all those beautiful pictures, she divined nevertheless that the pictures were hung up as though to strengthen the walls, and that all those dead things were put there to cover, perhaps also to conceal and guard, something intensely living. [. . .] She divined the fear behind all this, fear that sought to drown in festivals the monotony of every day which is the outward sign of growing old.[7]

Broch brings together in this depiction of the collector the longing for completion, the desire to subsume the mortal self into the permanence of objects, the attempt to control the inexorable passing of time by fragmenting it into anniversaries that can in turn be transformed into commemorating objects. It is a passage that pulls together the earlier disparate references to the collection in order to convert the writ-

[7] Broch, *Sleepwalkers,* 71. On the *vanitas* theme in the visual arts, see Cheney, ed., *Symbolism of "Vanitas";* and, on collecting, see Rheims's wonderful, idiosyncratic book *La Vie étrange des objets: Histoire de la curiosité* (Paris: Plon, 1959).

ten still life into a meditation on the passing of time and the materialistic way in which Biedermeier Germany, with its accumulations of weighty objects designed to indicate permanence, was confronting the unpleasant truth of transience.[8]

It is also a deliberately static still life in which the narrative voice assumes omniscience, allowing the character at best to divine but never really to know the truth of what she is observing. Broch is casting back into the past here, preparing the way for the two other short novels that comprise *The Sleepwalkers* and that take place in more recent times. The frozen nature of this still life reflects on his vision of a stultified society in which materialism and sensuality have taken the place of any desire for spiritual or intellectual fulfillment.

More recent depictions of time might tend to use as their basic symbol not so much the collection as the labyrinth. As J. Hillis Miller reminds us in regard to Ruskin's *Ariadne Florentina:* "Ruskin makes the distinction [between word and picture] problematic by relating both words and pictures to the primordial material act of scratching a surface to make a sign. That sign, Ruskin suggests, is always a miniature maze and is always connected to its context by labyrinthine lines of filiation. [. . .] For Ruskin, not only are signs always both verbal and pictorial, but also any configuration of signs has a temporal and narrative dimension. To trace out a sign is to tell a story."[9] Telling a story, however small a story, implies a narrative moving across time that in itself became, paradoxically, more problematic as the industrial revolution both made it possible to measure time more accurately and rendered human experience of time less dependent on diurnal and seasonal rhythms. Technological revolutions intensify modern humans' complex experience of time by precipitating us through geographical time zones, by bringing us news from places remote from us at the moment that it happens, and by bombarding us with images and sounds ranging across a wide temporal spectrum. Finding a way of reflecting that new experience of time, which brings with it a new experience of space and above all a new sense of self, is part of the challenge of modern writing and paint-

[8] For visual equivalents of this, see "The Biedermeier Bouquet and the Gift Table" in Sybille-Schifferer, *Still Life,* 281–86.

[9] J. Hillis Miller, *Illustration* (Cambridge: Harvard University Press, 1992), 75.

ing. This is in part what Borges alludes to in proposing a book that would in itself compose "a labyrinth of symbols. [. . .] An invisible labyrinth of time."[10]

Borges's fluid image of time, not as a one-directional arrow but as a "garden of forking paths"—in other words, as a labyrinth—is reflected in many twentieth-century works. That image, which dominates many modernist still life paintings, as it does modernist writing, can be seen as one of the many responses to Henri Bergson's influential studies of time and his insistence on the need to break free from the mechanistic and deterministic images of the self that had become a dominant feature of nineteenth-century thought, especially in the wake of Lamarck and Darwin.[11] Bergson promotes the values of *élan vital* and the power of intuition, demoting chronologically measurable time in favor of an awareness of duration.

These values find a parallel not just in the novels that deal in attempts to recover lost time—those, for example, of Dorothy Richardson and Marcel Proust—or that create a sense of temporal circularity, as for instance James Joyce does in *Finnegan's Wake* (1939), but also in modernist treatments of the painted still life in which the objects seem both mobile and labile, conveyed in colors that enhance the energetic vitality of the works. Matisse's 1912 *Goldfish and Sculpture* (fig. 15), with its indeterminate spatial planes, its intense, unsubtle colors, and its indication of contained movement conveyed through the bright red goldfish swimming at sharp angles to one another in their bright green tumbler, suggests the kind of questioning of categories that removes any stillness from the still life. In a quite different way, Chaim Soutine's 1926 *Still Life with Violin, Bread, and Fish* (Im Obersteg Collection, Oberhofen, Bern) refuses to conform to conventional perspective, while its grim echoes of still lifes in which dead animals hang before the viewer's gaze (the violin dangles before our eyes, its neck as limp as that of any still life swan or duck), and the intensely nonnaturalistic colors and rough brushstrokes forcefully maintain that this is not reality but an impassioned comment on what humanity has made of reality.

[10] Jorge Luis Borges, *Labyrinths,* trans. Donald A. Yates and James E. Irby (Harmondsworth: Penguin, 1964), 50.

[11] For a complex and detailed exploration of memory and the experience of time in the literature of this period, see Richard Terdiman, *Present Past: Modernity and the Memory Crisis* (Ithaca: Cornell University Press, 1993).

FIGURE 15. Henri Matisse, *Goldfish and Sculpture,* 1912. Oil on canvas. Museum of Modern Art, New York. © 2003 Succession H. Matisse, Paris / Artists Rights Society (ARS), New York. Digital Image © The Museum of Modern Art / Licensed by SCALA / Art Resource, NY.

For more fluid written still lifes, we might turn to Virginia Woolf, who in *The Waves* (1931) introduces a series of still lifes. Some of these serve merely to comment on character or to fix the flowing meditations of the protagonists in a humdrum reality that their thoughts might otherwise not convey, as in the following vignette: "'Cold water begins to run from the scullery tap,' said Rhoda, 'over the mackerel in the bowl.'"[12] Jinny, whose dreams are of belonging in upper-class society, is revealed through another little still life: "Here are gilt chairs in the empty, the expectant rooms, and flowers, stiller, statelier, than flowers that grow, spread green, spread white, against the walls. And on one small table is one bound book. This is what I have dreamt; this is what I have foretold. I am native here."[13] Here the familiar still life objects of flowers and books speak of an existence different from the one she knows, encapsulating privilege and promising pleasure.

As the novel progresses, Woolf inserts more complex passages that mark the passing of years. Each of these resembles a still life in the objects on which it focuses and in the attention paid to the quality of the light, but the primary function of these passages is not mimetic, but rather evocative and above all suggestive of a gaze other than those of the characters, a gaze watching time passing as if unaffected by it. One of the first of these still lifes offers the light of early day, paralleling the youthful nature of the friends on whom the novel focuses:

> The sun laid broader blades upon the house. The light touched something green in the window corner and made it a lump of emerald, a cave of pure green like stoneless fruit. It sharpened the edges of chairs and tables and stitched white table-cloths with fine gold wires. As the light increased a bud here and there split asunder and shook out flowers, green veined and quivering, as if the effort of opening had set them rocking, and pealing a faint carillon as they beat their frail clappers against their white walls. Everything became softly amorphous, as if the china of the plate flowed and the steel of the knife were liquid.[14]

[12] Virginia Woolf, *The Waves* (Harmondsworth: Penguin, 1964), 7.
[13] Ibid., 87.
[14] Ibid., 24. In the original, this passage appears in italics.

These are standard still life objects—flowers, fruit, plate, knife—that are transformed by the quality of the light: the something green in the window corner becoming both emerald and stoneless fruit, and equally capable of further transformations at the whim of the reader's imagination, just as still life fruit invite the viewer to see them differently. But whereas painted still lifes usually convey a moment seized and set in stone, conveying a gemlike quality to the objects viewed even when these are fish or fruit or flowers and thus subject to decay, Woolf here reinforces the sense of time in progress by insisting on the mobile, changing nature of her objects. This is the light of early youth, when everything is still in process, still capable of rapid and dramatic changes.

The next such passage suggests light of a very different quality, and with it conveys a different sense of time:

> The rising sun came in at the window, touching the red-edged curtain, and began to bring out circles and lines. Now in the growing light its whiteness settled in the plate; the blade condensed its gleam. Chairs and cupboards loomed behind so that though each was separate they seemed inextricably involved. The looking-glass whitened its pool upon the wall. The real flower on the window-sill was attended by a phantom flower.[15]

The exuberance of the earlier passage is gone, the style is more sober, the light no longer liquid, "settling" like a viscous fluid on plates and allowing the knife blade to condense the beam. The flower that in the earlier passage had so energetically burst into bloom is now settled into its role, projecting its shadow calmly before it.

When we come to the passage that reflects the characters' maturity, the sun is at its zenith, transforming the objects it falls on, but with a different intensity and to different effect from the early morning passage:

> The sun fell in sharp wedges inside the room. Whatever the light touched became dowered with a fanatical existence. A plate was like a white lake. A knife looked like a dagger of ice. Suddenly tumblers revealed themselves upheld by streaks of

[15] Ibid., 63–64. In the original, this passage appears in italics.

light. Tables and chairs rose to the surface as if they had been sunk under water and rose, filmed with red, orange, purple like the bloom on the skin of ripe fruit. The veins on the glaze of the china, the grain of the wood, the fibres of the matting became more and more finely engraved. Everything was without shadow. A jar was so green that the eye seemed sucked up through a funnel by its intensity and stuck to it like a limpet. Then shapes took on mass and edge.[16]

In this quite remarkable passage Woolf conveys all the intensity of an impassioned response to life through the medium of the written still life. The capacity of a still life to convey glass (as in Monet's *Jar of Peaches* [fig. 6], to give only one example among many) is elliptically suggested through the reference to tumblers upheld by streaks of light, while the description of the chairs rising to the surface with a film of color over them hints at the experiments with color carried out by the postimpressionist painters to whom her attention had been so sharply drawn by her sister Vanessa and her friend the critic Roger Fry. The ways in which certain still lifes, by their focus on shape and luminosity, confer on the objects they depict an intensity of color that draws the eye to what might otherwise be overlooked, are conveyed in the greenness of the jar, which is so intense that "the eye seemed sucked up through a funnel"—here one thinks of Woolf's comment on the Cézanne apples growing redder and greener and rounder. The emphasis on the shapes taking on mass and edge is also an invitation to us to see her characters, as they move into middle age, taking on a similar psychological weight and firmness of outline.

As her characters move toward old age, so the quality of the light is suggested through yet another still life: "The evening sun, whose heat had gone out of it and whose burning spot of intensity had been diffused, made chairs and tables mellower and inlaid them with lozenges of brown and yellow. Lined with shadows their weight seemed more ponderous, as if colour, tilted, had run to one side. Here lay knife, fork and glass, but lengthened, swollen and made portentous. Rimmed in a gold circle the looking-glass held the scene immobile as if everlasting in its eye."[17] Shadow, the shadow of evening, has entered the room; weight is no longer a sign of

[16] Ibid., 94. In the original, this passage appears in italics.
[17] Ibid., 179. In the original, this passage appears in italics.

force, but more a suggestion of all the accumulated emotional and experiential baggage the protagonists have gathered in the course of their lives. The crispness of outline and the potential for suggesting multiple possibilities, attributes that were associated with the knife and the glass in early passages, have gone, replaced by a swollenness that suggests fixity if not incipient decay.

Yet, while these progressive changes may seem a form of ossification or decomposition, Bernard's final personal still life shows that there is yet more to be seen here, that he has at last acquired a sense of self: "Let me sit here for ever with bare things, this coffee-cup, this knife, this fork, things in themselves, myself being myself."[18] The objects that have allowed the narrative voice to indicate shifts in time are also those that, despite their apparent simplicity and banality, have enabled him to find himself over the course of his life.

Woolf's lyrical exploration of time, and the highly painterly terms in which it is carried out, offer a particularly striking indication of the ways in which still life can be used to indicate time, despite the limitations Lessing so powerfully exposes. Many other twentieth-century writers have also carried out similar experiments, although their ways of conducting those experiments vary significantly.

Michel Butor, whose association with the French new novel and whose subsequent experiments within and across genres reveal a particularly playful and inventive cast of mind, deploys the possibilities of the detective novel in his first-person narrative *L'Emploi du temps* (1957). In this highly self-reflexive novel, the narrator discusses with an aficionado of the detective novel the pleasures of rereading such works. She responds to the narrator's initially incredulous questioning with calm certainty: "Do I reread detective novels? When you do, they take on a kind of transparency. As you trace out the illusions of the beginning you glimpse the truth that you remember more or less clearly."[19] While this is of course the case in the rereading of any text, it becomes especially problematic for the detective novel, for which, as Matei Calinescu argues, the manner of reading, like the conventional image of time, is emphatically linear.[20] The temporal structures such a reading imposes are

[18] Ibid., 254.

[19] Michel Butor, *L'Emploi du temps* (Paris: Editions de Minuit, 1957), 90.

[20] Matei Calinescu, *Rereading* (New Haven: Yale University Press, 1993), 206–24.

reflected in Butor's own text, in which the narrator, attempting halfway through his stay to account for his year in Bleston, begins a diary that gradually moves from covering one month at a time to a desperate attempt to account for several months simultaneously, ending as the narrator leaves the town with the awareness that no year can ever be completely recovered, as the lack of time to describe the events of February 29 symbolizes in this case.

L'Emploi du temps is rich in allusions to pictorial parallels that distort vision ("evil mirrors, coarse mirrors, disturbed and dull mirrors, confused mirrors, mirrors that have lost their shine")[21] and that simultaneously highlight the question of time. Thus, writing in August, he thinks back to his visit to the museum in June, where he saw a series of tapestries, and realizes that they are not each limited to conveying a particular moment in time but "all represent actions that have a certain duration, which is expressed by the fact that you can see, clustered in the composition of a single panel, several scenes in succession, the same character appearing in this way two or three times in number fifteen, the Descent to Hell."[22]

In an extension of this technique, Butor offers us a tiny still life, the traditional glimpse of the writer's table, on which lie the guides the narrator has bought to orient himself in this foreign town and which in themselves serve to tie together the spatial and the temporal, with their rational attempts to situate contemporary Bleston geographically and historically in ways that have little to do with the narrator's own confused, irrational, and labyrinthine experience of it:

> That book I thought I had lost without trace, that copy which I had just on the previous day, last Friday, described purchasing, which led me on Saturday to reread the text in the copy that had taken me months of research to discover at last in a secondhand bookstall in order to replace the lost copy, for the edition had gone out of print in the meanwhile, that copy marked with my name, whereas the one that is now on the left hand corner of my table, with the illustrated notice about the New Cathedral, the maps of Bleston, and the city guide bound in blue in the collection "Our Land and its Treasures," has a signature that I cannot decipher, that copy that

[21] Butor, *L'Emploi du temps,* 228.
[22] Ibid., 211.

had been occupying my thoughts for several days, the Bailey house, that house where I go so often, was certainly the last place where I would have dreamt of finding it again.[23]

Butor's complex and supple sentence structure moving apparently effortlessly among tenses and time periods folds this still life away in the midst of a convoluted description of the discovery of the initial copy of *The Murder of Bleston* that Jacques had bought, attracted by the ambiguity of its title and the blank space where the author's photo should have been. It is a still life that brings time and place together, but in ways that emphasize the image of the labyrinth that is both experientially present in the novel as Jacques strives to find his way through an unknown city, an imperfectly understood language, and an unfamiliar culture, and artistically represented in the story of Theseus that he finds depicted in a series of tapestries, one of which shows the Greek hero negotiating the Cretan labyrinth. The still life's placement on the desk on which he writes up his equally labyrinthine diary ties together his account of his life in Bleston, and the objects that appear to offer reflections of that life in symbolic or at least encapsulated terms but that might be just as misleading as the many clues Jacques fails to interpret, or indeed that he may be placing before us in a deliberate attempt to create confusion. It is, in other words, a still life that invites multiple readings without promising anything like the certainty we associate with the form of the detective novel.

Italo Calvino's *If on a Winter's Night a Traveler* (1979), which also uses as its main or at least ostensible narrative structure the topos of the quest, of which the detective novel is a subset, opens his book with a depiction of a character called the Reader carving out a path in the bookstore through the tantalizing ranks of other novels that attempt to seduce the reader and in doing so hold out other images of time:

> You pass the outer girdle of ramparts, but then you are attacked by the infantry of the Books That If You Had More Than One Life You Would Certainly Also Read But Unfortunately Your Days Are Numbered. With a rapid maneuver you bypass them and move into the phalanxes of the Books You Mean To Read But There Are

[23] Ibid., 62.

> Others You Must Read First, the Books Too Expensive Now And You'll Wait Till
> They're Remaindered, the Books ditto When They Come Out In Paperback,
> Books You Can Borrow From Somebody, Books Everybody Has Read So It's As If
> You Had Read Them, Too.[24]

Like the piles of books in a range of painted still lifes, from the Aix-en-Provence
triptych through those that lie scattered under skulls in such works as Jan Davidsz.
de Heem's *Vanitas Still Life* of 1683–84 (Museum des Bildenden Künste, Leipzig),
to more political statements, like Charles Bird King's *Poor Artist's Cupboard* (c. 1815:
Corcoran Gallery of Art, Washington, D.C.), this depiction of the temptations posed
by books is also an invitation to meditate on the role of reading, and particularly on
the relationship between reading and time. The *vanitas* still life shows book-reading
as a frivolous waste of time: the secular Calvino sees it, on the contrary, as an invita-
tion to become lost in the pleasures of narrative, a means at least of avoiding the
worst, as he puts it.[25] The books not read represent forks not taken in the labyrinth
of time, or at least forks not yet taken, and thus a different potential map of the
Reader's life, a map that folds together both space and time. Books, in Calvino's play-
ful list, become, like the railway stations in Forster's *Howards End,* "our gates to the
glorious and the unknown," encapsulations of different geographical trajectories:
"In Paddington all Cornwall is latent and the remoter west; down the inclines of
Liverpool Street lie fenlands and the illimitable Broads; Scotland is through the py-
lons of Euston; Wessex behind the poised chaos of Waterloo."[26]

It is hardly surprising, then, that Calvino chooses to start what purports to be the
novel proper in a railway station, although it is equally typical of postmodernist texts
that this is not one of Forster's grand exits from a capital city, but merely a nonde-
script provincial station, just as what the Reader initially takes for "one of those vir-
tuoso tricks so customary in modern writing, repeating a paragraph word for word,"

[24] Italo Calvino, *If on a Winter's Night a Traveler,* trans. William Weaver (San Diego: Harcourt Brace
Jovanovich, 1979), 5.
[25] Ibid., 4.
[26] Forster, *Howards End,* 12.

an attempt to "express the fluctuation of time," proves to be a mere printer's mistake, in which one signature was duplicated and another left out altogether.[27]

The novel then follows an increasingly complex series of forking paths as the Reader pursues a series of novels, all set in different countries and all of which break off, are confiscated, or disintegrate. Calvino's novel, therefore, is both a meditation on reading and a continuation of the piles of books the Reader left behind in the initial purchase of *If on a Winter's Night.* That first, apparently fleeting, still life of books is now revealed to be a summary of what is to come, a way of indicating the multiple levels of time that any reading, even of the most straightforward of books, always represents.

If still life depictions of books hold time compressed, like Bachelard's thousand honeycombs of space, so also do other still life objects. Those of Margaret Preston's still lifes that are inspired by her growing interest in Aboriginal art carry with them, for instance, both an element of timelessness and a strong sense of place. See, for example, her *Aboriginal Flowers* (c. 1928: Art Gallery of New South Wales, Sydney). Elisabeth Butel argues that Preston's "preoccupation with the analytical aspects of modernism had by this time taken on an almost spiritual purity of intent and in her interpretation of Aboriginal art, she allowed this tendency to dominate."[28] Through their choice of subject, but above all through ways of treating that subject that are both recognizable as Preston's own and a tribute to Aboriginal painting techniques, such still lifes proclaim their identity with Australia. While I do not want to limit these works to functioning as a statement about a particular place seen through a particular focus, I do want to suggest that part of their effect on the reader has to do with a vibrant and individualistic representation of place. Mexican artist Frida Kahlo also builds on the motifs of her country's folk art and on objects characteristic of its culture to produce still lifes that evoke a very particular sense of place, as she does for example in *Fruits of the Earth* (1938: Banco Nacional de México Collection, Mexico City).

Written still lifes, however, at least in my experience, tend not to offer that strong

[27] Ibid., 25.
[28] Butel, *Margaret Preston,* 53.

sense of place that certain painted still lifes convey. In part this may be because their function seems to be above all to emphasize universality through objects we interpret as part of our own experience. Even when, for instance, Byatt names specific shells or Woolf specifies particular flowers, the effect on the reader seeing them with the eye of imagination is that of familiarity; even when books in a written still life are named, we see them less as markers of place than as indicators of character, class, or gender. And globalization has so extended our awareness of the world's bounty that we do not necessarily associate passion fruit or potatoes, rhododendrons or camellias with their country of origin. Written still lifes seem to focus more on creating a sense of personal place than on the establishment of a particular country or region. David Malouf's exuberant still life conveying the skill with which the narrator's father arranged his apples and pears, for instance, works so well in part because what is transformed is not something exotic but rather, on the contrary, familiar elements of our domestic experience. In similar ways, even Le Clézio, seeking to depict the world with new eyes, chooses to allow that gaze to rest on profoundly familiar objects—oranges, corncobs, and so forth.

There are, of course, some exceptions, as when A. S. Byatt offers a typically enthusiastic list, presented through the gaze of a poet and serving to pinpoint a moment in time and a specific place:

> He discovered the glories of Goodge Street and Charlotte Street, Italian grocers smelling of cheese, wine casks, salami, Jewish bakers smelling of cinnamon, and poppy seed, Cypriot greengrocers overflowing with vegetables unobtainable in the north, aubergines, fennel, globe artichokes, courgettes, glistening, brilliant, green, purple, sunshine-glossed. In Schmidt's amazing *delikatessen* you could buy sauerkraut from wooden barrels, black pumpernickel, wursts cooked and uncooked, huge choux pastries and little cups of black coffee.[29]

While this list is partly a sign of linguistic pleasure, it also acts as social commentary, comparing English North Country life with that of London, and an attempt to seize a particular moment, when the English left food-rationing behind and, under the

[29] Byatt, *Still Life*, 172–73.

influence of such gifted food writers as Elizabeth David, began to expand their tastes and indulge their senses.[30]

Written still lifes can also evoke place in terms not of a particular point on earth but rather of the domain associated with a particular person, experience, or memory. Going to meet the woman he has long loved but who has married someone else, Ted Tyce in Shirley Hazzard's novel *The Transit of Venus* (1980) focuses on a grouping of objects that he knows will forever after sum up for him her presence, which is also in affective terms her absence:

> Through a glass strip, [he] saw a polished floor, mirror, white wall; a small picture of playing cards and a wine carafe. This time the newspaper on the table was explicit as the still life. An umbrella-stand of blue-and-white china was a monument. To come and go at will, forever, across this threshold was not simply a happiness denied him but held so large a meaning that it seemed scarcely permissible to anyone.[31]

This briefly glimpsed still life serves, however, not only to imprint on Ted's memory an image of a place that signifies unattainable happiness, but also to isolate the single moment in time when he can cross the threshold, whereas happiness would consist of the freedom to cross it "forever, at will."

Time and space thus meet in Hazzard's apparently simple accumulation of the objects frequently found in still life. The umbrella stand, the cards, the wine carafe, the newspaper, are glimpsed through a pane of glass, as if protected by it, or as if happiness can be glimpsed only through something that both distorts it and keeps us at a distance from it.

Many still lifes, painted and written, have that quality of frozen moments that bring together a particular point in time and a specific place, but that do so in ways that make the objects they highlight universal and timeless. Embedded in a novel, these still lifes may not present such an immediate target for critical and theoretical

[30] On Elizabeth David's influence, see, for instance, Julian Barnes, "The Land without Brussels Sprouts," in *Something to Declare* (New York: Knopf, 2002), 43–55.

[31] Shirley Hazzard, *The Transit of Venus* (Harmondsworth: Penguin, 1981), 216.

treatment as other elements of the work, and may offer so discreet a commentary on events or characters that they may indeed risk being overlooked, but their function, subtle and understated though it may be, is precisely to infiltrate the reader's consciousness in ways that subtly shape the reader's general appreciation and understanding of the whole.

CONCLUSION

BEFORE IT FADES . . .

When Joseph Cornell, under the powerful joint influence of surrealism and the Christian Science faith, began producing his remarkable series of boxes, he was extending a long tradition in still life paintings: that of the representation of the box of wonders, the *Wunderkammer* that was one of the early avatars of the modern museum.[1] Domenico (or possibly Andrea) Remps, for instance, produced a spectacular painting on canvas that presents in all its *trompe l'oeil* conviction an art cabinet (fig. 16) that gathers shells, mirrors, skulls, coral, beetles, drawings, and paintings within

[1] On this, see Lorraine Daston and Katharine Park, *Wonders and the Order of Nature, 1150–1750* (New York: Zone Books, 1998). On Cornell, see, above all, Dore Ashton, *A Joseph Cornell Album* (New York: Da Capo, 1974); Mary Ann Caws, "Cornell and Mallarmé: Collecting and Containing," in her *Art of Interference* (Princeton: Princeton University Press, 1989); and *Joseph Cornell's Theater of the Mind* (New York: Thames & Hudson, 1993); Dickran Tashjian, *Joseph Cornell: Gifts of Desire* (Miami Beach: Grassfield Press, 1992); and, for a recent biography, Deborah Solomon, *Utopia Parkway* (New York: Farrar, Straus & Giroux, 1997). This chapter's title is taken from Cornell's diary.

a glass-front cabinet that is bursting open under the pressure of its disparate offerings. The energy of this painting belies its categorization as still life, indicating the wonderful power inherent in the finest of these works. The cabinet still life in turn drew on the many *trompe l'oeil* paintings in which artists depicted the fruit, flowers, goblets, and cutlery of still life as though they were contained within cupboards or set out on shelves or in niches, as Adrien Coorte does with *Fruit and Bunch of Asparagus in a Niche* (1703: Koninklijk Museum voor Schone Kunsten, Antwerp) and Georg Flegel does in *Cupboard Picture with Flowers, Fruit, and Goblets* (c. 1610: National Gallery, Prague), or, in a rather different mode, the Urbino studiolo in the Metropolitan Museum of Art, New York.

Cornell's boxes continue in that line in their energetic accumulation of disparate objects but add to it a dreamlike, often mysterious, and always suggestive quality, brought about in large measure by the way in which they manage to imply that there is some elusive connection among the objects which, if only we as viewers could understand it, would illuminate not only the picture and the subject invoked by the title but also our own world. This is the case, for instance, in *Untitled (Juan Gris)* (fig. 17), which at once invites speculation on, and occults, the relationships among the sulfur-crested cockatoo, the newspaper, the ball, and the loop hanging from a bar at the top of the box. While a diary entry might claim that "the original inspiration [for the Gris boxes] was purely a human reaction to a particular painting at the Janis Gallery—a man reading a newspaper at a cafe table covered almost completely by his reading material,"[2] this bald statement in no way closes off possibilities of interpretation and response.

The notes Cornell jotted down for a "box for Matta" in an undated diary entry convey something of the quality of his boxes:

> top lined with blocks of pigments
> upper right lined with map—folded twisted piece of same material taking up space
> upper left—4 mirror lined compartments each containing piece of rock crystal, except piece resembling meteor blue glass
> center mirror in background suspended shells—things pasted on back of piece of

[2] Caws, *Cornell's Theater of the Mind*, 285.

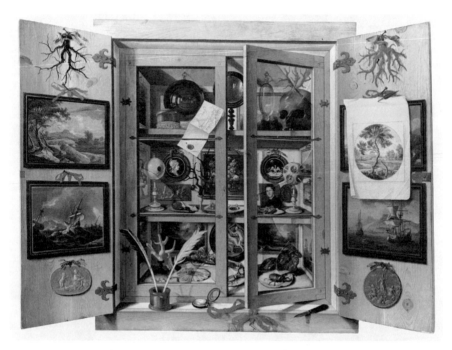

FIGURE 16. Domenico(?) Remps, *Art Cabinet Cupboard,* end of seventeenth century. Museo dell'Opificio delle Pietre Dure, Florence, archive photograph.

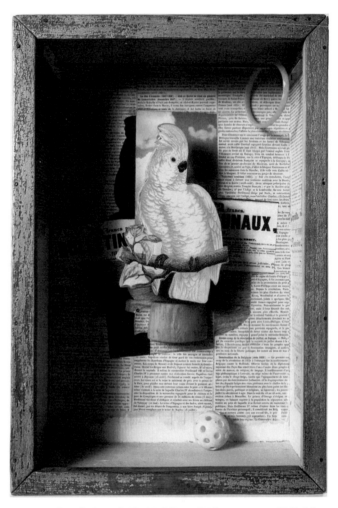

FIGURE 17. Joseph Cornell, *Untitled (Juan Gris),* c. 1953–54. Philadelphia Museum of Art: Purchased: The John D. McIlhenny Fund. © Artists Rights Society (ARS), New York / VBK, Vienna.

glass shown only in mirror—matched on front by end paper—left—newspaper
vague grey pieces of maroon one swinging—
right yellow chamber—streak of mixed colors like a cloud serpent moving diago-
nally across ground. Coloured head pins stuck in at head of comet
lower left—paleontological lined cylinder & chamber red block & yellow pigment
right—beautiful fish made of twisted green & silver tinfoil thru blue glass with
jack-black constellation lining mask of medium grey darker out line of frame.[3]

"Creative imagination," Cornell noted in a diary entry of May 23, 1965, is "stronger
than reality."[4] It is arguable that this written description, elliptical and imprecise as
it is, can appear more seductive than the boxes themselves, in that it leaves it open to
us to imagine the beautiful fish, where reality might fall short of our reveries, just as
the indication of "things pasted on back of piece of glass shown only in mirror" is in-
finitely more open than its corresponding reality. But whereas the written version
has to spell out the fact that those "things" are visible only in the mirror, the box it-
self can make this instantly true, although it might take the viewer some time to re-
alize it.

Whatever the advantages and drawbacks of writing, as opposed to showing, the
box of delights, at least one writer has recently incorporated similar boxes into her
novel, and done so, furthermore, by an amusing pun on the word "box," here given
its colloquial meaning of television. In the final volume of her tetralogy charting the
progression of a phalanx of characters from the 1950s to the end of the 1960s, A. S.
Byatt turns to the possibilities of that other potential box of delights and in a series
of bravura passages manages to convey much of the exuberant bad taste, experi-
mentalism, and optimism of the late 1960s. Her character Frederica is host of an in-
tellectual chat show called "Through the Looking Glass":

> *Through the Looking Glass* was, from the beginning, a rapid and elaborate joke
> about the boxness of the Box. As it opened, the box appeared to contain the hot
> coals, or logs, the flickering flames and smouldering ash, in the hearth which had

[3] Ibid., 78.
[4] Ibid., 293.

been the centre of groups in vanished rooms before the Box came. The fire in its shadowy cave was succeeded by a flat silvery mist (or swirl of smoke), in an elaborate gilded frame. The mist would then clear to reveal the interior of the Looking-Glass world. There was a revolving Janus clock, with a mathematical and a grinning face. There were duplicated mushrooms and cobwebs and windows. At the back of the box was what might have been a bay window, or a mirror reflecting a bay window. In the middle was a transparent box within a box, in which Frederica sat, into which the camera peered and intruded. All through the programme, round the edges of the contained space, from time to time, animated creatures and plants sauntered, sped, shot up and coiled. Roses and lilies, giant caterpillars and trundling chess pieces, multiplied by mirrors.[5]

The trail of literary and cultural allusions that runs playfully through this, from Plato to Lewis Carroll and through him to Cornell,[6] the commentary they provide on entertainments through the ages, on the duplicity of human intercourse, and on the complex nature of time itself, which is hinted at in the Janus-faced clock, the impossibility of knowing whether what we see is reality, illusion, or reflection, the theme of distorted vision—all these elements, explored elsewhere in Byatt's novel, are encapsulated here in a wonderfully postmodern version of the still life box. The brashness of the age and the medium is thrust into the foreground here, but so also is the sense of potential, in a box scene that has none of the gentle melancholy or subtly erotic undertones of Cornell's work.

The caterpillars have wandered on stage both from Carroll's text and from countless traditional still lifes, as have the mirrors and the chess pieces, but Byatt is creating her own aesthetics of the box by pirating and transforming those of the more traditional media, and in doing so is drawing sharp if unstated attention back to her own medium of writing.

Still life, in all its manifestations, has demonstrated that it is a remarkably flexible device for exploring not just the domestic areas of human experience but also

[5] Byatt, *Whistling Woman,* 139. See also another variation on the theme in a further program described in ibid., 155.

[6] On Cornell's parallels with Carroll, see Caws, *Cornell's Theater of the Mind,* 23.

FIGURE 18. Nora Heysen, *Still Life,* 1933. New England Regional Art Museum, Armidale, Australia.

much broader areas of experience, and for adding its own sometimes subversive, sometimes nostalgic, often wry and always energetic voice, a voice that proves to be just as potent in the written form as in the painted form. Above all, and perhaps precisely because it has tended to be overlooked in novels where other, louder modes of narration compete with it for our attention, it often acts as a subversive commentary on perception itself, on how we perceive reality and our place in it, but above all on whose gaze is seen as dominant, on which gender is presented as in control, on which individuals are to be assigned the role of objects and which will be elevated to subjects. And in the hands of many writers, both male and female, it throws into doubt those modes of thinking that refuse to grant subjecthood to anything designated as an object.

I want to close, therefore, with Nora Heysen's *Still Life* of 1933 (fig. 18). Here the foreground is dominated by a plate of quinces so intensely yellow, so lovingly observed in all their idiosyncratic bulges and concavities, so exuberantly reflected on the shiny dark surface of the cabinet on which they are resting, that the painted landscape hanging on the wall behind them fades into the background so we barely see its dramatic cliffs and romantic lighthouse. The aesthetic hierarchies are overturned in this quietly confident gesture where the domestic and the familiar take precedence over the grand designs of nature and the triumphant works of men. The phallic lighthouse, metonymically suggesting through its association with Baudelaire's great poem "Les Phares" (The Lighthouses) the masterpieces of art according to male-centered art histories, seems puny here, dwarfed by those rotund and solid quinces that Nora Heysen so boldly and serenely places squarely in the foreground. Moving the still life to the foreground has also been the modest aim of this book.

BIBLIOGRAPHY

Abrams, M. H. *The Mirror and the Lamp: Romantic Theory and the Critical Tradition.* Oxford: Oxford University Press, 1953.

——. *Natural Supernaturalism: Tradition and Revolution in Romantic Literature.* New York: Norton, 1971

Alpers, Svetlana. *The Art of Describing: Dutch Art in the Seventeenth Century.* Chicago: University of Chicago Press, 1983.

Appleton, Jay. *The Symbolism of Habitat: An Interpretation of Landscape in the Arts.* Seattle: University of Washington Press, 1990.

Arman [Armand Fernandez]. *Le Nouveau Réalisme.* Paris: Editions du Jeu de Paume, 1999.

Ashbery, John. *Selected Poems.* New York: Penguin, 1985.

Ashton, Dore. *A Joseph Cornell Album.* New York: Da Capo, 1974.

Auden, W. H. *Collected Poems.* Ed. Edward Mendelson. New York: Vintage, 1991.

Auerbach, Erich. *Mimésis: La Représentation de la réalité dans la littérature occidentale.* Trans. Cornélius Hein. 1946. Reprint, Paris: Gallimard, 1968.

Bachelard, Gaston. *La Poétique de l'espace.* Paris: Presses Universitaires de France, 1957.

Bal, Mieke. *Reading Rembrandt: Beyond the Word-Image Opposition.* Cambridge: Cambridge University Press, 1991.

Balzac, Honoré de. *César Birotteau.* Ed. P. Laubriet. 1837. Reprint, Paris: Garnier, 1967.

——. *La Cousine Bette.* Ed. Pierre Barbéris. 1846. Reprint, Paris: Gallimard, 1972.

——. *Le Cousin Pons.* Ed. André Lorant. 1847. Reprint, Paris: Folio, 1973.

——. *La Peau de chagrin.* 1831. Reprint, Paris: Garnier-Flammarion, 1971.

——. *Le Père Goriot.* Ed. Pierre Citron. 1835. Reprint, Paris: Garnier-Flammarion, 1966.

——. *Splendeurs et misères des courtisanes.* Ed. Antoine Adam. 1838. Reprint, Paris: Garnier, 1958.

Bann, Stephen. *Parallel Lines: Printmakers, Painters, and Photographers in Nineteenth-Century France.* New Haven: Yale University Press, 2001.

——. *The True Vine: On Visual Representation and Western Tradition.* Cambridge: Cambridge University Press, 1989.

Banville, Théodore de. *Petit Traité de poésie française.* 1872. Reprint, Paris: Les Introuvables, 1978.

Barbier, Carl, et al., eds. *Documents Stéphane Mallarmé.* 7 vols. Paris: Nizet, 1968–80.

Barnes, Djuna. *Nightwood.* 1937. Reprint, New York: New Directions, 1961.

Barnes, Julian. *Something to Declare.* New York: Knopf, 2002.

Bataille, Georges. *La Littérature et le mal.* Paris: Folio, 1957.

Baudelaire, Charles. *OEuvres complètes.* Pléiade. Ed. C. Pichois. 2 vols. Paris: Gallimard, 1975–76.

Baudrillard, Jean. *Le Système des objets.* Paris: Gallimard, 1968.

Belknap, Robert. "The Literary List: A Survey of Its Uses and Deployments." *Literary Imagination* 2, 1 (2000): 35–54.

Bell, Vanessa. *Selected Letters.* Ed. Regina Marler. London: Bloomsbury, 1993.

Benjamin, Walter. *The Arcades Project.* Trans. Howard Eiland and Kevin McLaughlin. Cambridge, Mass.: Belknap Press of Harvard University Press, 1999.

——. *Illuminations.* Trans. Harry Zohn. Ed. Hannah Arendt. New York: Schocken, 1969.

Berg, William J. *The Visual Novel: Emile Zola and the Art of His Times.* University Park: Pennsylvania State University Press, 1992.

Bergstrom, Ingvar. *Still Lifes of the Golden Age: Northern European Paintings from the Heinz Family Collection.* Ed. Arthur K. Wheelock Jr. Washington, D.C.: National Gallery of Art, 1989.

Betterton, Rosemary. *Looking On: Images of Femininity in the Visual Arts and Media.* London: Pandora Press, 1987.

Bishop, Elizabeth. *The Complete Poems, 1927–1979.* New York: Farrar, Straus & Giroux, 1983.

Bonnefoy, Yves. *Lieux et destins de l'image.* Paris: Seuil, 1999.

Borges, Jorge Luis. *Labyrinths.* Trans. Donald A. Yates and James E. Irby. Harmondsworth: Penguin, 1964.

Bowen, Elizabeth. *The House in Paris.* Harmondsworth: Penguin, 1935.

——. "Notes on Writing a Novel." In *The Mulberry Tree.* Ed. Hermione Lee. London: Virago, 1986.

Bowen, Stella. *Drawn from Life.* London: Virago, 1984.

Bradbury, Malcolm, and James McFarlane, eds. *Modernism.* Harmondsworth: Penguin, 1976.

Braider, Christopher. *Refiguring the Real: Picture and Modernity in Word and Image, 1400–1700.* Princeton: Princeton University Press, 1993.

Broch, Hermann. *The Sleepwalkers.* Trans. Willa and Edwin Muir. 1931. Reprint, New York: Vintage, 1996.

Broude, N., and Mary Garrard, eds. *Feminism and Art History: Questioning the Litany.* New York: Harper & Row, 1982.

Browning, Robert. *Selections from the Poetical Works.* London: Smith, Elder, 1886.

Brusati, Celeste. "Still Lives: Self-Portraiture and Self-Reflection in Seventeenth-Century Netherlandish Still-Life Painting." *Simiolus* 20, 1 (1990–91): 168–82.

Bryson, Norman. *Looking at the Overlooked.* Cambridge: Harvard University Press, 1990.

Bryson, Norman, Michael Ann Holly, and Keith Moxey, eds. *Visual Theory: Painting and Interpretation.* London: Polity Press, 1991.

Burton, Robert. *The Anatomy of Melancholy.* Ed. Holbrook Jackson. New York: New York Review of Books, 2001.

Butel, Elizabeth. *Margaret Preston: The Art of Constant Rearrangement.* Ringwood, Victoria: Penguin Books Australia, 1985.

Butler, Roger. *The Prints of Margaret Preston.* Melbourne: Oxford University Press, 1987.

Butor, Michel. *L'Emploi du temps.* Paris: Editions de Minuit, 1957.

Byatt, A. S. *Angels and Insects.* New York: Random House, 1992.

——. *Babel Tower.* New York: Virago, 1996

——. *Still Life.* New York: Collier, 1985.

——. *The Virgin in the Garden.* New York: Vintage, 1992.

——. *A Whistling Woman.* New York: Knopf, 2002.

Calinescu, Matei. *Rereading.* New Haven: Yale University Press, 1993.

Calvino, Italo. *If on a Winter's Night a Traveler.* Trans. William Weaver. San Diego: Harcourt Brace Jovanovich, 1979.

Carey, Peter. *Oscar and Lucinda.* 1988. Reprint, New York: Vintage, 1997.

——. *True History of the Kelly Gang.* New York: Knopf, 2000.

Carrier, David. *Principles of Art History Writing.* University Park: Pennsylvania State University Press, 1991.

Caws, Mary Ann. *The Art of Interference: Stressed Readings in Verbal and Visual Texts.* Oxford: Polity Press, 1989.

——. *The Eye in the Text: Essays on Perception, Mannerist to Modern.* Princeton: Princeton University Press, 1981.

——. *Joseph Cornell's Theater of the Mind.* New York: Thames & Hudson, 1993.

——. "What Can a Woman Do for the Late Henry James?" *Raritan* 14, 1 (Summer 1994): 1–17.

Cheney, Liana DeGirolami, ed. *The Symbolism of "Vanitas" in the Arts, Literature, and Music.* Lewiston, N.Y.: Edwin Mellen Press, 1992.

Clark, T. J. *Farewell to an Idea: Episodes from a History of Modernism.* New Haven: Yale University Press, 1999.

Claudel, Paul. *L'OEil écoute.* Paris: Gallimard, 1946.

Colegate, Isabel. *Winter Journey.* London: Hamish Hamilton, 1995.

Colley, Ann C. *The Search for Synthesis in Literature and Art: The Paradox of Space.* Athens: University of Georgia Press, 1990.

Connell, E. Jane, and William Kloss. *More than Meets the Eye: The Art of Trompe L'Oeil.* Columbus, Ohio: Columbus Museum of Art, 1986.

Cros, Charles. *Le Coffret de santal.* Paris: Garnier-Flammarion, 1979.

Daston, Lorraine, and Katharine Park. *Wonders and the Order of Nature, 1150–1750.* New York: Zone Books, 1998.

Decaunes, Luc. *La Poésie parnassienne.* Paris: Seghers, 1977.

Delvaille, Bernard. *La Poésie symboliste.* Paris: Seghers, 1971.

Derrida, Jacques. *Mémoires d'aveugle: L'Autoportrait et autres ruines.* Paris: Réunion des musées nationaux, 1990.

——. *La Vérité en peinture.* Paris: Flammarion, 1978.

Devisscher, Hans, André Lawalrée, Sam Segal, and Paul Vandenbroeck. *La Peinture florale du XVIe au XXe siècle.* Brussels: Crédit Communal, 1996.

Dickens, Charles. *Christmas Books.* 1843. Reprint. London: Collins, 1962.

Diderot, Denis. *Essais sur la peinture: Salons de 1759, 1761, 1763.* Ed. Jacques Chouillet and Gita May. Paris: Hermann, 1984.

Drabble, Margaret. *The Seven Sisters.* New York: Harcourt, 2002.

Ebert-Schifferer, Sybille. *Still Life: A History.* New York: Abrams, 1999.

Eliot, T. S. *Collected Poems 1909–1962.* London: Faber & Faber, 1963.

Flaubert, Gustave. *Correspondance.* Ed. Jean Bruneau. Vol. 1. Paris: Gallimard, 1973.

——. *Madame Bovary.* Ed. C. Gothot-Mersch. 1857. Reprint, Paris: Garnier, 1971.

Forster, E. M. *Howards End.* 1910. Reprint, New York: Vintage, 1989.

——. *The Longest Journey.* 1907. Harmondsworth: Penguin, 1967.

Freud, Sigmund. *Beyond the Pleasure Principle.* Trans. and ed. James Strachey. New York: Norton, 1978.

Fried, Michael. *Absorption and Theatricality: Painting and Beholder in the Age of Diderot.* Berkeley: University of California Press, 1980.

——. *Manet's Modernism; or, The Face of Painting in the 1860s.* Chicago: University of Chicago Press, 1996.

Fromentin, Eugène. *Les Maîtres d'autrefois.* Ed. Pierre Moisy. Paris: Garnier, 1972.

Fry, Roger. *Vision and Design.* 1920. Oxford: Oxford University Press, 1981.

Gadamer, Hans-Georg. *The Relevance of the Beautiful.* Trans. Nicholas Walker. Ed. Robert Bernasconi. Cambridge: Cambridge University Press, 1986.

Garb, Tamar. *Sisters of the Brush: Women's Artistic Culture in Late Nineteenth-Century Paris.* New Haven: Yale University Press, 1994.

Garvey, Ellen Gruber. *The Adman in the Parlor: Magazines and the Gendering of Consumer Culture, 1880s to 1910s.* Oxford: Oxford University Press, 1996.

Gass, William. *Reading Rilke: Reflections on the Problems of Translation.* New York: Knopf, 1999.

Gautier, Théophile. *Emaux et camées.* Ed. Georges Matoré. Geneva: Droz, 1947.

———. *Emaux et camées.* Iconography assembled and commented by Madeleine Cottin. Paris: Lettres Modernes, 1968.

———. *Mademoiselle de Maupin.* Paris: Garnier-Flammarion, 1966.

Gombrich, E. H. *Meditations on a Hobby Horse, and Other Essays on the Theory of Art.* London: Phaidon, 1963.

Gosse, Edmund. *Father and Son: A Study of Two Temperaments.* London: Folio Society, 1972.

Gould, Cecil. *Trophy of Conquest: The Musée Napoléon and the Creation of the Louvre.* London: Faber & Faber, 1965.

Guthke, Karl S. *The Gender of Death: A Cultural History in Art and Literature.* Cambridge: Cambridge University Press, 1999.

Hagstrum, Jean H. *The Sister Arts: The Tradition of Literary Pictorialism and English Poetry from Dryden to Gray.* Chicago: University of Chicago Press, 1958.

Hanson, Anne Coffin. *Manet and the Modern Tradition.* New Haven: Yale University Press, 1977.

Haskell, Francis. *The Ephemeral Museum: Old Master Paintings and the Rise of the Art Exhibition.* New Haven: Yale University Press, 2000.

Hazzard, Shirley. *The Transit of Venus.* Harmondsworth: Penguin, 1981.

Heffernan, James A. W. *The Museum of Words: The Poetics of Ekphrasis from Homer to Ashbery.* Chicago: University of Chicago Press, 1993.

Hegel, G. F. *On the Arts.* Ed. Henry Paolucci. 1979. Reprint, Smyrna, Del.: Bagehot Council, 2001.

Hollander, John. *The Gazer's Spirit.* Chicago: University of Chicago Press, 1995.

Holly, Michael Ann. *Past Looking: Historical Imagination and the Rhetoric of the Image.* Ithaca: Cornell University Press, 1996.

Honig, Elizabeth Alice. "Making Sense of Things: On the Motives of Dutch Still Life." *RES* 34 (Autumn 1998): 166–83.

Hughes, Richard. *The Fox in the Attic.* 1961. Reprint, New York: New York Review of Books, 2000.

Hughes, Robert. *Nothing If Not Critical.* New York: Penguin, 1990.

Hugo, Victor. *Les Travailleurs de la mer.* 1866. Reprint, Paris: Ollendorff, 1911.

Hylton, Jane. *South Australian Women Artists, 1890s–1940s.* Adelaide: Art Gallery of South Australia, 1994.

Jack, Ian. *Keats and the Mirror of Art.* Oxford: Clarendon Press, 1967.

James, Bruce. *Grace Cossington Smith.* Sydney: Craftsman House, 1990.

James, Henry. *Autobiography.* Ed. Frederick W. Dupee. New York: Criterion Books, 1956.

———. *The Golden Bowl.* Ed. Patricia Crick. 1904. Reprint, Harmondsworth: Penguin, 1984.

Jenkyns, Richard. *Virgil's Experience.* Oxford: Clarendon Press, 1999.

Jongh, E. de. *Still Life in the Age of Rembrandt.* Auckland: Auckland City Art Gallery, 1982.

Joyce, James. *Ulysses.* 1934. Reprint, New York: Vintage, 1990.

Kahng, Eik, and Marianne Roland Michel, eds. *Anne Vallayer-Coster.* New Haven: Yale University Press, 2002.

Keats, John. *Letters.* Ed. Robert Gittings. Oxford: Oxford University Press, 1987.

———. *Poems.* Ed. Gerald Bullet. London: J. M. Dent, 1974.

Kendall, Richard, ed. *Monet by Himself.* Trans. Bridget Strevens Romer. London: Macdonald Orbis, 1989.

Kipling, Rudyard. *Kim.* Ed. Edward Said. 1901. Harmondsworth: Penguin, 1987.

Klepac, Lou. *Nora Heysen.* Exhibition catalogue. Canberra: National Library of Australia, 2000.

———. *Nora Heysen.* Sydney: Beagle Press, 1989.

Laforgue, Jules. *OEuvres complètes.* 3 vols. Lausanne: L'Age d'homme, 1986–2000.

Lagerkvist, Pär. *The Dwarf.* Trans. Alexandra Dick. New York: Hill & Wang, 1958. First published in 1945.

Le Clézio, J. M. G. *L'Inconnu sur la terre.* Paris: Gallimard, 1978.

Lee, Hermione. *Virginia Woolf.* New York: Knopf, 1997.

Lessing, Georg. *Laocoön: An Essay upon the Limits of Painting and Poetry.* Trans. Ellen Frothingham. New York: Noonday Press, 1957.

Lévi-Strauss, Claude. *Look, Listen, Read.* Trans. Brian C. J. Singer. New York: HarperCollins, 1993.

Lindsay, Norman. *Halfway to Anywhere.* 1947. Reprint, Sydney: Angus & Robertson, 1979.

Lloyd, Rosemary. "The Art of Distilling Life: Mallarmé, Misogyny, and the Seduction of the Feminine." *Australian Journal of French Studies* 31, 1 (1994): 97–112.

———. *Baudelaire et Hoffmann: Affinités et influences.* Cambridge: Cambridge University Press, 1978.

———. "Figuring Ned: Nolan's Kelly, Carey's Kelly, and the Masking of Identity." *Word & Image* 19, 4 (October–November 2003): 271–80.

Loizeau, Elizabeth Bergmann, and Neil Fraistat, eds. *Reimagining Textuality: Textual Studies in the Late Age of Print.* Madison: University of Wisconsin Press, 2002.

Loti, Pierre. *Prime Jeunesse.* Paris: Calmann-Lévy, 1919.

———. *Le Roman d'un enfant.* 1890. Reprint, Paris: Garnier-Flammarion, 1988.

Lowenthal, Anne, ed. *The Object as Subject: Studies in the Interpretation of Still Life.* Princeton: Princeton University Press, 1996.

Lynn, Elwyn. *Sidney Nolan's Ned Kelly.* Canberra: Australian National Gallery, 1985.

Lyotard, Jean-François. *Sur la constitution du temps par la couleur dans les oeuvres récentes d'Albert Ayme.* Paris: Edition Traversière, 1980.

Mallarmé, Stéphane. *Correspondance: Lettres sur la poésie.* Ed. Bertrand Marchal. Paris: Folio, 1995.

———. *OEuvres complètes.* Pléiade. Ed. Bertrand Marchal. 2 vols. Paris: Gallimard, 1998–2003.

Malouf, David. *Harland's Half Acre.* London: Chatto & Windus, 1984.

Mann, Thomas. *Doctor Faustus.* Trans. John E. Woods. New York: Random House, 1997. First published in 1947.

Mauner, George. *Manet: The Still Life Paintings.* New York: Abrams, 2001.

Miller, Andrew H. *Novels behind Glass: Commodity Culture and Victorian Narrative.* Cambridge: Cambridge University Press, 1995.

Miller, J. Hillis. *Illustration.* Cambridge: Harvard University Press, 1992.

Miller, Jonathan. *On Reflection*. London: National Gallery Publications, 1998.

Mirzoëff, Nicholas. *An Introduction to Visual Culture*. London: Routledge, 1999.

Mitchell, W. J. T. *Picture Theory: Essays on Verbal and Visual Representation*. Chicago: University of Chicago Press, 1994.

———. "Romanticism and the Life of Things: Fossils, Totems, and Images." *Critical Inquiry* 28 (Autumn 2001): 167–84.

Modjeska, Drusilla. *The Orchard*. Sydney: Macmillan Australia, 1994.

———. *Stravinsky's Lunch*. Sydney: Macmillan Australia, 1999.

Montale, Eugenio. *Collected Poems, 1920–1954*. Trans. Jonathan Galassi. New York: Farrar, Straus & Giroux, 1998.

Mulvey, Laura. *Visual and Other Pleasures*. London: Macmillan, 1989.

Murdoch, Iris. *The Green Knight*. Harmondsworth: Penguin, 1994.

———. *The Sea, the Sea*. 1978. Reprint, Harmondsworth: Penguin, 2001.

Nora, Pierre. *Les Lieux de mémoire*. Paris: Gallimard, 1984.

North, Ian, Humphrey McQueen, and Isobel Seivl. *The Art of Margaret Preston*. Adelaide: Art Gallery of South Australia, 1982.

Panofsky, Erwin. *Meaning in the Visual Arts*. Garden City, N.Y.: Doubleday, 1957.

Pater, Walter. *Imaginary Portraits*. Ed. Eugene J. Brzenk. New York: Harper & Row, 1964.

Philostratus. *Imagines*. Trans. A. Fairbanks. Loeb Classical Library. Cambridge: Harvard University Press, 1931.

Pollock, Griselda. *Differencing the Canon: Feminist Desire and the Writing of Art's Histories*. London: Routledge, 1999.

———. *Vision and Difference: Femininity, Feminism, and the Histories of Art*. London: Routledge, 1988.

Ponge, Francis. *OEuvres complètes*. Pléiade. Ed. Bernard Beugnot et al. Vol 1. Paris: Gallimard, 1999.

Pope, Alexander. "An Essay on Man." *The Poems*. Ed. John Butt. New Haven: Yale University Press, 1963.

Powell, Margit. *Objects of Desire: The Modern Still Life*. New York: Abrams, 1997.

Praz, Mario. *Mnemosyne: The Parallel between Literature and the Visual Arts*. Princeton: Princeton University Press, 1970.

Prendergast, Christopher. *The Order of Mimesis*. Cambridge: Cambridge University Press, 1986.

Proust, Marcel. *Contre Sainte-Beuve*. Pléiade. Ed. Pierre Clarac. Paris: Gallimard, 1971.

———. *A la recherche du temps perdu*. Ed. Pierre Clarac and André Ferré. 3 vols. Paris: Gallimard, 1954.

Raser, Timothy. "Claiming Painting for Literature: Fromentin versus Claudel." *Claudel Studies* 25 1–2 (1998): 45–55.

Rathbone, Eliza E., and George T. M. Shackelford. *Impressionist Still Life*. New York: Abrams, 2001.

Reynolds, Joshua. *A Journey to Flanders and Holland*. Ed. Harry Mount. Cambridge: Cambridge University Press, 1996.

Rheims, Maurice. *La Vie étrange des objets: Histoire de la curiosité*. Paris: Plon, 1959.

Richardson, Dorothy. *Pilgrimage*. 4 vols. New York: Knopf, 1967 (1915–67).

Rilke, Rainer Maria. *Letters on Cézanne.* Trans. Joel Agee. Ed. Clara Rilke. New York: Fromm, 1985.

Robbe-Grillet, Alain. *Les Gommes.* Ed. J. S. Wood. Englewood Cliffs, N.J.: Prentice-Hall, 1964.

———. *Pour un nouveau roman.* Paris: Editions de minuit, 1963.

Rossetti, Christina. *Goblin Market.* 1862. Reprint, London: Gollancz, 1989.

Ryan, Judith. *The Vanishing Subject.* Chicago: University of Chicago Press, 1991.

Sarraute, Nathalie. *Le Planétarium.* Paris: Livre de Poche, 1959.

———. *Tropismes.* Paris: Editions de Minuit, 1971.

Schama, Simon. *The Embarrassment of Riches.* New York: Knopf, 1987.

———. *Landscape and Memory.* New York: Knopf, 1995.

Schapiro, Meyer. *Words, Script, and Pictures: Semiotics of Visual Language.* New York: Braziller, 1996.

Schoonbaert, Lydia, et al. *James Ensor: Belgien um 1900.* Munich: Hirmer Verlag, 1989.

Schor, Naomi. "Pensive Texts and Thinking Statues: Balzac with Rodin." *Critical Inquiry* 27, 2 (2001): 145–72.

———. *Reading in Detail: Aesthetics and the Feminine.* New York: Methuen, 1987.

Schwenger, Peter. "Words and the Murder of Things." *Critical Inquiry* 28 (Autumn 2001): 99–113.

Scott, David. *Pictorialist Poetics.* Cambridge: Cambridge University Press, 1988.

Shattuck, Roger. *Proust's Binoculars: A Study of Memory, Time, and Recognition in "A la recherche du temps perdu."* New York: Random House, 1963.

Solomon, Deborah. *Utopia Parkway.* New York: Farrar, Straus & Giroux, 1997.

Steiner, Wendy. *The Colors or Rhetoric: Problems in the Relationship between Modern Literature and Painting.* Chicago: University of Chicago Press, 1982.

———. *The Scandal of Pleasure.* Chicago: University of Chicago Press, 1995.

Stephens, Mitchell. *The Rise of the Image, the Fall of the Word.* New York: Oxford University Press, 1998.

Sterling, Charles. *Still Life Painting: From Antiquity to the Twentieth Century.* New York: Harper & Row, 1981.

Sterne, Laurence. *Tristram Shandy.* New York: Modern Library, 1950.

Stewart, Susan. *On Longing.* Baltimore: Johns Hopkins University Press, 1984.

Tadié, Jean-Yves. *Marcel Proust.* Paris: Gallimard, 1996.

Tashjian, Dickran. *Joseph Cornell: Gifts of Desire.* Miami Beach: Grassfield Press, 1992.

Taylor, Charles. *Sources of the Self.* Cambridge: Harvard University Press, 1989.

Terdiman, Richard. *Present Past: Modernity and the Memory Crisis.* Ithaca: Cornell University Press, 1993.

Topliss, Helen. *Modernism and Feminism: Australian Women Artists, 1900–1940.* Roseville East, NSW: Craftsman House, 1996.

Ure Smith, Sidney. *Margaret Preston: Recent Paintings.* Sydney, Australia: Sidney Ure Smith, 1929.

Valéry, Paul. *OEuvres.* Ed. Jean Hytier. 2 vols. Paris: Gallimard, 1957.

———. *Poésies.* Paris: Gallimard, 1958.

———. *Sea Shells.* Trans. Ralph Manheim. Boston: Beacon Press, 1998.

Van Gogh, Vincent. *The Complete Letters.* 1958. Reprint, Boston: Bulfinch Press, 2001.

Vernant, Jean-Pierre. *La Mort dans le yeux: Figures de l'autre en Grèce ancienne.* Paris: Hachette, 1986.

Wharton, Edith. *The House of Mirth.* 1905. Reprint, Harmondsworth: Penguin, 1985.

Wheelock, Arthur K., Jr., et al. *Johannes Vermeer.* New Haven: Yale University Press, 1995.

Williams, Rosalind H. *Dream Worlds: Mass Consumption in Late Nineteenth-Century France.* Berkeley: University of California Press, 1982.

Wind, Edgar. *The Eloquence of Symbols: Studies in Humanist Art.* Ed. Jaynie Anderson. Oxford: Clarendon Press, 1983.

Woolf, Virginia. "Character in Fiction," *The Essays of Virginia Woolf.* Vol 3: *1919–1924.* Ed. Andrew McNeillie. New York: Harcourt Brace Jovanovich, 1989.

——. *The Complete Shorter Fiction.* Ed. Susan Dick. New York: Harcourt Brace, 1989.

——. *The Diary of Virginia Woolf.* Ed. Anne Olivier Bell and Andrew McNeillie. 5 vols. London: Hogarth Press, 1977–84.

——. *Jacob's Room.* London: Hogarth Press, 1990.

——. *Mrs. Dalloway.* Frogmore, St. Albans: Panther, 1976.

——. *A Room of One's Own.* 1929. Reprint, London: Collins, 1988.

——. *The Waves.* Harmondsworth: Penguin, 1964.

Yates, Frances. *The Art of Memory.* Chicago: University of Chicago Press, 1966.

Zola, Émile. *Au bonheur des dames.* Paris: Flammarion, 1971.

——. *La Curée,* ed. Claude Duchet. Paris: Garnier-Flammarion, 1970.

——. *Le Ventre de Paris,* in *Les Rougon-Macquart.* Ed. A. Lanoux and H. Mitterand. Paris: Gallimard, 1963.

INDEX